THE ART OF COMIC BOOK WRITING

OPEN ON THE TWENTY-FIFTH ANNIVERSARY O
E EVENT. ELI ENCOUNTERS AN OLD MAN, HEN
ADAMS, WHO TELLS HIM THAT THE EVENT WAS
AX. USED TO THE OCCASIONAL SKEPTIC, ELI
NORES HIM. THAT NIGHT, ELI FINDS HENRY
ITING INSIDE HIS APARTMENT. ELI ALERTS
THORITIES (THE POLICE) AND QUESTIONS HE
NRY TELLS ELI THAT THE PROPHET HAS TO D
R WHAT HE'S DONE. THE AUTHORITIES DRAG
NRY AWAY BEFORE ELI CAN QUESTION HIM AB
E DEATH THREAT.

TER THEY LEAVE, ELI FINDS THAT HENRY
INTED AN ENTIRE MURAL ON HIS WALL
NSISTING OF NAMES, NUMBERS, AND PHRASES
I TAKES A PICTURE OF THE WALL MAP AND H
TSIDE TO CALL HIS GIRLFRIEND BETHANY ON
BLIC PHONE (SINCE HIS PHONE ISN'T WORKI
ILE ON THE PHONE, AN EXPLOSION ROCKS HI
ARTMENT BUILDING.

EAN-UP CREWS ATTRIBUTE THE EXPLOSION TO
ULTY MECHANICS IN THE BUILDING, BUT ELI
RY. HE GOES TO BETHANY'S APARTMENT AND
OWS HER THE MAP AND TELLS HER ABOUT THE
ATH THREAT TO THE PROPHET. WHEN THEY
SCOVER THAT HENRY AND THE AUTHORITIES W

THE ART OF
COMIC BOOK
WRITING

THE DEFINITIVE GUIDE TO OUTLINING,
SCRIPTING, AND PITCHING YOUR
SEQUENTIAL ART STORIES

MARK KNEECE

WATSON-GUPTILL PUBLICATIONS
Berkeley

The SCAD Creative Essentials Series

The SCAD Creative Essentials series is a collaboration between Watson-Guptill Publications and the Savannah College of Art and Design (SCAD) developed to deliver definitive instruction in art and design from the university's expert faculty and staff to aspiring artists and creative professionals.

Published in the United States by Watson-Guptill Publications, an imprint of the Crown Publishing Group, a division of Penguin Random House LLC, New York.
www.crownpublishing.com
www.watsonguptill.com

WATSON-GUPTILL and the WG and Horse designs are registered trademarks of Penguin Random House LLC

Library of Congress Cataloging-in-Publication Data
Kneece, Mark.
 The art of comic book writing : the definitive guide to outlining,
scripting, and pitching your sequential art stories / Mark Kneece. —First Edition.
 pages cm. — (The SCAD Creative Essentials Series)
 Includes bibliographical references and index.
1. Comic books, strips, etc—Authorship. I. Title.
 PN6710.K63 2015
 741.5'1—dc23

 2015007716

Trade Paperback ISBN: 978-0-7704-3697-1
eBook ISBN: 978-1-6077-4751-2

Printed in China

Design by Chloe Rawlins

10 9 8 7 6 5 4 3 2 1

First Edition

To my wife, Paula.
And to all the teachers I've known, living or dead,
employed or unemployed, who've helped those
around them see things more clearly.

CONTENTS

Introduction 1

CHAPTER 1

STORY BASICS: IDEAS, DEVELOPMENT, AND VISUALIZATION 5

Generating Story Ideas: Getting Started 6

What Comics Stories Need: Developing Your Story 7

Being About Something in a World of Static Visuals 10

Lights, Action . . . Comics!: Making Your Story Visual 11

Important Tips, Warnings, and Considerations 14

Have Fun Creating Your Story 17

CHAPTER 2

FORMATTING A COMICS SCRIPT IN "FULL SCRIPT" 19

Comics Script Methodology 20

Drawability 28

Story Structure and Script Formatting 29

Formatting and Editing 30

Avoiding Bad Habits 30

Know Your Destination 34

CHAPTER 3

THE ALMIGHTY PAGE 39

Page Dimensions 40

Page Outlines Can Help 41

Act Structure and Page Breakdowns 44

Page Outline to Script Pages 49

When Telling Is Best 55

Take It in Stages 55

CHAPTER 4

TALKING TO THE ARTIST AND WRITING THE SCRIPT 57

Script as Blueprint 58

Words to Describe Art 61

Shot Calls: Yes or No? 62

Generality vs. Specificity: Making Objects and Actions Clear 66

Presentation Order 67

CHAPTER 5

SCRIPT ENERGY: DIALOGUE, TEXT, AND VISUALS 73

Using Text 74

Text or Visual Action? 83

Seeing and Hearing the Story 86

CHAPTER 6

CHARACTER DYNAMICS 89

Building Characters 90

Developing the Main Character 92

Naming Characters 93

Controlling Idea and Character 93

Art and Character Development 100

CHAPTER 7

WORLD BUILDING: PROPS, STRUCTURES, AND ATTITUDES 103

Setting Shapes Narrative 104

The Physical World 104

The Historical Setting 105

The Social and Cultural Atmosphere 106

Reality, Cartoons, and Art Style 106

The Backstory Blues 110

Setting as Symbol 116

CHAPTER 8

PACING THE STORY, PART 1: ROOM TO BREATHE 121

Streamlining the Complications 122

The Joy of Discovery 124

Why Pacing Does Not Occur Naturally 124

Compression vs. Expansion 124

Art Distension 128

Talk While Doing 133

Time Equals Understanding, Right? 133

Story Time Is Rarely *Real* Time 133

CHAPTER 9

PACING THE STORY, PART 2: BREAKING THE RULES 141

Tempo and Rhythm in Comics 142

Don't Waste Story Time! 144

Storytelling Cruise Control 147

Formulaic Comics Narratives 154

Inner vs. Outer Conflict (and Pacing) 155

What to Do About Bad Pacing 159

CHAPTER 10

PUTTING TOGETHER A SYNOPSIS FOR SUBMISSION 161

What Is a Story Synopsis? 162

Logline as Plot Armature 162

Technicalities of the Synopsis 165

Putting Everything Together 167

Conclusion 173

Appendix: Mark Schultz Talks About Writing Comics 175

Acknowledgments 179

Contributors 180

Index 182

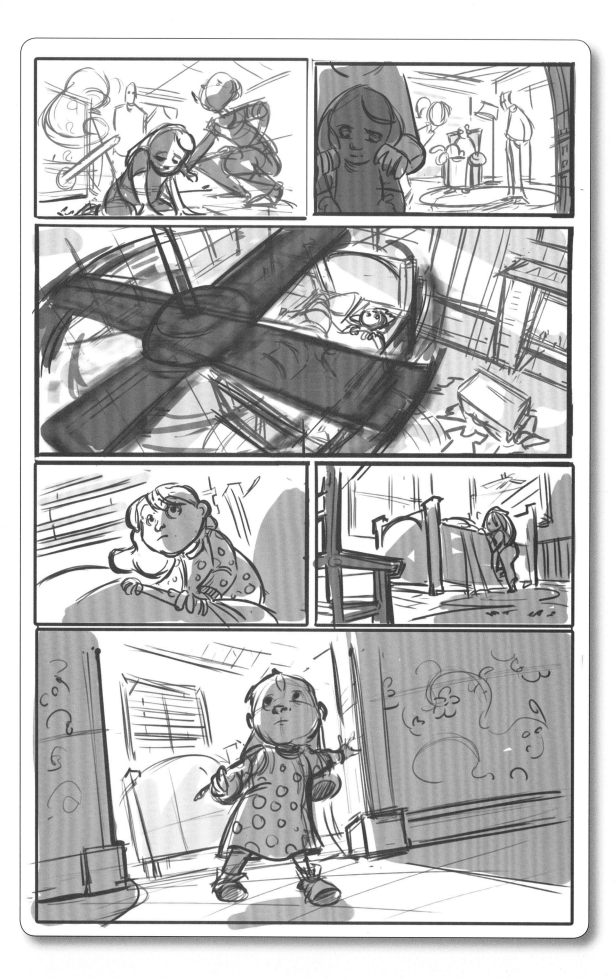

INTRODUCTION

Comics writing is not only an art form, it is a *difficult* art form. The audience for comics writing is extremely narrow. The main audience is one person, the artist drawing the story. There may also be editors, publishers, colorists, letterers, or stalwart fans who are interested in what the original script looks like; however, most people never see it. Instead, they see the final product, the finished comic.

Story is the alpha and the omega of comics; it is *that* important. In comics, good art only goes so far if the story is lacking. On the other hand, we may sometimes forgive bad art if the story is interesting enough. The connection between narrative and art, however, is vital for creating comics stories. A comics writer must intimately understand how both aspects function, what works well, what doesn't work so well, and when to bend the rules a little. Not all comics writers draw, but no one can ever be a comics writer without a firm conception of what a story is and of how art can be manipulated to tell that story.

Story is an inescapable facet of comics art. If someone is interested in art only, but not the story, I would strongly suggest that that person put this book down right now and walk away. To that person I'd say, go back to drawing and don't let me interrupt you any further. Don't get me wrong: Good art is important. I teach at a school where drawing is emphasized heavily. Students spend months mastering the figure, grappling with perspective, and wrestling with line weights, color palettes, T squares, and various complicated software programs in order to improve their art. Those skills are important; however, learning to manipulate text and art to create narrative is exponentially more difficult. It is *not* a given that everyone who knows how to draw will also know how to tell a story, much less how to write one. Sequential art serves one almighty master—the story.

In comics, story is rigidly governed by the dictates of the page. The lack of movement and the use of panels generate all of the same problems for the creator of webcomics as for the creator of print comics. However, a talented comics writer crafts stories around the strengths of the medium. Static images in relatively small spaces can achieve power and drama.

The comics medium is more than just the stepchild of illustration and film. It has its own set of complex rules about what can and can't be done, about what does and doesn't work. No one really wants to *read* a comic book, at least not in the way one would read a prose novel, and no one wants to watch as if it were a movie. That's the first mistake

amateur comic book writers make—overloading the script. They think about writing novels, films, or possibly even plays, instead of focusing on working in a visual medium where *art* rules—art that doesn't move, doesn't speak aloud, and doesn't occupy much space. Anyone who thinks that writing a comic is exactly like writing a film is dead wrong. Ask any screenwriter who's tried turning to comics writing.

Many comics writers turn to film-writing books as sources of information about storytelling within a visual medium. They are not bad places to go for some of the most basic principles. I personally use Robert McKee's *Story* as a textbook in some of the comics writing classes that I teach. Somewhere along the line it occurred to me, wouldn't it be a good thing to have an in-depth book to cover the art of writing for *comics*? When the opportunity arose, I decided to take the things that I'd learned over the past two decades of teaching comics writing at SCAD and set them down here.

What makes this book so special, you might ask? I've taught four classes per quarter, with ten to twenty students in a class on average, each and every year since 1993. In the last twenty-plus years, I've taught somewhere in the neighborhood of four thousand students about comics writing. As a teacher, that's a lot of practice. Every new student is full of great ideas and has a lot of questions. The fun never gets old. Many of those individuals are out there somewhere right now, making me very proud to have helped them in some small way.

Based on my experience with both students and professionals, here's one thing I know to be true: successful creators all have a sound work process. Those two words, "work" and "process," along with imagination and insight, will help transport those wishing to become comics creators to the place they want to go. What I hope to accomplish in this book is to explain what the work of writing is, what the process may be, and possibly even open the door to some of that imagination and insight that's needed. Does that mean that everyone who reads this book will get hired to write *Spider-Man* or create the next *Teenage Mutant Ninja Turtles*? Hardly. That's not the point of creating art. Though, very often, it is a side effect.

—MARK KNEECE

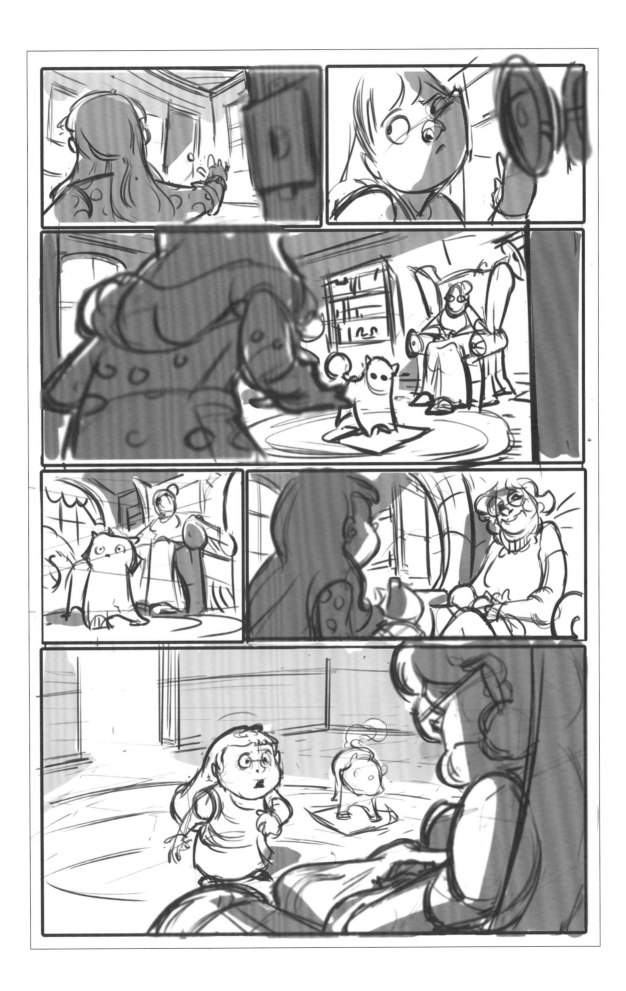

STORY BASICS: IDEAS, DEVELOPMENT, AND VISUALIZATION

Coming up with story ideas is often the most difficult task for any writer, but especially for a comics writer. Beginning comics writers often make the mistake of worrying too much about what is currently selling or what they think a publisher might be looking for, rather than listening to their inner voices. Chasing the market leads to derivative story ideas or worse, unconscious plot rip-offs. Furthermore, any writer creating something just because it is popular probably doesn't have much personal stake in the work. The ideas that a comics writer (or any writer) should consider writing about should come from someplace more distinct and fundamental, whether the writer is creating a story for an established character or developing a personal, indie-type story.

GENERATING STORY IDEAS: GETTING STARTED

With so many directions available, a writer can go just about anywhere with a story. That in itself can become a problem. How does a writer decide where to begin? There are three fundamental questions that you should always ask yourself, whether you're developing your own unique graphic novel idea or whether you happen to be writing for a well-established character like Wolverine: *How much do I know about the subject? How much do I care about the subject?* and *How objective can I be about the subject?* These questions provide the basic guidelines that should govern your choices, no matter what kind of story you want to write.

Guideline 1: Know what you are talking about

Ask yourself, *What do I actually know about my subject?* Superficial knowledge of a subject won't do. You can gain knowledge either through firsthand experience or research. If you intend to write a comic set in World War II, do research on the war—learn the weapons, equipment, tactics, and history. Such details often lead to convincing plot points. Even better, talk to someone who was in the war. Know not only the subject matter and the rules of the world that you've set up, but also the genre you're getting into. What do readers expect, for instance, from a detective comic or a horror comic or a romance comic? Knowing what has been done should inspire you to come up with

something different, playing off of those previously established expectations.

Guideline 2: Write about things that you care about

Caring means having a personal reason for wanting to create a comic about a particular subject. It's not enough just to know a given subject. Why are you writing about it? What point is the story trying to make? Make the story something that you would want to read. Even working with an established character, a writer can find a way to put something that she cares about into the story.

Amazingly, no matter how much a writer might love an established character, the only way to do anything new with that character is to work a story around subject matter that the writer actually cares about. Otherwise, the story will become a cliché, a fan homage to the character.

Guideline 3: Be objective

Objectivity has two parts. First, be fair to the characters and the situations in the story. Don't set up villains that are obvious and easily dealt with. Consider the motivations of the bad guy or gal as well as those of the good guy or gal. No problem in life is ever *that* easy; otherwise, it wouldn't be a problem. Easy problems will not sustain a graphic novel or multiple issues of a comic book series.

Second, remember that anything that you publish is going to be read and potentially criticized by editors, artists, letterers, colorists, and later on, critics, reviewers, commentators, and even the people who order books from Amazon. No one is forcing you to write about extremely sensitive subjects that embarrass you. There are plenty of autobiographical comics where raw anger, unfiltered frustrations, and intimate confessions are written and drawn, but *narrative* comics are driven by highly structured plots that require careful, objective editing. Life experiences and personal observations are what give writers their unique voices, and lend energy to their stories. Personal, thoughtful honesty

> **Three Questions to Generate Story Ideas**
>
> 1. How much do I know about the subject?
>
> 2. How much do I care about the subject?
>
> 3. How objective can I be about the subject?

is the most obvious way to say something that no one else has thought of. To some extent, all writing is autobiographical. Here's the secret that all highly successful writers know: if they do not stick their necks out just a little—take some kind of risk with the writing—their stories probably won't be very interesting to read.

WHAT COMICS STORIES NEED: DEVELOPING YOUR STORY

In creating a comics story, you will have to consider some of the rules that govern *all* stories. The comics storytelling medium has its own distinctive set of requirements as well. In developing a story idea for comics a writer must first have an interesting story, then an understanding of what makes a story work as a comic. It's important to know not only the basic rules of storytelling but also the rules as they apply to comics. Not every story works well as a static visual narrative.

A Succession of Chronological Events with Characters

For a moment, let's forget about comic books. Instead, think about the way all stories are told, as a succession of character-related events in a chronological arrangement. Consider the story below. Is it a good one?

A man wakes up at 6:00 a.m. when his alarm goes off. He takes a shower and pours some coffee. He switches on the television and checks the weather and the headlines for the day as he pours a bowl of cereal. Thirty minutes later, he brushes his teeth, combs his hair, then gets into his car and drives to work. At work, he checks his email and discovers that his company has hired three new employees. He looks through his stack of files. He begins working. At 10:00 a.m. he takes a break.

There is an obvious sequence of events spread out over time. The character lives in a house, has an alarm clock, and eats cereal for breakfast. He has a job.

As a story, it's all pretty ordinary. The narrative lacks *conflict*. Conflict grows out of a problem to be solved.

Conflict = Story Problem

A story must have conflict—or a story problem. Consider why people read. There are two basic, primal reasons: (1) to learn and (2) to be entertained. Straightforward learning, of course, may not be very entertaining. Characters in stories exist to create problems and to attempt to solve problems. In comic books, readers may enjoy extreme or fantastic problems and marvel at incredible solutions. Problem invariably means conflict, and *a conflict must lie at the heart of the telling.* If he conflict is not resolved, the story will not be very satisfying.

Take another look at the previous story. It has been revised below to have an obvious and understandable problem.

The reader's interest lies in whether or not the man solves his problem. If the problem is solved too easily, then the storyteller hasn't given the reader a full measure of entertainment, and it feels as if nothing has been learned. The story isn't just about a cut foot, it's also about how this *particular* character deals with the problem within this *particular* world. Is the character angry, frightened, determined, or completely unfazed? Could one problem that is fairly easily solved lead to more problems that are more difficult to solve?

Returning to the story about the man who cut his foot in the shower. Let's add a second story event, caused by the first. In addition, let's continue to consider the story as a visual narrative. Think

A middle-aged man, slightly overweight—needing a shave, not having slept well—wakes up at 6:00 a.m. when his alarm goes off. Groggy, he walks into the bathroom and drops a bottle of liquid soap. The glass shatters on the tiles. He steps on a sharp piece of glass, gashing his foot. Wet and limping to the first aid kit, he tries to stanch the heavy flow of blood. He calls 911, just before he grows woozy and passes out. Firemen arrive. He is saved.

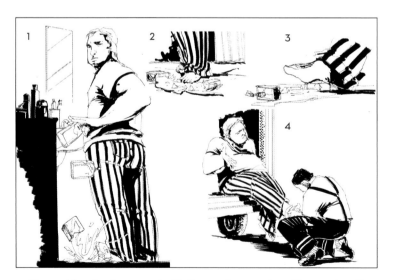

The problem has to connect with the reader somehow. The most easily understood of all problems, of course, is survival—life and death.

The same man, now with a bandaged foot, has just limped into work at his hectic office. He is significantly late because he spent four hours in the hospital's emergency room. His boss is not pleased. He has been having difficulties for several weeks with his new boss—a young man who was recently hired. He checks his email and discovers that he has just been asked to come to the personnel office at 3:30 p.m.. Gripped by anxiety, he checks the time—it's 12:30 p.m..

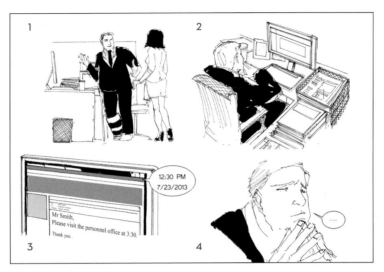

A story with no internal conflict, no complexity, feels somehow flat. Emotional turmoil in a character may be challenging to convey, but it usually makes for interesting storytelling.

about how the story could be told, not in words, but as a sequence of images.

The cut foot causes the main character to be late for work. Being late for work creates a new problem. The cut foot sets up a narrative syllogism. A *syllogism* is a deductive line of reasoning often consisting of a major and a minor premise. For example, if A happens, then it will cause B. If B happens, then it will cause C, and so on. *If I cut my foot, I may be late for work. If I'm late for work, I could be in trouble.* This type of logic is of utmost importance in storytelling. It helps to set up why things happen. To a large extent, the second problem is an internal one. The world is a complex place, and the man in this story faces one of those complexities. As the old saying goes, "The plot thickens." Now the threat of possibly bleeding

to death from the wound has passed, but a new threat has arisen: he could potentially be fired from his job, a problem that, in his mind, may be even more serious than the cut. Getting to work on time was hindered by a *complication*—visiting the hospital. The complication now leads to a *complexity*—anxiety over the resulting trouble. Physical complications most often either lead to or are accompanied by complexities, the obstacles a character feels internally, such as anxiety, doubt, or insecurity. If a story is nothing more than a sequence of complications, physical obstacles the narrative journey places in front of a character, then there is a good chance the reader is going to grow bored.

Complexities have less direct causes as well. A character may be a little insecure about his job to

begin with, but the new set of complications causes those insecurities to grow. Usually characters don't just get angry or sad or even happy for no reason. There should be an identifiable cause that the reader can understand.

BEING ABOUT SOMETHING IN A WORLD OF STATIC VISUALS

Comic book stories should have some kind of point. The turmoil and resolution of inner and outer conflicts generate the point of the story. Complications in the story often force a character to overcome complexities, and thus alter the character. Readers frequently connect stories to ideas of justice or injustice. If the story on page 9 ended with the man being fired, it would probably leave the reader wondering what the man does next. The reader feels, and rightly so, that firing would motivate another action. Would the man sue his boss? Would he find another job? Would he become motivated to be highly successful doing something else? Would he spiral down into the life of a homeless vagabond? Would he become a criminal? Did the

Preaching (What Stories Don't Need)

Don't announce what the reader should think. Nothing turns a reader off more quickly than the perception that a writer has an ax to grind or an agenda to pursue. Always remember the three guidelines covered on page 6: know the subject matter, care about the subject matter, and *be objective*. Leting readers draw their own conclusions about what to make of the events in the story is part of being objective. In the example of the man with the cut foot, it would not be a good idea, for instance, for the writer to announce: "What is happening to this man isn't fair." It is much better to show readers what is happening to the man, and let them judge for *themselves* whether or not it is fair.

man deserve what he got? What does the story seem to say about what happened? The narrative syllogism sets up something that the reader perceives as justice or injustice. That perception lingers in the reader's mind and becomes the point of the story, the place where the story connects with the bigger world in which we all live. I'll return to the man with the cut foot and the work anxiety soon, but first let's talk about a few other story considerations.

Reflection of Life

Life is chaotic, and art reflects life. In doing so, it helps to resolve life's chaos. The writer's main job is to arrange an organized presentation of a set of events, the premises of the narrative syllogism. The moment a writer decides, "If these things happen, *this* will result," he embeds opinions about the world into his story. If the writer creates a story, he is doing so because he selected that idea out of the thousands of random ones floating around in his head, selected it because it loomed conspicuously in his imagination, because some nexus that connects that idea to the bigger continuum of human endeavor suggested itself. Readers don't have to agree with the outcome of the story, just understand it.

A Strong Story Spine

Keep the *story spine* simple. Story spine, often a cinematic term, is sometimes referred to as the story "throughline." As the name implies, the spine connects all the parts of the narrative syllogism. A story can have many complications and complexities, but the main problem of the story should always be clear. *Star Wars*, for instance, has many subplots and various conflicts. The consistent story problem that forms the spine of the story is the Rebels versus the Empire—or perhaps the Jedi versus the Dark Side. A character should have one main understandable objective within the story. Digressions may be more acceptable in prose writing, where the mind may move via associations into different subject matter, but in comics, simplicity is vital because the images must tell the story by developing the conflict through the character's visible actions.

A Solid Structure

Structure might be described as the way a story is organized. Most stories fall into a familiar pattern. There is nothing wrong with the pattern. It is the way most readers understand story development. Ordinary life is changed somehow, presenting the main character with a problem. The main character tries to restore life to a comfortable level of ordinariness, setting up a number of *shortfalls*, or failed attempts, that escalate the tension of the story, forcing the character to try more and more risky solutions. In the climax of the story, the character must put forth the greatest effort. From there the character succeeds or fails once and for all. Readers are accustomed to these familiar hallmarks of storytelling. Anyone considering developing a story idea for a comic book should consider the arrangement of the story. In the realm of comics it is vital to make the arrangement work with the

page organization. More will be said about page organization in chapter 2.

LIGHTS, ACTION . . . COMICS!: MAKING YOUR STORY VISUAL

For a story to work well in comics it needs some type of action. *Action* means the suggestion of movement. Actions are the prime means by which the reader comes to know characters. Some actions are stronger than others. Talking, for instance, is a weak action. Arguing is a much stronger action. Art can only show physical poses. When characters don't physically move, the snapshot moments probably center around small emotional changes that register in the character's face. You have to consider how well actions communicate to the reader. What does a character look like when contemplating the universe? How is that look different from, say,

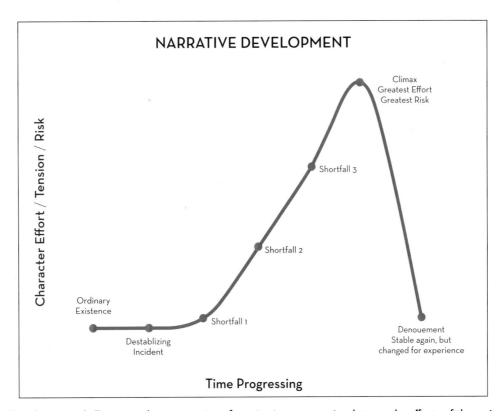

NARRATIVE DEVELOPMENT

Character Effort / Tension / Risk

Climax
Greatest Effort
Greatest Risk

Shortfall 3

Shortfall 2

Ordinary Existence

Shortfall 1

Destablizing Incident

Denouement
Stable again, but changed for experience

Time Progressing

The above graph illustrates the progression of tension in a story as it relates to the efforts of the main character to achieve a desire over time within the story structure. The line on the graph reflects the story spine, as tension builds to the climactic point of the story, then drops off rapidly before the denouement. The *denouement* of a story is the ending, where all the loose threads of the plot are tied up.

Unmotivated and repetitious actions become dull to the reader if no convincing context is provided.

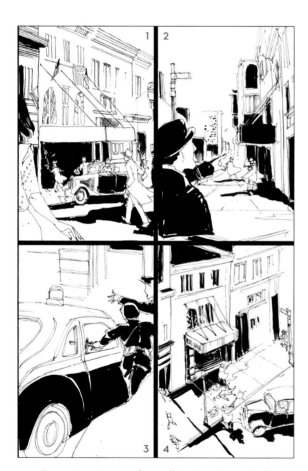

Dynamic action can be really interesting to look at in a comic, but it needs narrative logic in order to make sense. The action above, on its own, is a fun illustration, but it has no point.

being in love? The comics writer must constantly ask, *What is the reader looking at here? What is there to show?* It is difficult to write comics stories based only on internal conflicts. Outward physical conflicts present more opportunities for dramatic moments, and that's probably why action/adventure is one of the biggest comic book genres.

Action should arise naturally as part of the narrative syllogism. All action should be caused by something, or should achieve something within the logical development of the story. Action has to connect with *story*. If a story is only about violence for the sake of violence, the reader will tire of it. Unsophisticated writers sometimes include actions just because they look good on the page. Remember, the efforts of characters to solve the story problem drive the story. Characters don't necessarily fight just because they run out of things to say.

Consider this brief sequence of events:

```
Panel 1: Three bank robbers are
about to enter a bank.

Panel 2: OTS (over the shoulder,
looking over the cop's shoulder),
a cop sees them.

Panel 3: Cop reaches for machine
gun in cop car.

Panel 4: Cop and bank robbers blast
away at one another.
```

The sequence is exciting, but outside the context of a bigger story that establishes who the characters are, what's at stake, and what the struggle is about, the scene ultimately has no purpose.

Fit Visuals into the Narrative Syllogism

Let's return to the man with the cut foot for a moment. As a visual narrative, that story presents a number of challenges for a comics writer. What does this man look like? How would one *show* that he has a history of problems with his boss? Such ideas almost seem to demand words, not images.

Large blocks of text in comic books, however, not only cover artwork, but they also slow the pacing and annoy the reader. *Showing*, not telling, is important. To work well in comics the man needs to do something to generate action and visual interest (see illustration below).

See the Story in Your Head

It helps to think cinematically, but remember a comic book *isn't* a movie, and doesn't share the limitations of the film medium. Comics are a great medium for dramatic, atmospheric stories. That may be why so many comics are horror stories, superhero stories, or war stories. According to Diamond Distributors, in 2012, the best-selling comics were *The Walking Dead*, *Uncanny Avengers*, and *Spider-Man*. Characters don't have to be realistically rendered, or even human, or, in some cases, even alive; however, you must absolutely have a picture of them in your mind, not just a philosophical attitude toward them. How characters think is important, but those thoughts must manifest themselves in drawable actions. The more complicated the world and characters, the more difficult the story becomes to visualize, thus the more the story leans on words instead of art to explain things. If the characters or the world of the story are murky in the writer's mind, the story becomes difficult to plot, more difficult to script, and virtually impossible to draw.

Frozen moments make up comics stories. One of the reasons that comics have done so well with superheroes and action-packed adventure stories is that such stories offer lots of opportunities for exciting, action-oriented snapshots. An artist has to draw the story with lines and colors, using ordinary tools. Comics have no smell, taste, sound, or feel. Things do not move. Comics employ carefully arranged static visuals and a few words to cover everything a reader must know. It's one of the reasons comics are so difficult to write. A story for sequential art must possess a graphic visual component strong enough to survive this stasis.

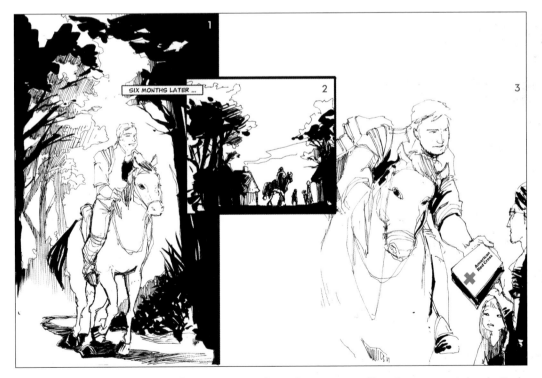

Being fired could cause the man, for instance, to take a job in a remote village in some exotic locale. Such a development would not only be logical storytelling, but it could give the story interesting visual contrast.

Express Ideas and Stakes Visually

A comics writer can't think abstractly, but must think visually. Knowing *what to write about* and knowing *what the story is about* are two completely different concepts. A visual narrative deals with concrete objects; however, *the story* is about the ideas those objects generate, not the objects themselves. For example, if a woman wants to win the lottery, there may be nothing especially exciting about that goal. If, however, a woman decides to mortgage her house and buy four hundred thousand lottery tickets, the story becomes much more interesting because of the simple fact that more is at stake than just investing a dollar or two for a couple of tickets. The fact that the woman is willing to risk, and potentially sacrifice, so much for what she wants is intensely interesting. If the woman wins millions, she will be viewed as a hero. If the woman loses, she may be viewed as a fool. Either way, the understanding of the risk draws the reader to the story.

Of course, stories can have more visually interesting objects than lottery tickets, but the point of the story is focused on the characters, not the objects. Obviously, the obsession with the physical object could lead to internal conflicts in the woman's life. The story is about whatever creates the greatest source of conflict.

IMPORTANT TIPS, WARNINGS, AND CONSIDERATIONS

Try to provide the reader with a unique reading experience. Before setting up a story it is important to consider who your readers may be and what they may have already seen. Do your best to create a plot that is not predictable, trite, or trivial. Writing stories with solid plots that are exciting to readers involves many considerations.

Know the Hook

The *hook* grabs the reader's imagination, makes the reader want to understand what the plot may be. The writer should thoroughly understand what the hook of the story is, and the hook should be distinctive. The premise of "Superman" may contain one of the best-known hooks in comics: an alien comes to Earth and discovers that his ordinary abilities on his home planet are extraordinary on Earth. However, the idea that was new and exciting in 1938 has been copied so many times now that,

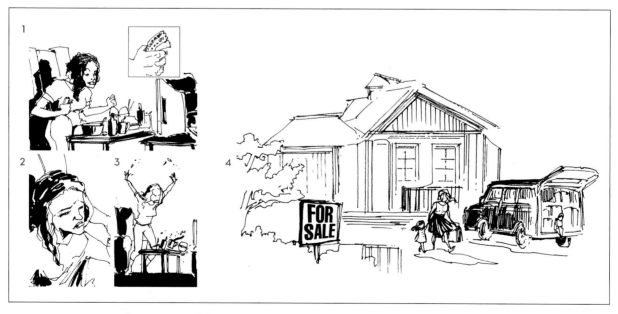

Lottery tickets, as a visual object, are essentially boring. However, the visuals connected with the actions of a woman losing the lottery and consequently losing her house, can be dramatic.

without some new wrinkle added, it has almost become a cliché.

Be wary of comic book "tropes." A *trope* is a well-worn path in storytelling, not necessarily a cliché, but poised to become one. A character who is given (or finds) a magical amulet, for instance, is a trope. A character whose longtime lover is cheating on her is a trope. *A trope in itself should not be used as a hook.*

A trope must be accompanied by some interesting twist, something different that sets it apart from all other examples. Consider the basic plot of Rumiko Takahashi's *Ranma ¹/₂,* for instance. A boy is cursed to change into a girl whenever he encounters cold water and change back to a boy when he encounters warm water. Gender confusion is an age-old comedic trope. What makes Takahashi's take on the subject unique is the use of water as a source of transformation, which leads to lots of interesting plot possibilities.

What's the Idea behind the Thing

The objects of a story can be anything: robots, teacups, giant squids, magic wands, serial killers, secret doorways, and so on. A comics story should have visually interesting, drawable things that look good as art. However, a comics story (or any story) is not about a thing, but the idea *behind* the thing. Courage is an idea. A story may have a vampire in it (interesting and fun to draw), but the story might really be about a character gaining the courage to confront the vampire. The story isn't about vampires any more than the lottery story is about lottery tickets. The vampire is part of the syllogism allowing a character to demonstrate what the story is really about.

Inexperienced writers sometimes get lost in "cool art," which is to say cool *things*. The characters that exist in that world and the uniqueness of their reactions to the things in that world should drive your narrative.

Stories that have good visual dynamic tend to work well in a graphic environment.

The writer should visualize how the characters look. The character with the cut foot, first described on page 7, could be drawn many different ways in a comic book, generating different reactions from the reader.

Use Three-Act Structure

Nearly all comic books or graphic novels, no matter their length, use three-act structure. The three-act structure serves as a secure framework on which you can build a story. Act I sets up the problem of the story and the story hook. Act II develops the problem as the character struggles to resolve it. The character's first attempts are usually only first steps toward discovering the necessary ultimate solution. Act III contains the climax of the story, the most exciting part. Here the hero wins or loses (or something in between) and comes out altered by the experience. More will be said about three-act structure in the chapters that follow.

Stories and Gags are Distant Cousins

Change is the technical difference between a story and a gag. The word *gag* is used to describe either single-panel or strip comics that are essentially just a joke, stories that simply lead to a punchline. In a gag comic the characters do not learn, they do not experience change. Comic strip writing is an old and honorable part of sequential art. Comic strips in the newspapers mostly take the form of gags intended to make the reader chuckle, but are not meant to provoke worry or wonder. Confusion arises because the word *story* is often used loosely for any narrative progression. If any writer wonders whether or not he has created a *story*, check for change. Beetle Bailey, for instance, does not become sadder or wiser as the result of a pummeling by Sarge. Gag comics can be delightful. There's nothing wrong with gags, but they don't sustain interest. A graphic novel can't be just a series of panels with a punchline at the end.

Write Down Your Ideas

This last piece of advice I would like to give you is perhaps most important of all. Create a synopsis of the story that covers the basic narrative structure in a page or two. A synopsis is simply a summary of the story. The synopsis does two things: It solidifies how the story ideas in your mind work in black and white, and it helps you generate even more story

Be careful of simply having unexpected things happen. A true story hook isn't just a surprise, but a new and unique set of circumstances.

ideas. Things that seem simple in your mind may seem cumbersome when written. You can easily manipulate and edit the story if ideas arise as you set the story down. Ideas *will* arise. In fact, one of the most interesting things about writing a synopsis is that it may unlock fresh thoughts. The act of writing, in itself, generates story ideas. Don't be afraid of that. Allow it to happen. Those ideas are valuable. Furthermore, it's also a good idea to get used to writing synopses because that's a big part of pitching stories to publishers. (More will be said about that in chapter 10.)

These tips, warnings, and considerations will bring you closer to generating a story that is uniquely your own. Human beings have been telling stories since people have existed, so you're probably not going to come up with a narrative that is about an entirely new subject. No matter how many stories people have read, however, no one has read *your* story. That's the one you want to tell. Considering these five tips will help you separate trite ideas from

inspired ideas and come up with a story that works well in a comics format, that an artist will be excited to draw, and that will ultimately be engrossing to the reader.

HAVE FUN CREATING YOUR STORY!

It's sometimes a good idea to jot down a list of many story ideas before settling on one. It is essential, given all the work that goes into producing a lengthy comic, to be sure that the story you are creating excites you. It is difficult to go the distance in creating a story if you're only mildly interested. Keep the three basic guidelines in mind: know what you're talking about, care about what you're writing, and be objective. Developing the story as a comics narrative will be much easier if you follow the advice in this chapter: Keep the main conflict in the story simple. Be sure the story is original. Keep the story centered around visual action. Above all, remember to have fun building the story.

Most comic strips these days are gag strips in which the characters never seem to learn anything new and don't change. They can be very enjoyable and entertaining, however.

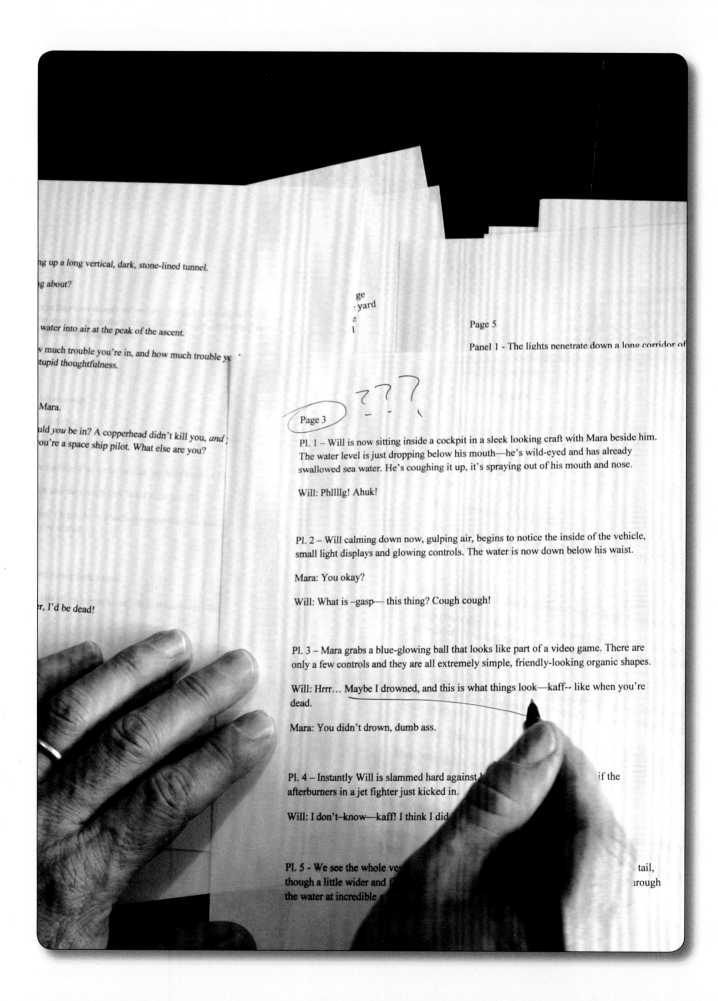

FORMATTING A COMICS SCRIPT IN "FULL SCRIPT"

In a "full script," the writer thinks through and writes out both the visuals and the text of the story, similar to the way a screenwriter creates a script for a movie. Separating the tasks of writing and drawing allows the writer to focus on the narrative and the artist to focus on the art, providing better results for both. Even when the writer is also the artist, first conceptualizing the page allows the writer/artist to later focus more attention on drawing the story rather than simultaneously attempting to draw and write the story. Think of *conceptualizing* as mapping the story out ahead of time. That is essentially what a comics script is.

< *Full scripting* means that the writer conceptualizes all parts of the script, including scene description, captions, dialogue, thoughts, and sounds.

COMICS SCRIPT METHODOLOGY

How exactly does a comics script work? Your script first addresses a single person—the artist. The writer tells the artist the story that the world will see: "Here's the story, and here's what you need to draw." A comics writer walks a thin line between getting the story across and conceptualizing it for the artist, who then renders the story. This is true regardless of whether the writer and the artist happen to be the same person. In order to clarify what the artist is supposed to do, the story is put into a particular, consistent format. The script should communicate the story to the artist as efficiently and effectively as possible.

A script needs to tell an artist what the story is and what he or she is supposed to draw from page to page in the comic. The word *format* means *how* a writer chooses to provide the artist with that information. Scripts for film, for instance, have a very specific set of rules for formatting, but comic book scripts do not. The fact that there is no definitive set of rules for formatting a comics script sometimes creates confusion for writers, especially beginners. The good news is that there are very few *wrong* ways to format a comic book script. Some companies, individual artists, and writers may have their preferences, but for the most part, no one in the comics industry would condemn a script because it is formatted wrong. There are, however, best practices in writing comics scripts. These include the three Cs: be clear, consistent, and concise.

Full Script Method

The most common form of comic book scripting is called *full scripting*. In full scripting, the writer breaks the story down into pages, and breaks each page into a specific number of panels. The two essential parts of any panel of comics are the image and the text. The writer then details the action and the art specifies in each panel.

The writer expresses *imagery* in the form of scene descriptions for the panels. These should be fully objective—only giving the parts of the story that an artist can draw. Unlike a film script, where the scene is mostly left up to the director with

minimal description from the writer, a full comics script specifies, as briefly and clearly as possible, the desired art for each panel. The writer suggests what the artist should draw, but not *how* to draw it. It is up to the artist to interpret the writer's suggestions.

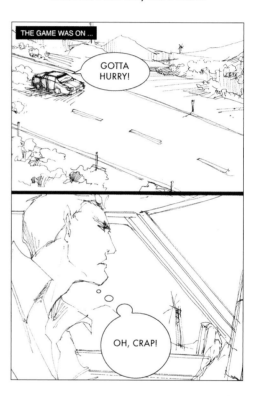

Most people have no trouble intuitively reading the panel progression in the art below. For those accustomed to reading comic books, the idea of a script may be a bit alien. Things look different when they are written.

If the panels above were written as a full script, the script might look like this:

```
Panel 1 — A small car (Toyota?)
speeds down a deserted highway.

Caption: The game was on . . .

Man: Gotta hurry!

Panel 2 — Inside the car. Profile of
the man driving. He looks anxious.

Man (thought): Crap!
```

The great thing about writing is that no one ever has to see your mistakes. There are no comics writing police. Focus on creating good stories.

Text in the script refers to all words that specifically appear in the panel: caption boxes, word balloons, thought balloons, and sounds (SFX). Each serves a specific function and each is clearly labeled in the script. For the writer, the text is of particular consequence because the text is the part of the written script that appears, unfiltered by the artist, directly in the comic. The writer is solely responsible for text. The words of the comic should be as near-perfect as possible by the time a script is finished.

Basic Formatting Guideline

Below is a basic formatting guideline for writing a full script, one that I often hand out to my students. It provides a flexible, generic guideline for clarity, consistency, and conciseness.

```
TITLE OF STORY

By Writer's Name

Page 1

Panel 1 — Write scene description here. Include only the exact information the artist
will need to draw the panel. Remember, only one action per panel per character; be
sure the information is clear for the artist. Be brief.

Caption: Include narrative voice here. This can be first person, second person, third
person. Sometimes caption boxes are thoughts belonging to characters. Sometimes the
speaker here is not seen in the story.

Bill: Write dialogue as if writing a play.

Jane: Space is important. Remember that dialogue takes physical room. What the--!?

SFX: Blam! Blam!

Panel 2 — More scene description goes here. Use shorthand (close up (CU), medium
shot (MS), full shot (FS), over the shoulder (OTS), etc.) for camera directions. Try
to write the scene in a way that makes the camera angles obvious. Avoid pointless,
repetitious camera instructions.
```

continued

Bill: That sound! It's almost like actually hearing the sound.

Jane: There's no sound, Bill. It's all in your mind. But the writer has to think of the precise words to create the right sound. Ever heard of onomatopoeia? *Onomatopoeia* is when words sound like what they mean, e.g., slam, bang, crash. Writers often invent non-words to create a specific sound, e.g., *slork*, *kaboom*, *crik*.

Panel 3 — Describe characters briefly for the artist. Don't try to control every detail of what goes in the art. Don't try to draw the panel with words. Allow the artist some discretion.

Jane: Scripts are easier to read if they are well spaced. I'd suggest spacing three to four times between panels. Double-space between scene description, caption, dialogue, and sound effects.

Bill: You know Jane, sometimes panels don't have captions and sound effects. Sometimes not even dialogue.

Panel 4 — Jane's fist connecting with Bill's face.

SFX: Wham!

Panel 5 — Bill rubbing his jaw and looking sheepish. Jane has her hands on her hips, superhero-like.

Jane: Never take the script lightly, Bill!

Bill: Sometimes I put in a slash to indicate more than one balloon. / And do change type size and italicize or make bold, to indicate emphasis on certain words—because nobody's really hearing this, but reading it.

Page 2

Panel 1 — Bill and Jane now embrace.

Jane: I guess it's time for a new page now, Bill.

Bill: Yeah, did you notice that I left a lot of extra space between pages?

Panel 2 — Jane looks down.

Jane: Uh huh. / And you're not numbering the word balloons either—good for you, Bill! / There's no need to do that until you've finished editing the thing, and only if you're sure the publisher wants them numbered.

[The script will continue in this manner, building page by page and panel by panel, until the entire story is told.]

The guide on pages 21–22 may not answer *every* formatting question, but it does give a solid means for getting your script formatting under way. One thing every writer must understand is that until the last edit is made and the script is finalized, the visuals and the text are flexible. Everything can be adjusted if changing it improves the story.

There are also variations in the way some writers approach full scripting. Do some research on the Internet to see the variety of formats used by some of the top writers in the business. All, however, have the same basic separation of text and images.

Advantages of Full Script

Full script, when executed well, allows the artist to focus on creating the art. Based on the script, the artist will know exactly how much "dead space" to leave for the amount of dialogue indicated and how many panels are supposed to appear on the page. *Dead space* is the area in the art where there is little visual narrative content and where words can be placed.

Comic books don't usually include a script for the reader. For those considering writing a comics script, it may be difficult to get a clear conception as to what a comics script is supposed to look like or how it relates to the finished product. Here is part of the synopsis of *Talos*, by artist and writer Dan Glasl, followed by a few pages from the script, to provide some perspective into how a story develops from idea to script to art. It's clear that he has a strong and vivid conception of the events of the story.

```
TALOS

Synopsis for first segment of
the story:

The story is set in the near
future, so everything should look
somewhat contemporary but slightly
more advanced. Think Minority
Report or Blade Runner. A woman
wakes up strapped to a chair with a
mysterious doctor hovering over her
asking her questions about herself.
She has no memory of what he's
talking about. A SWAT team bursts
in and interrupts what's going on.
```

Making a reference to other works that are in a similar vein is a good idea for establishing the atmosphere of the story. Keep this concise.

The synopsis focuses on objective visuals, but it is not yet a script. Some editors may also require page breakdowns, especially for first-time writers. A *page breakdown* is a micro-summary of what happens on each page, or on sets of pages, scene by scene throughout the story. The page breakdown helps the writer further conceptualize how the story will spread out on the pages of the book. This is an especially good idea for stories that involve multiple issues or that are graphic-novel length. The breakdown ensures that the story fits into the required amount of pages. The breakdown shown on the next page is obviously very loose, sometimes clumping multiple pages together as part of a single sequence in the story. Do not attempt to be too detailed with your page breakdowns. (I'll talk more about fitting a story into the page requirements later.)

The page breakdown for the sequence from *Talos* might look like this:

> Pages 7—9: Eve wakes up to
> questions and a mysterious
> scientist.
> Pages 10—11: A SWAT team invades
> the lab.

Once the breakdown process is complete, the writer may script the story without worrying about how many pages each scene should have. Adjustments to the story are much easier in the page-breakdown stage than after the script is written.

SCRIPT AND ART FOR TALOS

In the script stage, it becomes clear how the action of the page plays out, as it expands the basic concept given in the breakdown. The script emphasizes setting up the scene and the character's "acting," without attempting to describe every detail of what might appear on the page. Notice how the art (see page 25) adds many things that the script does not directly call for. Dan's script (see below) is specific, but it still allows room for artistic interpretation. It tells the artist what to draw, not how to draw it. The artist (Dan himself, in this case) is free to consider the type of panel layout and the details of each scene. The visuals themselves tell the story without leaning too heavily on the text.

Page 8 (5 Panels)

Panel 1 — On the other side of the room, sitting at a bank of computer monitors with large display in the center, REED, a man in his mid-50s with a small pair of glasses and an oxygen line running to his nose. He smokes a cigarette as he types away at a holographic keyboard display. He speaks without turning to even look at Eve.

Reed: You're awake earlier than I expected.

Panel 2 — Eve struggles to pull away from her restraints.

Eve: What the hell is going on here!? Who are you!?

Panel 3 — Reed walks from his computers toward Eve.

Reed: Interesting, you should remember me. I might have gone too deep.

Eve: What are you talking about!?

Panel 4 — Reed stands over Eve holding a data pad (basically what would be a holographic iPad 7).

Eve: I am a Talos agent! Let me free right now!

Reed: Just stay calm. I need to see how deep the mental wipe went.

Panel 5 — CU of Eve eyes wide in shock.

Eve: Mental wipe?!

• The scene descriptions are kept as lean as possible. Only the things that can be drawn are mentioned.

Panels per Page: A Very Basic Idea

The number of panels in the *Talos* script holds to five to seven per page. For a writer, it is best to keep the script closer to five panels per page if possible. It is all too easy to overwrite a script. The basic rule is that the more visual information each panel contains, the bigger the panel becomes and the fewer panels that can fit on the page.

The script for *Talos* demonstrates that it is useful to know and use camera directions when needed, but that one should avoid overuse of them. Some publishers ask for their placements in scripts, but for the writer, it is usually best to avoid them unless they effect the execution of the story. A discussion of camera directions and more detailed explanations for their use appears in chapter 4.

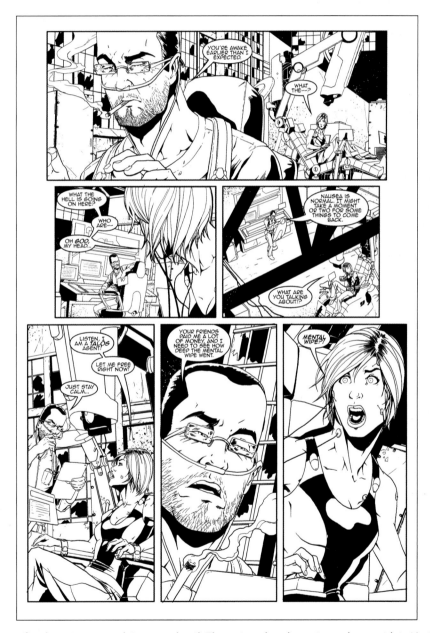

It isn't necessary for the writer to explain every detail. The artist takes the script and runs with it. Notice how some of the dialogue was changed, edited between writing and drawing. Notice also that an extra panel was added in the art after the script was written. It is not unusual for an artist to suggest adding or deleting panels in drawing the story, but if there is an artist/writer team or an editor involved, it's a good idea for the artist to discuss such changes first.

Page 9 (6 Panels)

Panel 1 — Reed sits next to Eve looking at the holographic display of his data pad.

Reed: Answer me a few questions—

Eve: Let me go now or I will—

Panel 2 — Reed looks up at Eve with a dark scowl.

Reed: You are in no position to make threats. I can erase you back to a five-year-old. Now answer my questions.

Panel 3 — Eve calms down and looks cautiously at Reed.

Reed: Do you know your name?

Eve: Eve Guerra.

Reed: Do you know what year it is?

Eve: 2053.

Reed: What is the muzzle velocity of an M-326 assault rifle?

Panel 4 — Eve gets angry and snaps at Reed.

Eve: This is ridiculous! Tell me what the hell is going on!

Panel 5 — An alarm sounds and Reed turns to look at the monitors behind him that have all turned red with "ALARM" displayed.

Panel 6 — Reed drops his cigarette, shocked, as Eve looks at him intensely.

Reed: No, no, no!

• Beware of putting more than one action into a panel. That is one of the main problems beginning writers have. Since it is possible for her to do both of these things simultaneously, it's okay to state them both in the scene description.

Spacing

It seems a trivial point, but spacing can become a hugely important part of full scripting. Notice that the formatting of the *Talos* script leaves a great deal of white space around the script's elements. There is no formal rule for comics scripts that indicates how much white space should exist on the page. Some writers run scene descriptions, dialogue, captions, and new panels and pages together. However, seeing the script clearly is an important tenet of writing comics.

A script is much easier to read and edit if you can see at a glance where a panel begins and ends, and where the various elements of the panel separate: scene description from caption, caption from dialogue, dialogue from SFX. It is also important to see where a page begins and ends. Some writers actually insert a page break at the beginning of each new story page within the script, starting panel 1 at the top of a fresh new page. The artist will also appreciate being able to distinguish scene description from dialogue at a

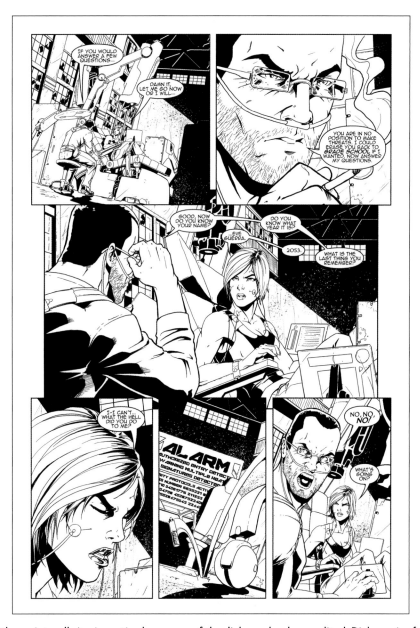

The art follows the script well. Again, notice how some of the dialogue has been edited. Dialogue is often edited many times to achieve the right fit with the artwork. Some of the dialogue was not absolutely necessary and was cut.

glance. Many artists like to print the script and make notes and sketches on the script itself.

Keep the Big Picture in Mind

Formatting shouldn't become a distraction from the way panels work *with* one another, which is incredibly important. You need to be keenly aware of the relationship between the panels and what is happening in the gutters between those panels. *Gutters* are the spaces between panels in a comic book (see box below).

If a writer attempts to format at the same time the story itself is being created, the story will probably suffer as a result. Write your script in stages that build to the formatting of the full script.

Approach Scripting Comics as a Process

I have seen writers start a story over and over again in frustrated attempts to get the script perfect the first time. It makes a great deal more sense to approach writing the script itself as a process. Of course, everyone works differently—which is to say—everyone has a slightly different process. Those who seem to write great scripts very quickly have simply written so much that they have internalized many stages of their processes.

DRAWABILITY

A comics story must be visual. Therefore, the script must emphasize concrete and exciting imagery. The last chapter covered story generation. The script clarifies the story, creating concrete visual items and actions for all of the general ideas you may have set down in the synopsis. Specific images used in the story should connect with the general story ideas and clarify what the story is about.

The Plot, the Story Ending, and Imagery

Having a unique image to draw doesn't necessarily mean the story will be good. Too often artists attempt to write stories around something that they really enjoyed drawing, but that does not mean that the art will take the story to a satisfactory conclusion. If the writer or artist has some solid ideas about images that she would like to have in the story, then the plot may be crafted in such a way that the story can involve those images.

Writing Gutters

```
A gutter is the space between the panels
that is both a physical and an imaginative
leap into the next panel. Gutters do not
exist in the script, only in the artwork.
The writer has to visualize them. Comics
is the only form of storytelling in which
a gutter formally exists. In a comic book,
the story largely occurs within the
gutter. Since the panels themselves are
static, readers fill the gap between the
images of the panels with their own
thoughts. Gutters are one of the unique
properties of sequential art. A comics
writer largely works with the elements of
action, space, and time involved in the
gutters. The images in the panels must
suggest what takes place between the
panels. This principle is where the real
art of creating comics narrative occurs.
```

Formatting the script often means arranging images that the writer already conceived of as connected to a specific topic into a logical order. It's a good idea to keep a sketchbook journal of characters and situations that might inspire a visual narrative.

Art can inspire story ideas, but be sure that the images in the scene descriptions *need* to be there in order to tell the story. Sometimes inexperienced writers, inspired by a single interesting visual, find that the story that they're writing quickly loses energy, as they struggle to come up with ideas that make sense in relation to the art. Think through the story until all parts of the script can be worked out, especially the ending.

Script for Giant Monster Fight

Panel 1 — The Giant Monster getting ready to deliver a haymaker of a punch to the robot beast.

Panel 2 — The punch connects.

Panel 3 — The Giant Monster walking back into the sea with the robot beast smoldering where it fell.

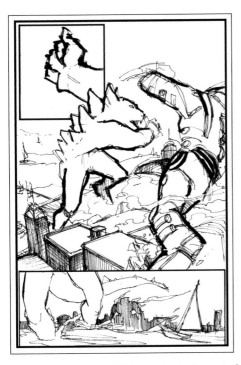

A comics writer should have a logical sense of what is necessary to show and the possibilities for artistic interpretation of the scene. The visuals have to make sense within the narrative.

STORY STRUCTURE AND SCRIPT FORMATTING

Keep working at your script until you can legitimately write the words "The End." Do not go back and rework your beginning until you have finished the entire story. By *writing*, you become fully immersed in the development of characters and concrete images for your plot. You get to know your characters by writing them. If you start over, momentum is lost, and writing can stall. You can edit later. It's important to see what you've got before you go back and edit. Editing is very often connected to fitting the story ideas into a specific script format.

Keep the flow of ideas loose in the beginning. Remember: Writers work in different ways. Some writers create all parts of a panel before moving to the next panel. Others may first figure out the visual progression of a page, then fill in captions and dialogue. Settle on a method that works best for you.

Formatting Style Recommendations

1. Single-space scene descriptions, dialogue, captions, and thoughts.

2. Double-space *between* scene descriptions, caption, dialogue, thoughts, and SFX.

3. Triple-space (at least) between panels.

4. Indicate page breaks with significant amounts of white space. Some editors prefer that you give a page break each time there is a new page in the comic book.

5. Clearly label dialogue, captions, and SFX as shown in the formatting guide at the beginning of this chapter.

6. Do not use actor's prompts in dialogue. For example, *Bill (angrily): Come here, you!* There are no actors in comics, only two-dimensional drawings. A character's actions or emotional state should be obvious from the scene description and the context of the situation.

7. When giving SFX, write the sound using onomatopoeia (see definition on page 22). SFX do not have to be actual words, but they should at least be the appropriate vowels or consonants for the sound intended.

Connect the Idea of the Story to the Structure of the Story

Formatting, of course, doesn't just mean filling in random, cool things for the artist to draw from panel to panel. Each time a scene description is set up, it should move the story forward. The story idea is refined through the concrete images placed in scene descriptions and the ideas you express in dialogue and captions. The stages of the writing process are not mutually exclusive. You can alter a script at any point to accommodate ideas that work better with the concrete (drawable) visuals.

Be Bold

As your idea gets played out in visuals, you may cringe. There's a big difference between prose writing, where a writer can express risky ideas in words, and a comic, where such ideas are shown in the unblinking concreteness of the art.

Obviously, it's one thing to say there's a dead body in a story, and quite another to see the body in the art. Some writers are stymied by a refusal to fully invest an idea with concrete images, dodging the dangerous parts by filling them with vagueness or clichés—safe images that we've all seen again and again. Writing comics means connecting ideas and concepts to specific images in a way that prose writers aren't required to do. All *good* comic stories offer a unique visual experience. Unique almost always translates as risky, even if only in a small way.

FORMATTING AND EDITING

Editing a script involves much more than formatting. You must review the script in terms of action, dialogue, pacing, character, and environment, all of which I will cover in upcoming chapters. Formatting should be relatively straightforward, but sometimes isn't. Be sure everything that you're saying is clearly expressed. Look for any passages that send mixed signals to the artist. Rewrite to provide clear direction as to what to draw. Make sure that scene descriptions are concisely stated, giving the artist only what is needed in order to draw the panel. It is also important to have a consistent method for writing the script so you almost unconsciously know what to do to convey to the artist exactly how he should interpret the parts of your script. The more scripts you write, the better you'll get at these things.

The basic rule of comics storytelling should always be *keep it simple*. One action per panel. Keep everything drawable. Editing a script often means reconsidering the approach to the story. The writer has to select the action snapshots that will most effectively communicate the narrative. Anything that seems difficult or complicated to explain within the format should most likely be streamlined— or omitted.

AVOIDING BAD HABITS

Avoid sloppy writing habits. An assortment of small problems—bad spelling, poor grammar, and so on— makes it difficult to see larger problems. Correct the things that are easy to correct immediately. In practical application, a weak grasp of punctuation, grammar, and spelling almost universally goes along with bad story ideas. These problems prevent you and others from understanding what you are talking about. Immediately correct anything that gets in the way of seeing your script clearly. Here are some obvious things to consider when formatting a script:

Style and Grammar

1. Use upper and lowercase letters, capitalizing in appropriate places for names, sentences, or wherever capital letters are normally used. Do not write parts of your script in all caps unless a publisher specifically requests it. Even then, in the initial draft, it's best to use regular letters for yourself so you can see your story better.

2. Write complete sentences where possible. Punctuate appropriately at the ends of sentences. Use commas and apostrophes where appropriate.

3. Commas and periods always go *inside* quotation marks in American usage. Question marks and exclamation points go inside if they are part of the quotation. Learn the rules of quotation marks for American usage. Don't get lazy with punctuation.

4. Be succinct. Opt for a lean style. Avoid wordy expressions. This applies to both scene descriptions and text. Write in the active voice as opposed to the passive voice. If you don't know what the active voice is, look it up (or see page 165). Most screenplays are written in the active voice.

5. Use standard 12-point type and a font such as Times New Roman or Verdana that is common and not difficult to read. Use standard one-inch margins.

6. Be absolutely certain that every word means what it is supposed to mean and works in context. Also, make sure that each word is spelled correctly.

7. Sometimes you may use reference photos in a script for things that would be difficult to describe in words. *Reference photos* are pictures pulled from the Internet or other sources that show exactly what you mean. Only use these if it is necessary for the sake of clarity.

Critically consider this raw first draft of a page of a student script, keeping in mind all I've said so far about formatting and writing:

```
Boating on the Fourth of July

Page 1

Panel 1: An ocean channel, drunken co-eds (mostly naked) crowd each side of the
waterway. Jam-packed boats of all sizes anchor in between. Some of the anchored
boats are also tied up next to each other, creating floating island party barges.
As the tide rushes in, their anchors strain to hold them steady.
Caption: It's easy to mistake 4th of July in Wilmington, NC, as MTV Spring Break.
Last year, all we did was drive by this ruckus on our way to find a quiet lagoon.
SFX: Music and cheers from the massive party
```

With the text and the scene descriptions running together, the script becomes difficult to see.

SFX needs to approximate the sound, not state what it is.

continued

Panel 2: A much smaller boat navigates through the congested channel. Skippered by Captain Ray, this seven-person capacity boat is enjoying its own overcapacity party. Our hero—first mate Jeffrey—half in the bag, has reservations about Captain Ray's proposed plans.

Caption: Feel like an old tourist, but some things are better enjoyed from a distance. Like going on a Safari. But Capt. Ray wants to reclaim the glory from his youth.

Capt. Ray: I knaw a guy ha owns one-na dese boats! Let's tie up!

Panel 3: Ray's undersized vessel pulls up next to a much larger boat, which is attached to another yacht that's attached to a few more yacht-size boats. The party cheers in a sign of welcome. Just then a man emerges from the crowd with warning.

Drunken man: aid-a-minut! Yers- da every-udder boat! Ya gotta anchor in or we fload-a-way! Bud-a currents com-in fast gotta pull up-head n toss'n yer anchor and den tie-uup!

Capt. Ray: Got that Jeffrey . . . ?

Panel 4: Jeffrey pushes through the oblivious drunkards that pack Ray's boat, with anchor in hand navigating to the front of the small craft. He prepares his best anchor throw.

Jeffrey: Got it . . .

Panel 5: Just before the throw is released, the current pushes the boat back toward the party barge. The few that notice shout warnings. The current has pushed Ray's boat back into the party barge. It shifts suddenly as both sides brace themselves to avoid collision.

Crowd (off panel): Watch out!

Panel 1 is a huge scene that doesn't introduce any of the principal characters. It would be a good idea to consider incorporating panels 1 and 2 together to streamline the storytelling.

The characters need brief descriptions. What does the captain look like, for instance? The content reads like prose exposition rather than objective, drawable material. It would be impossible for an artist to draw Jeffrey's "reservations."

The panel suggests elements of motion when the man "emerges from the crowd."

Dialogue will be discussed more in a later chapter, but the dialogue could be cut down, and the accent of the drunken man feels overworked.

Again, the panel contains multiple actions. Jeffrey can't simultaneously "push through" and "prepare."

The words "off panel" given in parentheses means that the speaker of the words is not seen in the panel.

Of course, the script on pages 31–32 isn't *bad*—it's just not professional. It does have many interesting visual elements. Concrete, action-oriented things happen. There are, however, (as pointed out below the script) problems lurking in the script, should anyone decide to draw it. Most of the problems can be easily solved by keeping the script simple and thinking about the principle of keeping everything clear, concise, and consistent within the panels.

Below is a revised version of the page that reconsiders the various problems presented in the initial version of the script.

Boating on the Fourth of July

Page 1

Panel 1 — Captain Ray, a plump yet jolly-looking man, shirtless and sunburned, drives his seven-person capacity boat, which is clearly overcapacity with people drinking, up next to a group of yacht-size boats. The co-ed occupants of the boats are in skimpy bathing suits and drinking heavily. Our hero, first mate Jeffrey, who is lean and fit, stands beside Captain Ray and looks uneasy.

Caption: It's easy to mistake 4th of July in Wilmington, NC, as MTV *Spring Break*. Ray had said we were going to find a quiet lagoon.

Capt. Ray: Drop the anchor here, Jeff!

Jeffrey: I don't know about this Ray . . .

Panel 2 — Jeffrey, with anchor in hand, heads to the front of Ray's small boat pushing through all of the drunkards on board.

Panel 3 — Jeffrey tosses the anchor off the bow of the boat. His foot clearly in a tangle of line.

Panel 4 — The anchor rope, tangled around his foot, pulls it out from under him.

SFX: Snatch!

Panel 5 — Jeff, wide-eyed, being yanked into the water.

SFX: SPLOOSH!

The revised panels build the page around the first panel, which sets up the situation. The visual information presented in the first four panels of the original script is condensed into two panels. The directions to the artist are clearer and the more open formatting makes the elements of the script obvious. With decreased congestion, the page can develop in a much more interesting direction as well, as Jeff goes overboard. There may be a few places where the writer could polish the story even more, but the script is now much more workable for the artist.

Editing a script usually takes place in stages. Each pass through a rough draft of a script brings its story more clearly into focus and eliminates more and more unnecessary material from the pages. The result is a much tighter and more satisfying story.

KNOW YOUR DESTINATION

Before setting out to write any story, you should find out as much as possible about how and where your story will be used. Some comics are not necessarily formatted like traditional comic books. Publishers create books in a variety of shapes and sizes that aren't traditional comics shape. In those cases, the scripts need to be altered to accommodate the different formatting required. The script excerpt on pages 35–36, by artist Ariela Kristantina, is intended for a wider format and demonstrates the point well. Due to the page size and orientation, here it makes sense to have eleven panels.

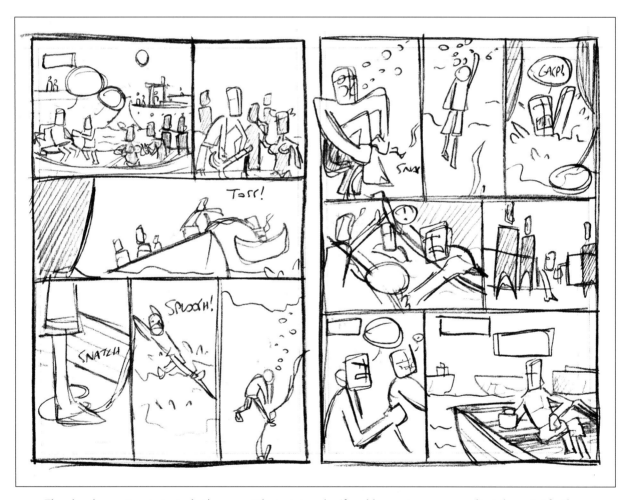

Thumbnail your story to test whether or not the script works. If problems arise, you can adjust the script further.

Save Haven

Panel 1 — A big argument is going on with lots of yelling. Words become part of the backdrop: "Your fault!" "You Stupid Idiot" and "Jerk."

Panel 2 — Pulling back a little to see the unhappy faces of a man and a woman.

Panel 3 — A young girl comes home from school. She's still wearing her backpack. She sees the family arguing. The father is just drawing back his hand to strike the mother.

Panel 4 — The Father slaps the mother across the face.

SFX: SLAP!

Panel 5 — Silhouette of a hand following through with the mother cringing in the immediate foreground. Girl in background.

Girl: No!

Panel 6 — The little girl runs up the stairs. The parents only now realize that she's seen what was going on. She's obviously seen other fights before.

Girl: Stop it! Stop it! Stop it! Stop it!

continued

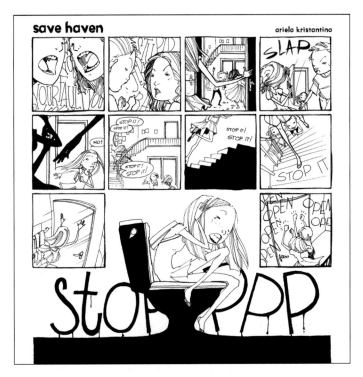

Ordinarily, eleven panels would feel like a lot of visual information to pack into one page. However, in this case, the page is much wider than the usual 6 by 9 or 7 by 10 inches that's standard for comic book stories.

Formatting a Comics Script in "Full Script" 35

```
Panel 7 — She runs up the stairs. The words "Stop it" become part of the backdrop.

Panel 8 — Her parents are following behind her now, alarmed at what she's doing,
a little afraid themselves.

Panel 9 — The girl locks herself in the bathroom.

Panel 10 — The girl sits on the toilet seat crying, with "Stop" spread across the floor.

Panel 11 — Her parents are outside pounding on the door. The word "open" appears in
the artwork over and over.
```

The way art is laid out and presented on a page can be extremely complicated. A writer does not have absolute control over page layout, but it is entirely appropriate for the writer to make suggestions. It's also possible to write a full comics script that accommodates almost any kind of subject matter, drawn in just about any style. If you have a particular style in mind, it's a good idea to make specific notes to the artist. Of course, if the writer is the artist, then this may not be necessary. The following script excerpt is from an adaption of Lewis Carroll's classic poem "Jabberwocky," an assignment I frequently give in my comics writing classes. The art that follows is by artist David Gildersleeve. It does an excellent job of bringing the poem to life.

```
Jabberwocky

By Lewis Carroll

Note to artist: The art should have a scary/whimsical feel to it, some combination
of Edward Gorey and Arthur Rackham. The style should be very loose, but somehow
innocent.

Page 1 — A rustic house near the woods at dusk. The windows glow from the light
inside.

Title: Jabberwocky

Caption: 'Twas brillig, and the slithy toves

Did gyre and gimble in the wabe:

All mimsy were the borogoves,

And the mome raths outgrabe.
```

Including a brief note to the artist often helps the writer to explain what he has in mind. Communication between the writer and the artist before the script is drawn, should be part of the process, if possible.

Panel 2 — An old man's face, holding a cautionary finger up in front of it.

Old Man: Beware the Jabberwock, my son!

Panel 3 — A young boy's face, astonished and horrified.

Old Man (caption): The jaws that bite, the claws that catch!

Panel 4 — The old man standing outside beside the young boy. They stand in the light of the open doorway and the old man points into the darkness of the woods. The kid stands beside him gazing into the woods and seeming intensely interested.

Old Man (caption): Beware the Jubjub bird, and shun

The frumious Bandersnatch!

Formatting is usually only difficult in the beginning. It gets easier with practice. Pretty soon, scene descriptions, captions, word balloons, and sound effects fall into their proper place almost without thought. (Of course, what those may be requires a great deal of thought.) Full script allows the writer to consider all aspects of the story while writing. For a writer who is not an artist, full script helps establish an understanding as to how the story interacts with the page and, as I shall show in the next chapter, the page is of monumental importance for creating sequential art narratives.

The style of art is an interesting aspect of the story that the artist creates. It's a good idea for a writer to know who the artist is and what the artist's style may be as the writer works out the script so the story takes advantage of an artist's strengths. Here the artist takes a few liberties with the text itself to bring more energy to the presentation.

THE ALMIGHTY PAGE

For experienced writers and artists, the page and panel grid are second nature. For those just beginning to write comics, the page and its relatively small size can seem challenging. It is essential that you visualize the page, and get a sense for how many panels can fit on it in a way that reads well and suits your story.

PAGE DIMENSIONS

American comics typically have a page size of roughly 7 by 10 inches. Comics are also published in "digest size" (sometimes called "manga size"), which is even smaller. Most comics have five to seven panels per page, meaning that each panel must fit comfortably into a relatively small area. The picture in your head when visualizing the page has to be a realistic one.

Many comics and graphic novels are produced in "digest size" (sometimes called "manga size"), which is roughly a 6 by 9-inch trimmed page size.

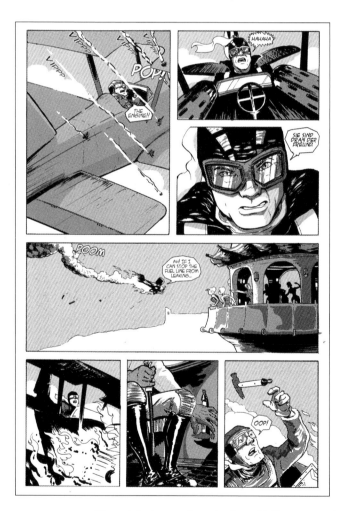

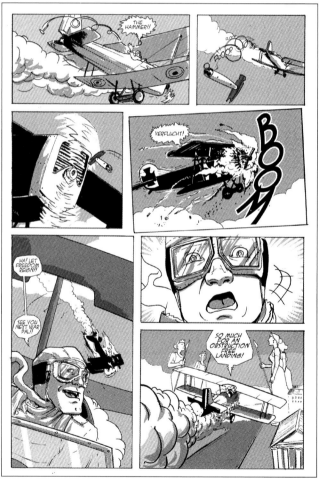

The original pages by artist Dove McHargue are drawn larger than the finished pages in the book (see above). Most professional artists work large. A writer thinking of the way an artist works might be fooled into believing that she has more room, but the pages will be reduced, compressing both art and text.

PAGE OUTLINES CAN HELP

Once you have a story plot hammered out, and before you launch into the script itself, you should create a page outline as mentioned in chapter 2 to estimate which sequences of the story will fall on which pages. Carefully and realistically consider how much of the story can be told on each page without compromising the look or integrity of the story. Plan around the idea that each page will comfortably contain five to seven panels. That's the *average* number of panels on a page in most comic books. Of course, those panel numbers are only a general guideline. A page might contain only one panel (splash), or more than seven.

Ruling It Off

For those who don't have a clear conception of the amount of visual information that a page may contain, rule off an area equivalent to the dimensions of the finished book on a piece of paper, then thumbnail the panels for a couple of the pages of your outline. A *thumbnail* is simply a very quick, rough sketch of the things called for in the page. Sketching the page is the best way for a writer to build a feel for page capacity and see how the story fits on the page. They don't have to be especially good (stick figures will do), but physically sketching the pages helps solidify a visual understanding of the script. As you gain experience, such thumbnails may not feel necessary.

The Dramatic Potential of the Page

Pages are the places where the metaphorical curtain goes up and then comes down on various parts of the story. Each page should become, as much as possible, a *beat* (a small unit of dramatic development that builds a scene) in the story. You can view each page as a step in the progression of the story, providing visual information that will create the proper logical connections, the cause and effect of the action.

Basic guidelines for thumbnails: (1) They should be readable even without words.
(2) They don't have to be expertly rendered. Just seeing the story in a graphic form can be helpful.

Remember, the more panels on the page, the smaller the panels and the less visual information they can contain. The grids above can help you visualize the page in order to avoid overwriting a panel.

Fully Develop the Scene

As a rule, *show*—don't tell. Don't assume that the reader knows things that have not been made clear. Consider the following scenario: *A man enters a familiar diner for a meal.* This simple scene requires several important components in order to work effectively as a visual narrative: entering the coffee shop, establishing the coffee shop atmosphere, being well-acquainted with the coffee shop. You can't convey all these ideas in just one panel, maybe not even in just one page. The scene requires multiple panels in order for the reader to follow it. To write comics, you have to visualize what will be necessary to express actions through art. The script for the example above may look like this:

> Panel 1 — An average-looking man walks over to a diner.
>
> Panel 2 — The man enters and is greeted by Jan, the cashier.
>
> Jan: Morning, Frank!
>
> Panel 3 — She smiles as she comes over to take his order.
>
> Jan: The usual?
>
> Frank: Yeah. Thanks, Jan.

The fact that someone in the diner knows him, calls him by name, and even knows what his order is going to be speaks volumes about how often the character comes into the diner without the writer having to explain it in so many words.

Of course, a writer could just show the man sitting in a booth with a caption box reading: *He ordered the same donut and coffee in the same coffee shop he'd visited a thousand times before.* The words save space, but that's not showing it—that's telling it. If you can show it, show it.

Here are a couple of things to consider when trying to decide how much room the story requires:

1. *Exposition should only occur as it is necessary.* Information should be smoothly incorporated into the visual action of your story. Don't waste space on it, however, unless it is necessary to the overall story.

2. *Action sequences require more room, and therefore, more pages.* The more time a story spends on any one of its parts, the more the story becomes about whatever that part of the story is, even if you think it's supposed to be about something else. Many writers lose the reader in rambling explanations of complicated motivations. If a story, for instance, is supposed to be about a cop's shootout with a robber in a diner, but dwells on what the cop is having for breakfast, then the story is probably getting bogged down in the cop's routine rather than the shootout. In effect, that becomes the story simply because it occupies most of the space on the pages.

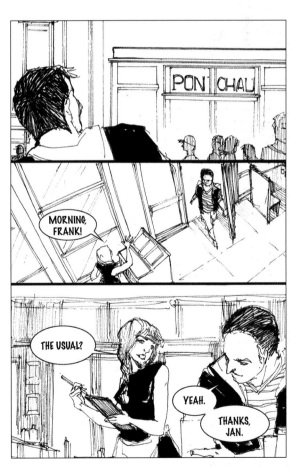

In the art above, it takes three panels to comfortably illustrate the relatively short sentence:
A man enters a familiar diner for a meal.

There is an inverse relationship between exposition and action in most comics stories. *Exposition*, in story, means specific plot information that is being conveyed to the reader. Exposition, which often takes a great deal of room in a synopsis, will be condensed into as small a space as possible in the actual script. A well-told comics story should reflect a rhythm of exposition and action. As the story progresses, getting closer to the climax, usually there is less exposition and more action. Of course, that also depends on what kind of story you're telling. This principle is a major component of three-act structure.

ACT STRUCTURE AND PAGE BREAKDOWNS

When creating the page breakdown, keep in mind the three-act structure mentioned in chapter 1. Consider using the percentages listed here when building your story:

- Act I (no more than 25 percent): Establish the main character, give the problem of the story (*inciting incident*), and have the main character decide to embark on a journey toward obtaining whatever is desired.

- Act II (65 percent +/-): The main character strives to understand the challenge faced, taking greater and greater risks along the way, potentially thinking what is desired has been found. Remember that the greatest risk and the greatest discovery must be held back until Act III.

- Act III (10 percent +/-): Hero takes the greatest risk, puts forth the greatest effort, and ultimately wins or loses (or something in between). This should be the climactic part of the story.

These percentages (25, 65, and 10) are in no way absolute. In my experience, if the opening act extends much beyond the first 25 percent of a comics story, the structure is likely to have

problems. (Act I can, of course, take less than 25 percent, depending on the story.) The same seems to hold true for the other percentages. The only absolute, of course, is to write a good story. It can be extremely helpful, however, to consider those percentages as not just theoretical, but *practical*— a way to set up the story structure. Comics are highly structured. Inspiration is, of course, extremely important, but you must maintain structure. Keep your story centered around action, but be sure the structure is clear.

Start with the easy, obvious parts of the structure—the beginning and the ending. Most writers have a good idea about the beginnings and the endings of their stories. The middle (Act II) is the confusing part. If you have a firm beginning and ending, you can create the breakdown like a suspension bridge, building toward the middle from either side. The necessity to fill in the outline may demand that you create new story parts to logically connect existing ideas together, inspiring new scenes and potentially altering old ones. The following plot helps to illustrate the point:

```
Billy, the school nerd, gets a
ring from a genie. The ring gives
him amazing power—he's fast and
strong. He decides to show off for
everyone at school and becomes
popular by joining the football
team. Meanwhile, the girl he has a
crush on gets into a car wreck on
the night of the big game, just as
he's on the verge of kicking the
winning field goal. He leaves the
game to help her. The team loses
and everybody dislikes him, except
the girl. She tells him she liked
him even when he was a just a nerd.
So he returns the ring to the genie
and goes back to being a nerd—with
his newly won girlfriend.
```

Let's say this story must fit inside twenty pages. It is self-evident that the opening of the story begins on page 1, and the conclusion comes on page 20. The rest of the pages can be filled in, using the three-act structure and the idea of five to seven panels per page. If we allow that Billy needs to be established, then receive the ring, five pages might be a good guess for the opening. (If this turns out to be a bad guess, it can always be altered.) The page breakdown, therefore, might look something like this:

Pages 1–5: Billy is a nerd. He gets a power ring from a genie.

Pages 6–19: (Yet to be determined.)

Page 20: Boy gives power ring back, wiser for the experience, happy with the girl, though scorned by the school.

Parts of the story that are not quite clear yet may simply be left blank for the moment, as the structure is being set up.

Now it becomes a matter of deciding which pages to use for the other parts of the story and how much room to devote to each part. The beginning and ending of the story are firm, but the action for the middle of the story, so far, is vague. Three-act structure has certain formal qualities that will be helpful for breaking the story down. Consider the percentages given on page 44. If the story is twenty pages, and Act I should occur within the first 25 percent of the story, then Act I should be concluded within the first five pages. If Act I is about receiving the power ring and Billy beginning his transformation into the school football star,

then that should all happen by page 5. Act III—the climax of the story (saving the girl)—should most likely happen within the last 10 percent of the story. Using those numbers, we can determine that part of the story should occur within pages 18, 19, and 20. Two pages for Act III and a final page for the denouement. Act II—meaning all the other parts of the story, will be spread across pages 6–17 (eleven pages, roughly the 65 percent discussed on the previous page for Act II).

Structuring the page breakdown this way is not an exact science. It is only a way to get the feel for structuring and to help you begin to pace story events. Here's the plot synopsis, as it applies to the page breakdown so far:

Pages 1–5: Nerd gets a power ring.

Pages 6–17: (Yet to be determined.)

Pages 18–19: Boy decides to save the girl, instead of win the game.

Page 19: He succeeds in rescuing her.

Page 20: Boy gives power ring back, wiser for the experience, happy with the girl, though scorned by the school.

As the amount of space each part of the story must occupy becomes clarified, more of your story can be built.

Acts I and III, the beginning and the ending, are now in place. Remember that Act II is going to be the longest and most complicated act. In that part of the story, there should be attempts to deal with the story problem that lead to shortfalls in which the character's desires are not accomplished—all of which lead to the climax. Nine pages of the twenty, however, are already accounted for, reducing the number of creative decisions needed to complete the rest of the story. (Existing ideas, of course, can still be edited as necessary.) Having the beginning and the ending means that the story can't possibly wander, the events of Act II must lead to the conclusion. The story so far is admittedly a bit cliché, but for the moment, the point is about structure not originality.

Consider Act II deliberately and separately from Acts I and III. Keep in mind that the character needs to struggle. Here's the page breakdown with an attempt to add such material:

Pages 1–5: Nerd gets a power ring.

Pages 6–14: (Yet to be determined.)

Page 15: The boy is put in during the final tense seconds of the big game.

Page 16: The boy is about to kick the winning field goal.

Page 17: The fans are going crazy, winning depends on his ability to kick the goal. If he wins, he will get the popularity that he thinks he wants—but someone tells him Susie (let's give her a name at this point) is in trouble.

Pages 18–19: Boy decides to save the girl instead of win the game, rushing off to help her.

Page 20: Boy gives power ring back, wiser for the experience, happy with the girl, though scorned by the school.

As the segments of the story that still need to fit into the structure grow smaller, the question marks fill in and the structure comes closer to completion. The most important parts of the story are placed in their proper positions—at the end, where the climax should occur.

Now, nearly half the pages of the story have been accounted for. The most important turning points of the story have been set up. Knowing this much of the story makes it easier to develop the rest of the pages as creatively as possible.

The missing parts of this story could read something like the outline below:

Page 1 — Act I, scene 1: Billy picked on by jocks as he has a crush on Susie, an attractive girl he meets in the hallway.

Page 2 — Scene 2: Billy, humiliated, finds ring on the way home.

Page 3: Ring grants power. Billy has doubts.

Page 4: Billy becomes convinced of power.

Page 5 — Scene 3: Billy thrashes the bullies. Filled with new confidence, he asks the girl out. She accepts (she secretly liked him anyway).

Page 6 — Act II, scene 1: Disastrous date with girl. Decides he doesn't need her, gains popularity and friends.

Page 7 — Scene 2: Performs amazing feats for the team. Becomes placekicker for football team.

Page 8: Becomes homecoming king. Dates homecoming queen.

Page 9 — Scene 3: Takes part in harassing other school nerds—and the girl from before.

Page 10: Feels bad about hurting her, begins to reconsider his whole position.

The details surrounding how they're picking on him could help add a hook to the story.

A humiliated kid is honestly never a cliché. It's almost archetypal in its evocative power for the reader. Readers hope that such people will triumph in the end, that justice will prevail.

Discovering and dealing with power is a trope (see chapter 1). What's something unique or interesting that Billy could do with this power?

Billy could do something really fun and visually interesting—leaping over the school, perhaps?

Some element of physical conflict helps to keep the script visually interesting.

Complications are added to the story here.

Further complications enter the story. Act II is about adding on more complications for the main character, Billy, as he struggles to remember his main goal.

continued

Page 11 — Scene 4: Because of him, team is in playoffs for championship. Everyone's counting on him.

Page 12 — Scene 5: At the mall malt shop, he tells girl that he likes her and that he's sorry. She says she likes him too and that he should try hard in the game. (Jealous homecoming queen sees them. She's angry about being rejected.)

Page 13 — Scene 6: Some time later, the girl loses control of her car and it plunges into a lake. (Sabotaged by vindictive homecoming queen?)

Page 14 — Scene 7: The game is a close one. Billy is put in during the final tense seconds of the big game.

Page 15: He is about to kick the winning field goal.

Page 16: The fans are going crazy, winning depends on his ability to kick the goal— but he learns that the girl is in trouble (possibly overhears a conversation with one of the homecoming queen's henchmen in the sabotage). He realizes other members of the team are in on it.

Page 17 — Act III, scene 1: Boy decides to save the girl instead of win the game. Rushes to lake (superspeed).

Page 18: Struggling to get her out of the lake, his superstrength comes in handy. (Kicks out car's windows?)

Page 19: He lifts her out of the car. She's apparently dead. Mouth-to-mouth resuscitation brings her back.

Page 20 — Scene 2: (Homecoming queen gets hers?) Boy returns power ring, wiser for the experience, happy with the girl, scorned by the school.

The story is stronger if there is some logic to why the accident happens rather than having it be a random occurrence. The sequence of events involving Billy and the homecoming queen, in effect, causes the sabotage. These details, brought about in page construction, move the story farther away from a simple cliché.

Now we have a complete page breakdown. The description is still very loose, allowing the writer great facility for editing the story and thinking through the scenes. Admittedly, some of the narrative could be more original, but the structure of the story is solid. Obviously, many ideas about the "homecoming queen" character were not given in the plot synopsis, but had to be invented in order to fill out Act II logically. The story depends heavily on a trope, gaining magical powers, but the details are interesting. Inserting a jealous rival into the story adds a potential for further conflict. Act II now provides the necessary challenges to the main character, putting him under pressure that keeps the reader interested.

What's the Story About?

In reviewing the page breakdown, it becomes apparent that the story is more about Billy's relationship with the girl than it is about his "power ring." Billy's object of desire is not a superpower, but the girl. The ring is only a means of reaching his real desire. The act of returning the ring at the end signifies that fact, as the ring becomes a hindrance to winning the affections of the girl. The story has a happy ending and demonstrates an optimistic worldview. You can ascertain all of this information by examining the story through the page outline. Knowing this information could be helpful for building the visuals detailed in the script.

When constructing a page outline, the writer should review and reconsider all of the story's possibilities. If changes in the fundamental structure of the acts or scenes or the fundamental development of the story are to be made, the page outline is a good place to do so.

PAGE OUTLINE TO SCRIPT PAGES

Once the writer is satisfied with the page outline, the script should be much easier to write. The last chapter covered script formatting, but as should be clear, formatting itself is secondary to the important matter of deciding the underlying structure of the story and making choices that work well within a visual medium regarding story development.

A solid page breakdown guides you through a multitude of unforeseen story diversions that might possibly lure you toward narrative tangents that prove to be dead ends. On the other hand, *writing is discovery*. If an idea presents itself, especially in a story that could potentially use a little more energy, then you should keep an open mind about it. Energy means *surprise*. Never *mindlessly* follow an uninspired outline. In most stories, the hero either wins, loses, or the ending is ironic. That is not a surprise. However, if your reader can easily guess the

Acts vs. Scenes

It is important to understand that *acts* (major turning points in the story) are built from *scenes* (minor turning points in the story). A scene is often associated with a change in location, and is built around a conflict that has an outcome. However, it is not a major turning point in the story that sends a character in a whole new direction. Most acts are comprised of a sequence of scenes that, in a comic, usually last no more than one to four pages. In comics, it is unusual for a scene to go longer than that. If you notice that a scene is taking an inordinate number of pages, it is a good idea to examine the scene carefully and decide whether or not everything in it is necessary. While a scene can sometimes end in the middle of a page, scenes should end at the bottom of the page where possible, sending the reader to the next page of the book.

progression of events that leads to the ending, your story probably isn't very good. Stories have to be logical, fit the established structure, and be inspired.

Scripting the Page

A comics page should have direction, should lend momentum to the story, and should create a reason for the reader to turn to the next page. That means that whatever you build across the page either leaves something to be revealed on a new page or delivers a satisfactory revelation that points the story in some new and interesting direction.

```
Points to Consider When Developing
Panel Progressions

* Keep it simple. In comics, overly
  complicated and overstuffed pages are
  among the worst offenses of beginning
  comics writers. This happens when the
  writer does not consider the physical
  size of the page in deciding what
  visual or textual information to add.

* What will each page look like? What
  will the panels look like next to each
  other? What will each page look like
  alongside the other pages? Are the
  visual connections logical?

* Consider carefully what function each
  of the pages serves and what function
  each panel on each page serves. The
  arrangement of shots should lead
  readers deeper into the story. (I will
  discuss this in more depth in chapters
  8 and 9.)

* Be economical with panel progressions.
  Do not give readers more than they
  need in order to understand what is
  transpiring.

* Remember, the more time spent on any
  given part of a story, the more emphasis
  that part of the story gets in the
  reader's mind. Do not allow any part
  of the story to become a distraction.
```

Let's Talk Panels

Each page should be *about* something. Panel progressions exist to give pages their meaning, to indicate what the pages are really about. The reader will follow your panels as long as logic holds. The panels on the page are not disconnected illustrations, but *logical* parts of a bigger idea—the page—and what it's about. *No panel should exist simply because it looks pretty or is a "cool visual."* All panels have to be part of some kind of logic—though the type of logic may vary. This is called *coherence*. There is, of course, nothing wrong with a panel looking interesting, but no single panel should become a distraction from the story progression.

PANEL ARRANGEMENT AS OBSTACLE AND ASSET
The comics page has strengths found in no other visual medium. Panels sustain images. They are not always of equal weight. Some panels are neutral story movers and some are magnetic. The magnetic panels draw the reader's attention. Panel progressions in comics are not simply linear in the way that images in a film are. The reader's eye moves back toward an interesting panel on a page even as it follows the information being given in the panels around it. A comics writer has to instinctively understand this principle and has to decide which panels *should be* the magnetic panels. Writers unfamiliar with comics often fail to grasp that the creation of panels on a page is not simply a matter of placing one thing after another, but thinking about *why* one thing should come after another and manipulating the reader's attention for the best story results.

Consider the point about panel emphasis in the three versions of the following hypothetical page:

In version 1, the suddenness of the T. rex appearing on the page dampens all the information that follows. The first panel absolutely grabs the reader's attention. The shift to a quieter scene in panel 2 contrasts sharply with the action in panel 1. Panels 2 through 5 supply interesting information, but force the reader to wait for Alice's reaction. Such an arrangement might make more sense if something in these memories had an influence on what Alice does next. She might recall, for instance, that Betty packed T. rex repellant in their picnic basket. Without something of this sort to justify the flashback, the writer interrupts an emphatic panel with unrelated exposition.

"A Nice Day at the Beach"

Version 1:

Pl. 1 — Alice, a cute girl wearing a bathing suit, leaps up from the beach clutching a towel in front of her as a drooling T. rex with blood on its teeth stands over her ready to attack.

Alice: Eeee!

T. rex: Growl . . .

Pl. 2 — Flashback: Alice greets her friend Betty who's arrived to drive her to the beach.

Alice: You really think we should go, with all the stories about monster attacks in the news lately?

Betty: Don't be such a wet blanket, Alice!

Pl. 3 — Flashback continues: The two are lying beside each other on their beach towels. No one else seems to be on the beach.

Betty: Yay. We've got the beach all to ourselves!

Alice: Maybe we should have stayed home . . .

Pl. 4 — Flashback continues: Betty, who we don't see, awakens Alice with a scream as Alice sleeps on beach towels.

SFX: AAA-A!

Pl. 5 — Flashback continues: Alice awakens and Betty is gone.

Alice: Betty?

Version 1: Notice how the T. rex in panel 1 holds the eye longer than any of the other panels. The eye unwillingly leaves that panel behind to read the others.

Version 2: The interesting T. rex panel is now at panel 3— in the center of the page. This arrangement causes the reader to pivot around it while reading the other panels.

In version 2, the panel with the most interest occurs in the center of the page—at panel 3. Such an arrangement can be very effective, if the emphatic panel there represents some kind of meaningful reversal in the direction of the page. After seeing the T. rex, Alice suddenly recalls her feelings that she shouldn't have gone. Of course, the problem of

believability arises here. In the panic of the moment, it is hard to imagine that Alice would pause to think about following her instincts—unless maybe she were recounting the story of her escape to someone else after the fact. In that case, the structuring of the page would help to underscore the idea that the entire page is a flashback.

Version 2:

Pl. 1 — Alice, a cute girl wearing a bathing suit and sleeping on a beach towel, awakens to the sound of a scream.

SFX: AAA-A!

Pl. 2 — Alice looks around and her friend Betty is gone, though a towel beside her lies dented in the shape of a person.

Alice: Betty?

Pl. 3 — Alice now leaps up, clutching a towel in front of her as a drooling T. rex with blood on its teeth stands over her ready to attack.

SFX: Growl . . .

Alice: Eeee!

Pl. 4 — Flashback: Alice begins to think about all the strange happenings that she's seen in the news lately as she greets her friend Betty who's arrived to drive her to the beach.

Alice: You really think we should go, what with all the stories about monsters in the news lately?

Pl. 5 — Flashback: The argument Alice had with Betty on the way to the beach in their convertible Volkswagen Bug.

Betty: The beach is going to be fun!

Alice: Maybe we should have stayed home.

Betty: Don't be such a wet blanket, Alice!

In the final version, the T. rex comes at the end of the page after an appropriate buildup. This is perhaps the most natural arrangement. The reader will scan ahead and see panel 5 before it happens, which forces the reader to absorb panels 1 through 4 quickly. Panel 5 also generates a nice mini-cliffhanger in the story that will cause the reader to turn the page to find out what happens next.

Version 3:

Pl. 1 — Alice, a cute girl wearing a bathing suit, greets her friend Betty who's arrived to drive her to the beach.

Alice: You really think we should go, with all the stories about monsters on the news lately?

Betty: Don't be such a wet blanket, Alice!

Pl. 2 — Alice argues with Betty on the way to the beach in Betty's convertible Volkswagen Bug.

Betty: The beach is going to be fun!

Alice: Maybe we should have stayed home.

Pl. 3 — Betty awakens Alice with a scream as Alice sleeps on a towel at the beach.

SFX: AAA-A!

Pl. 4 — Alice looks around and Betty is gone.

Alice: Betty?

Pl. 5 — Alice clutches a towel in front of her as a drooling T. rex with blood on its teeth stands over her ready to attack.

SFX: Growl . . .

Alice: Eeee!

Yet another arrangement of the information might include holding back on the revelation of the T. rex until the next page. Instead of the page showing the T. rex at all, have the page show Alice's shocked expression:

Pl. 5 — Alice's eyes bug out and her jaw drops open as she looks up.

Alice: Dear god!

In that last case, the T. rex becomes the *reveal* when the page is turned instead of the cliffhanger.

Panel arrangements direct the reader's eye through the story structure. You need to be aware of the effect presenting material one way as opposed to another way will have on your readers. The arrangement should not be arbitrary, but controlled.

WHEN TELLING IS BEST

Choose showing over telling, as a rule. However, there are times when it is more practical, and perhaps more straightforward, to tell. For instance, it is much quicker and clearer to say, "They searched for the answer everywhere," than to attempt to show as much. Remember, if the story spends a great deal

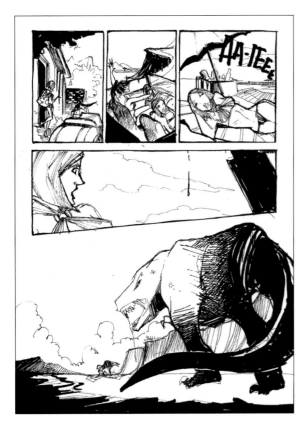

Version 3: Here the T. rex panel is the last one on the page. The other panels become a buildup to it.

of time (page space) on something, the reader may get confused as to what the story is about. Words tend to draw less attention to themselves on the page than art. Sometimes four or five words can clarify a concept that would become confused with a page of art.

Remember, space on the page is precious. As a writer, you should decide how important it is to see a certain thing. If your story is about the precise way in which a couple of characters fell in love, then it may be highly important to emphasize that to the reader visually. If it's the start of the story and you want to begin close to the point where they are already in love, then a simple panel of the two holding hands along with the caption "Bill and Mary fell in love" can save a huge amount of space and allow you to get on with the real point of your story. On the other hand, no one would want to be *told* about a T. rex. The reader would demand to see it. Between telling with words and showing with pictures, showing is dramatically powerful and is often perceived as more honest. The character who says she's happy is never as convincing as the character who *looks* happy.

TAKE IT IN STAGES

I would recommend looking at a number of comic books and carefully evaluating the amount of material covered on each page. Comics pages tend to be open and readable, without large blocks of text in word balloons or overcrowded panels of art. The action of the panels moves in a logical way.

Working from a page breakdown focuses your attention on the arrangement of the story and allows you to think more carefully about what exactly is being done in each individual panel. Taking the writing one step at a time will usually help you avoid overwriting and overcrowding the page. Use a conscious arrangement or outline to get the script moving in a particular direction. This will make the entire process of scripting much easier to tackle.

TALKING TO THE ARTIST AND WRITING THE SCRIPT

Find out as much as possible about who the artist may be and his style of art. Artists have particular styles and particular things that they *like to draw* and are *good at drawing* as well as things that they *don't like to draw* and are *not good at drawing*. It is your job to research the story—to not only make the narrative clear to the artist but also to make the narrative work for that artist's particular style as much as possible.

< Good communication between writer and artist is important. If it is at all possible, the writer and artist should make time to meet and discuss the script so that each understands the other's concerns and ideas.

SCRIPT AS BLUEPRINT

The script is a blueprint for the story. Get into the habit of using the same method each time you write a panel, even if you are only writing for yourself. It will help keep everything clear for you and for the artist. (Review the set of basic stylistic suggestions on pages 29–30 for writing the script.) The artist has to be able to efficiently deliver what the script asks for. Remember, the artist is not a camera. Things that you can easily photograph take painstaking hours to draw. *Your story will be drawn by a human being. That person will be using lines, shading, and possibly colors in boxes on a small page.* Writers get into trouble when they forget these simple facts.

Loose but Clear

A script should give the artist room to maneuver, but what is desired in the art should be clear. In this example, for instance, the story is a take on an ancient legend. An artist could interpret the script and the mythical beasts contained in it in a number of ways.

```
Giant

Page 1

Panel 1 — Close up of the girl's feet as she approaches her pet gryphon.

Girl: Faithful friend.

Panel 2 — She climbs on board the gryphon to begin searching for the final ogre.

Girl: An ogre has yet to die . . .

Panel 3 — She travels along on the back of the gryphon.

Girl: . . . the one my mother spoke of . . .

Panel 4 — Flashback begins: A huge ogre approaches her sad mother.

Girl (from previous panel): . . . the one that made the bargain.

Caption: Twenty-two years earlier.
```

In the script, the writer does a good job of keeping the scene descriptions concise, but they don't explain much about the world of the story. If the writer and the artist have not discussed the characters or what kind of world this may be, the resulting comic could be nothing like what the writer had in mind.

Even the idea of an ogre is subject to artistic interpretation. Hopefully the artist enjoys drawing such creatures.

Panel 5 — The ogre gives the mother magic cucumber seeds.

Ogre: Here! But . . .

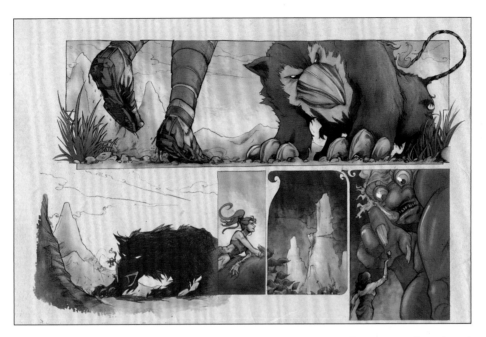

Artists are not cameras, but interpret stories artistically. Each artist has a distinctive style and aesthetic.

When dealing with flashbacks, be sure the artist knows where they begin and end. Here it would be a good idea to say "flashback continues."

Page 2

Panel 1 — The huge ogre is turning to go, leaving the mother holding the bag of cucumber seeds.

Ogre: . . . when I return, she must marry me!

Mother: Okay. . . . But what do I do?

Panel 2 — The mother clutching the bag of seeds.

Caption (ogre): Plant the seeds.

continued

Panel 3 — A jade necklace, prominently around the mother's neck.

Caption (ogre): Wear the magical necklace.

Panel 4 — The mother tells the story of the magical cucumber the ogre instructed her to plant that later became her daughter.

Caption (ogre): A daughter will come . . . from a golden cucumber.

Panel 5 — The mother tells the daughter that the ogre will return one day to claim her. The girl is horrified.

Caption: Eight years later . . .

Mother: You must go far away.

Panel 6 — The sad eyes of the mother as she tells the little girl that she will have to go far away to the dojo in order to not be claimed by the ogre.

Mother: Learn to fight so he can never claim you . . . and always remember, Mother loves you.

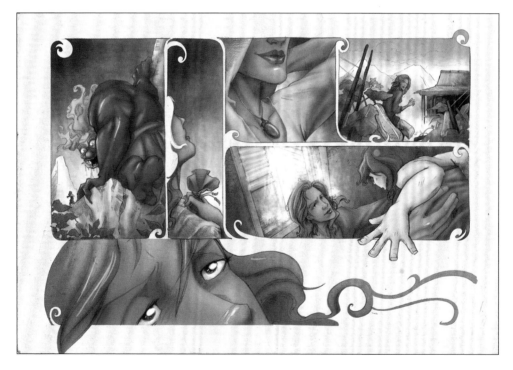

It is vital for the artist to know what to draw. The writer, however, doesn't tell the artist *how* to draw.

Here a different part of the flashback begins. This may confuse the artist as well as the reader.

Discussing the script means listening to the artist's questions, concerns, and thoughts on the story, and clarifying any confusion. It may be necessary to rework panels or even whole scenes to accommodate the artist's style or strengths, if it makes for a better product in the end. Art and writing must work as a collaboration. Good scripting craftsmanship will allow the artist to do the best possible job on the story.

WORDS TO DESCRIBE ART

To write good scene descriptions, start with the basics. *Write clearly.* Give brief, telling details of scenes and characters, and have a specific, story-related focus for each panel. The panels themselves should form an understandable logical pattern on the page that develops the story and helps it to progress, as discussed in the previous chapter.

Length of Panel Descriptions

Legendary comics writers Alan Moore and Neil Gaiman are known for writing lengthy scene descriptions. Moore's script for *The Killing Joke* is notable for its opening, page-length panel description. The length of a scene description is, of course, up to the individual writer; however, a beginning writer is best advised to keep scene descriptions brief and to the point. Long scene descriptions are mostly the exception, not the rule. Get to the point. The writing should proceed as quickly as possible without sacrificing the information necessary for the artist to draw the panel.

The first panel in a new scene may be much longer than the others, especially if you are introducing new worlds and fantastic characters. Think telegram instead of essay, however. Most artists prefer quick, concise, definitive scene descriptions. The artist has one pressing question: *What should I draw here that best tells the story?* Each scene description should cause the story to unfold objectively, without opinions, personal biography, or poetry. Try to limit yourself to no more than three lines in a scene description.

Telling Details

Obviously, the artist will draw many details in the background of a story. However, unless they play a role in what happens in the story, you would not consider them telling details. *Telling details* contrast with what you might call *incidental details*. An artist, for instance, may put a bird in the sky because it looks nice. If the bird were removed from the story, things might not look as nice, but the story would still be completely understandable. On the other hand, if a killer sends messages via a trained parakeet, then details about the bird become crucial to the reader's understanding of the story—they are *telling details*. The writer *must* supply these details, but should leave the incidental (non-telling) details to the artist. In Osama Tezuka's graphic novel series *Buddha*, Chapra—a pariah, a slave who masquerades as a general's son—is revealed by a mark on his foot that signifies his status as a slave. The mark is a telling detail that was there from the inception of the character.

A telling detail may serve as a set up in a story. For instance, a character may have a scar or birthmark on his face when he is young. If the scar turns up later, when the character is older, the reader will remember and recognize him.

Beware of writing scene descriptions that call for multiple actions within a panel. Each panel should focus on one main action.

If the actions are important enough to the story, they can be broken apart and presented as separate panels.

Panel Numbering and Page Numbering Errors

Be very careful to proofread for numbering problems in your script. Problems usually occur due to cutting and pasting in the editing process. It is an embarrassing problem for a writer and can be very easy to miss. The numbers can be critical, however, because a script must fit within a given set of pages and the number of panels on a page is always vital. Errors here can be very confusing for the artist. There is no substitute for carefully reading the finished script.

Having such a boundary (even if it is a bit arbitrary) helps you to keep your script on track. The reader of the comic book will never see your scene description, only the art. In cases where a part of the scenery is particularly difficult to describe, some writers actually incorporate reference photos directly into the script. Artists appreciate the visual reference. However, photos shouldn't substitute for clear writing.

Scene descriptions can contain only *one* action. A big problem with long scene descriptions is that they have a way of obscuring the fact that multiple actions may have seeped into them—a mistake that can confuse the artist. The artist is then forced to decide what part of the action to draw. As a writer, you should decide what the important action is, or whether each step of the action warrants its own separate panel.

Think of comics as a sequence of frozen moments in time. Part of being concise in writing comics scene descriptions means selecting only the one action appropriate for story progression.

SHOT CALLS: YES OR NO?

The question often arises as to whether or not to use shot calls. In a script, a *shot call* is when the writer explicitly states what cinematic "camera direction" the artist should use. Of course, in comics the camera is only metaphorical, but the language of cameras is often employed. Camera directions such as "full shot," "OTS" (over the shoulder), "CU" (close-up), along with many others, get tossed around quite a bit in comics writing. (I'll discuss what these shots mean in more detail on pages 63–66.) I tell students that if the shot call doesn't mean anything to the *story*, then it should be cut.

If the artist, for instance, decides to draw a full shot instead of a medium shot, does it matters to your story? If it doesn't, then don't bother naming it.

Some shot calls, however, *do* matter to a story. Sometimes choosing one shot over another implies something different about the mood of the story, or the character's involvement with what's taking place. In those cases, you should *absolutely* mention the shot. If shots calls are only mentioned

when they're meaningful, the artist will pay more attention to them. If a story needs more visual variation, sometimes specifying different shots helps to achieve that. It might also be noted that some publishers want to see shot calls. If this is the case, by all means supply them. Whether or not shots should be specified may be something that it would be useful to discuss with the artist.

Think about why you are using certain camera directions. Many camera directions are related, and most have storytelling implications. Sometimes, however, writers use them reflexively, without a clear thought as to why. Often these can be cut if the publisher or artist doesn't require them. Here are some considerations for a few of the more common shot calls.

Camera Directions

Here's a quick list of some of the most commonly used camera directions in comics. Camera directions (or shot calls) usually indicate distance, placement of the camera, or the relationship of the camera to characters or objects. The list moves from some of the most frequently used shot calls to those that may be used less often but come up often enough that you should be familiar with them. It's a good idea for a comics writer to be thoroughly familiar with all types of shot calls, but be wary of using obscure cinematic directions with which the artist may not be familiar. Common abbreviations are also provided for some shots, but avoid using ambiguous or confusing abbreviations.

Close-up (CU)—A close-up is usually a shot of the character's face. Close-up is best used to convey emotions, such as anger, thoughtfulness, fear, happiness, or grief.

- Sometimes a close-up lends visual variety to a story, especially if the story has lots of full shots or long shots.

- Do not confuse with *close shot*, which includes the shoulders with the face.

Medium Shot (MS)—Waist-up shot of characters. Don't use this shot to describe inanimate objects such as cars or trees.

- There are rare occasions when it is critical to the story to show a character from the waist up.

- Do not call a medium shot a *midshot*. There's no such thing as a "midshot."

Full Shot (FS)—Head-to-toe shot. Often an unnecessary call given the context of the scene.

- This could reveal character's costume, weapons, height.

Long Shot (LS)—Sets characters against the landscape. The scene description often suggests this shot to the artist without the necessity of stating it.

- Never tell the artist when to use one-point, two-point, or three-point perspective. These are art-specific instructions equivalent to telling the artist what type of pencil or brush to use. The technical aspects of drawing the scene are strictly the artist's call.

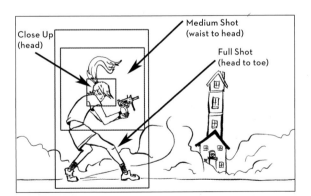

Basic shot calls are choices for how much of the scene to reveal within the frame of the scene.

Extreme Close-Up (ECU or XCU)—Zeroes in on something that does not usually get examined this closely.

- If used with a character, it could denote a minute gestural shift, such as a tear welling up in the corner of an eye.

- If used with an object, this shot draws the reader's attention to it, emphasizing its importance in the story.

- Certain types of extreme close-ups have become clichés in comics, especially extreme close-ups of snarling mouths and angry eyes.

Shots that involve extreme close-ups of a character's eye with an object reflected in it have become comics clichés.

An over-the-shoulder shot is frequently used in comics to place two characters in proximity to one another and to create drama.

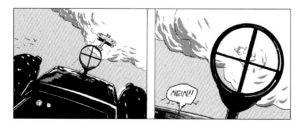

You can use forced perspective in a variety of creative ways to pull the reader more deeply into the story.

SHOTS EMPHASIZING CHARACTERS OR OBJECTS

Point of View (POV)—The camera becomes the eyes of a character in the story.

- These shots pull the reader into the head of the character. The reader literally sees the world through a character's eyes.

- Sometimes these shots are used to show that a character's vision is distorted, blurry, or in some way peculiar.

- Use them sparingly. Such shots can quickly begin to feel gimmicky.

Over the Shoulder (OTS)—The camera is placed behind the shoulder of a particular character as if the reader is standing just behind that character in the story. It is a shot that almost always has to be named in order for the artist to clearly understand what is desired.

- This is similar to point of view, but without the camera becoming the eyes of the character. Instead, the effect is often to connect a character solidly to the thing being looked at.

- This shot places the reader in the position of eavesdropping.

- You may also use it to create mystery if we're looking over the shoulder of a character who is perhaps an unidentifiable silhouette.

Forced Perspective—Any time a character or an object is placed so close to the "camera" that the character or the object looms large in the immediate foreground.

- This shot can be used to emphasize or exaggerate the importance of whatever is in the foreground.

- If the shot includes other characters deeper in the perspective of the panel, these characters will often look small or insignificant beyond whatever is in "forced perspective."

CAMERA HEIGHT

High Angle—The camera generally tilts downward to look at subjects. High angle means that the camera is at least above eye level, but how far above eye level should be clarified in the scene description.

- High-angle shots often tend to make whatever is portrayed appear vulnerable or powerless, as if the reader is looming above.
- High angle is often confused with bird's-eye view (see below), an extreme form of high angle.

Low Angle—The camera tilts upward, usually from below ordinary eye level. As with high angle, the scene description should clarify what this angle may be.

- Low-angle shots, where the reader is looking up at something, tend to make those people or objects seem more powerful and significant in the story.
- Low angle is often confused with worm's-eye view (see right), an extreme form of low angle.

Bird's-Eye View (BEV)—Extreme high angle, looking directly down on a subject.

- Bird's-eye view tends to flatten the art, removing all drama-inspiring perspective by looking directly down on things. In movies, some forms of BEV are referred to as "helicopter shots."
- Such extreme shots should be called for only under circumstances that warrant them.

Worm's-Eye View (WEV)—Extreme low angle, looking directly upward from ground level, as if from a worm's perspective.

- This angle, as with BEV, is often overused. Usually the writer means "low angle."
- Worm's-eye view could be used to make a character look extremely powerful or even grotesque.

Worm's-eye view is an extreme form of a low-angle shot. The writer should be careful not to overuse such shots.

Bird's-eye view is an exaggerated form of a high-angle shot.

HORIZONTAL MOVEMENT

Pan—This sometimes describes moving up or down but usually describes shots that move horizontally. In comics, a pan shot is used to create timing with panel breaks as the reader's eye travels across a continuous horizontal scene subdivided into multiple panels. In *Understanding Comics*, Scott McCloud refers to the shot as a "polyptych." These shots need to be specified and used only with deliberate purpose.

- Such shots usually involve a sequence of panels. One panel can't be a pan shot by itself. Asking for a scene to be broken this way probably should include a note in the script to the artist in order to clarify.

- Drawing the reader's eye by stages across a continuous scene creates a timing effect, similar to a movie camera moving slowly across a scene.

There are, of course, many other types of shots, but these are the ones that a writer will encounter the most frequently. It's a good idea to be careful with obscure or overly complicated shot calls, because there is always the possibility that the artist may not understand them. Once again, communicating with the artist (or publisher) is a good idea when deciding how and when to use certain shot calls.

GENERALITY VS. SPECIFICITY: MAKING OBJECTS AND ACTIONS CLEAR

The objects and actions you choose for a scene description should be specific and concrete. An artist can't draw a generality or an abstraction. If, for instance, you write, "An evil force hovered over the planet," the artist will have no idea what to draw. What is an "evil force"? You must be more specific. Put this way, "A Klingon battleship hovers over the planet," the scene can be drawn.

Visualize the page. If it were a published book, what exactly would the page show? Remember, it's your story. Consider the details and state them plainly. Never put the burden of conceptualizing the visual fully onto the shoulders of the artist (for example, "Draw whatever you want, just so it looks evil.") This applies not only to the objects but also to actions. As closely as possible, state what a character is doing in the panel. Give the artist well-considered, concrete actions.

Levels of Generality and Levels of Specificity

Again, the words selected in a scene description should be as specific and concrete as makes sense for the artist. When selecting the appropriate words,

A pan shot is really not a single shot but a series of panels that give the effect of a movie camera panning over a scene.

consider the level of specificity. In describing objects, a writer should come up with something drawable:

NOUNS (OBJECTS)

- *Things* (general; not drawable)

- *Wooden Things* (less general; still not drawable)

- *Furniture* (more specific; drawable but still broad)

- *Queen Anne Chair* (concrete; drawable object)

- *Queen Anne chair with a paisley pattern and a cigarette burn on the left arm. A dusty faded fringe hangs underneath and hides the scuffs on the legs.* (too specific; contains elements that are not drawable)

In considering movement, a writer should be equally specific:

VERBS (ACTIONS)

- *To exist* (abstract; not drawable)

- *To move* (vague but drawable)

- *To walk* (ordinary but drawable)

- *To shuffle along* (drawable; more precise)

- *She shuffled along exhaustedly, as if the last hope had been drained out of her and she hadn't fully realized it yet.* (goes too far; contains elements that aren't drawable)

The ideal degree of scene description is the point at which the artist can clearly conceive of what the writer has in mind. Being overly descriptive means exceeding the point of concreteness and adding words that go outside what art can show. If additional, more abstract information is required, it can be given as part of a caption in the panel—but be sure that it is necessary to the story before including it. Sometimes it is okay to create "atmosphere," but within the context of the story, the point of the action or thing described should be obvious.

PRESENTATION ORDER

A scene description in a comics script should contain all of the information relevant to drawing the panel. Make sure that the scene description is in the same place each time, as specified in the formatting guide in chapter 2. Do not mix scene descriptions in with dialogue, sound effects, or captions. Also, have a logical and consistent order to the arrangement of the scene description. It might be a good idea to begin with the setting, then mention the characters involved. Group all of the descriptions of a particular character in one place. Then give the action, what the character(s) is doing? That way the artist begins to understand what to expect from each scene description, where to look for its parts—setting, characters, action—reducing any confusion over what is important in the scene.

Setting

Establish setting at the beginning of a scene any time the story moves to a different physical location. Many writers neglect to give some very basic information to the artist. With scene descriptions, you should concisely state:

- The nature of the physical world in which the story exists (is it day or night, indoors or out?)

- The time elapsed between parts of the story

- The historical period or type of world in which the story takes place

Character

Briefly describe characters for the artist. Only important characters need to be given much attention. A description of a character:

- Should be given when the character is first introduced, unless something about the character changes

- Should be no more than a few carefully selected words (e.g., a thin, nervous fellow in jeans and a T-shirt)

Sometimes it's a good idea to create a comparison to flesh out the idea of a character (for example, "He looks like Albert Einstein, only skinnier").

Actions

The scene descriptions must let the artist know what the character is *doing*. Try to avoid having an important character appear in the scene description as a name only. Always think about a specific action for the character to do.

Take a look at the following student script, and consider its scene descriptions.

In the example below, the scene descriptions for the story need more concrete detail in order to speak clearly to the artist. The repetition of "shot of" should be omitted throughout the script. In panel 3, scene description isn't presented consistently but gets mixed up with the dialogue. Never place comic script dialogue in quotation marks if the speaker is obvious and the dialogue labeled. Given the names of the characters, the

```
Wolves, Dogs, and Men

Page 1

Panel 1 — Long shot of a werewolf sitting in a pile of garbage in a city alley.

Panel 2 — Shot of a Doberman walking by the alley and noticing the werewolf.

Panel 3 — Shot of the Doberman talking to the werewolf.

Doberman: *sniffs the Werewolf* "Hey sah, you okay?"

Werewolf: "Urrr . . . yeah. I think so. Where am I?"

Doberman: Well sah, this is a city that hates creatures of the occult like us.
We're considered lower beings, no more than dirt ta them.

Panel 4 — Long shot of the werewolf and dog walking down the street.

Doberman: I'll help ya get around here or get out ah here, but wherever ya go,
take me with ya.
```

The shot calls seem reflexive. Since they're not important to the story, they could be cut. Also, what kind of werewolf? How will we know that it is a werewolf?

Indeterminate. If no camera angle shot is specified, omit "shot of." Is the Doberman an actual dog? Or is this some kind of anthropomorphic character? What should the artist do with this?

The action is obvious and doesn't seem to mean much to the story itself. Come up with a more "telling" action.

Do not include scene descriptions or actions in the dialogue. "Sniffing" should be part of the scene description. Also, do not use quotation marks around obvious dialogue.

"Walking" might not be specific enough. Werewolf was, after all, somehow in trouble it seemed. Could he be limping or leaning on Doberman? The action seems too cursory.

world of the story seems to involve supernatural creatures and talking animals, but is the Doberman an anthropomorphic animal, as in the *Blacksad* comic series, or is it an actual dog? The last panel states "the werewolf and dog walking down the street," but are they walking on four legs or two? The artist has to make a conceptual decision, but the writer should have already visualized the page and communicated that to the artist.

Part of the setting feels concrete, but the writer should include more specificity. For instance, "Pile of garbage" can be interpreted many ways. Is the garbage rotten cabbage, or is the word being used in a more general sense, meaning old newspapers, pizza boxes, tires, and broken furniture? Plus, what kind of city and what kind of alley?

The actions should also be more specific. In panel 1, the werewolf is described as "sitting in a pile of garbage." Is the werewolf injured, homeless and depressed, drunk, or just resting? Werewolf asks, "Where am I?" This line of dialogue could be interpreted in various ways. Is he groggy because Doberman wakes him up? Is he blind, lost, or drunk? Since the werewolf apparently gets up and walks away with Doberman, the artist will absolutely need to know how to handle his condition. Even

The thumbnails here show an interpretation of the story that may not be what the writer had in mind. The animals here are anthropomorphic rather than real dogs and wolves.

apparently obvious statements become murky when someone has to draw them. "Walking away," for instance, could also be sharpened.

Even writers who plan to draw their own stories should get into the habit of eliminating vague thoughts and the potential for ambiguity. If an artist has written the script and plans to draw it later, he will likely forget the details when it comes time to actually draw the art. Since the actions of the script are vague, the artist will be left virtually rethinking (and thus rewriting) the entire page in order to draw the scenes. Writing concrete and specific scene descriptions does not take more room to write; just substitute concrete details for general ones. Conceptualizing scenes in concrete details is an immense help to the artist drawing the script, even if the artist is also the writer.

Consider the script again, with some revisions:

Wolves, Dogs, and Men

Page 1

Panel 1 — A fierce-looking werewolf, monstrous and hairy like a beast from *American Werewolf in London*, leans against a brick wall in a grungy alley beside a liquor store. There are various articles of bloody clothing torn and flung about the alley as if the creature has just eaten somebody.

Panel 2 — Closer, the werewolf looks confused, hung over. He's holding his head as if he has a headache.

Panel 3 — The werewolf looks up suddenly at someone speaking off panel.

Doberman (off panel): Hey, you okay? Not going to eat me, are you?

Panel 4 — A Doberman Pinscher/Man (walking on two legs and wearing pants and a flannel shirt) now stands at the end of the alley, keeping his distance and sniffing at the werewolf. His hands are on his hips.

Werewolf: Urrr . . . Where am I?

Panel 5 — The Doberman Pinscher/Man has his hands in his pockets looking down sympathetically at the werewolf.

Doberman: You're in Detroit, a city that hates creatures of the occult like us.

Panel 6 — Doberman helps the werewolf guy up. The werewolf guy gazes at him curiously, losing some of his ferocious demeanor.

Panel 7 — Close up of the two of them—Doberman earnest about a proposition and werewolf guy a little shocked.

Doberman: I'll help ya get around here or get out ah here, but take me with ya. / Let's go raise hell together like Thelma and Louise!

This scene has now been given a specific setting (alley behind a liquor store) that indicates a certain time and place and set of values. The werewolf has become more specific, and there is even a hint as to what he's been up to (the bloody clothes and so on). Doberman is now definitely a dog/man, and there's poignancy in the fact that Doberman states that the city hates them. Does he, therefore, approve of the werewolf's implied actions? The dialogue has also been adjusted to focus the scene. Specific, concrete actions have been imposed: "walking" has been replaced by "taking his hand"—a connection further underscored by the Thelma and Louise idea planted in the dialogue. The story may not be what the original writer had in mind, but the artist knows what to draw, which is to say that the writer is communicating effectively with the artist.

Understanding the needs of the artist is key to effectively writing a script. It is a good idea to have a conversation with the artist about what she likes to draw and wants to see in the script, before beginning to write. Of course, sometimes writers have no idea who the artist may be. In these cases it is a good idea to opt for absolute clarity. If the script doesn't speak to the artist clearly, it will be extremely difficult for the artist to deliver what the writer has in mind. Even in those cases where the writer and the artist are the same person, it is important to communicate well so that important aspects of the story aren't forgotten later, especially if the story is a lengthy one.

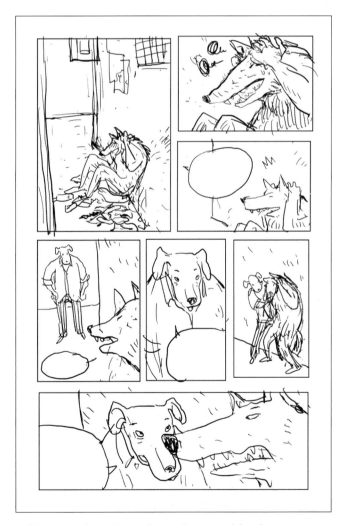

In the revised version of the page, the action is directed more and the characters are given more definition.

SCRIPT ENERGY: DIALOGUE, TEXT, AND VISUALS

Most people would agree that comics is a visual medium, but text is also a vital element. In a script, the story breaks down into two primary components: (1) *text*—what is read (dialogue, captions, thought, and sound), and (2) *visuals*— what is seen (the action of the story, the artwork, and the panel layouts). These two components work together to generate energy within the script, and thus within the story. *Script energy* may be thought of as a surprising set of circumstances or reactions. If characters are doing and saying exactly what the reader expects, the script will feel dull, and so will the story. A successful writer is a master of both text and visuals and understands how to manipulate the reader's imagination by carefully modulating both elements.

< Word balloons are a fundamental part of page graphics. Well-thought-out text can strengthen the art itself and enhance the story.

USING TEXT

Text is usually the *only* thing the writer does that goes directly to the reader without being filtered through the artist's interpretation. Artists may have distinct opinions about page layout and scene content, but most artists don't consider it their job to rewrite text. Of course, an editor may make corrections to the text, but if the editor has to make too many corrections, the script will be bounced back to the writer, or the writer may be replaced.

Consider the text portrayed in the following story:

```
Little Carpenter Meets Blackbeard

Page 2

Pl. 1 — The damp woods of the Carolina Mountains, around dusk. It's spring (mid-
March?) and the trees are putting out the first dusting of new leaves. Maybe a patch
or two of snow in low places.

We're in a clearing of a small valley between some tall rocky hills with massive gray
boulders sticking out, and a river is quietly flowing through it. Along the water,
there should be willows with branches that drag in the current. A low fog hangs
close to the ground. Some rough-looking driftwood should clutter the banks. Maybe
canoes have been dragged out onto the bank (if there's room for it). There are a few
houses around.

A group of Cherokee men sit around a small fire behind some large rocks. They are
huddled in blankets. Some of them hold their hands out to the fire to show that it's
cold. One of them, Little Carpenter, is a relatively young man, short and athletic.
Everyone respects him. It is now the year 1715. (Just so you know—it doesn't need to
show up in the story exactly.)

Caption (the old man): "It's kinda complicated. But if you really want to know, I'll
tell you what happened. This is how it was told to me . . . "

Pl. 2 (Inset) — Little Carpenter is looking off toward the woods.
```

• The period and atmosphere of the setting requires an involved explanation. Afterward, the script returns to shorter descriptions.

Page 3

Pl. 1 — One of the Cherokee leans in to the others.

Cherokee Man: You hear something over there in the trees?

Pl. 2 — Little Carpenter looking off over his shoulder.

Little Carpenter: I have been smelling men approaching since before the sun went down. It is a bad smell. It's strong now.

Pl. 3 — They all steal a look over the boulder and into the trees along a ridgeline.

Little Carpenter (whispering): My god, they have hats like boats!

You can give whispering as smaller text. Simply change the point size. It should still be designated as whispering, however.

continued

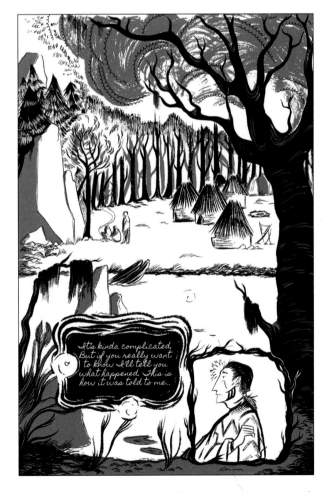

A voice-over caption lets the reader know that someone is narrating the story.
Such narration creates perspective for what is being said.

Pl. 4 — From over their shoulders, we see figures standing in the trees along the ridge. They are mostly silhouetted with enormous shapes on top of their heads. They're holding something up toward the sky and trying to see it in the dying light. Some of them are obviously holding the ends of something (poles shoved through the rings of an iron chest—for later reference). The fog should be drifting around them. Put some fireflies in the scene too if you can—that might be fun.

Sailor: What in blazes are those things?

Blackbeard: Haven't ya ever seen fireflies, you fool?

Sailor: They look like spirits!

Pl. 5 — Eight men, pirates, dressed as if they are way out of their element. They are wearing heavy boots, and they are trying to look at a map in the fading light. The one holding the map is a slightly effeminate-looking boy.

There's a stocky sergeant-at-arms type named Treacle. The rest are just whatever you want them to be. The one looking at the map has a huge three-cornered hat and a flowing black beard (William Teach, of course: Blackbeard). The men all look tired in the dim lighting. The one sailor swats fearfully at the flashing bugs. The misty fog should be drifting up from the river and swirling around their legs like in some werewolf movie. They're all slowly walking as they speak.

Blackbeard: Leave the chest by the river a moment. Spell yourselves. / Where the bloody hell are we, Mr. Treacle?

Treacle: It's too dark. I can't make it out, sir.

"The rest . . . them to be.": In this case, the writer is speaking directly to the artist. No reader will ever see this. It isn't necessary to completely delineate every character in the story.

Just a whiff of archaic language helps to establish the time frame—and the character of Blackbeard.

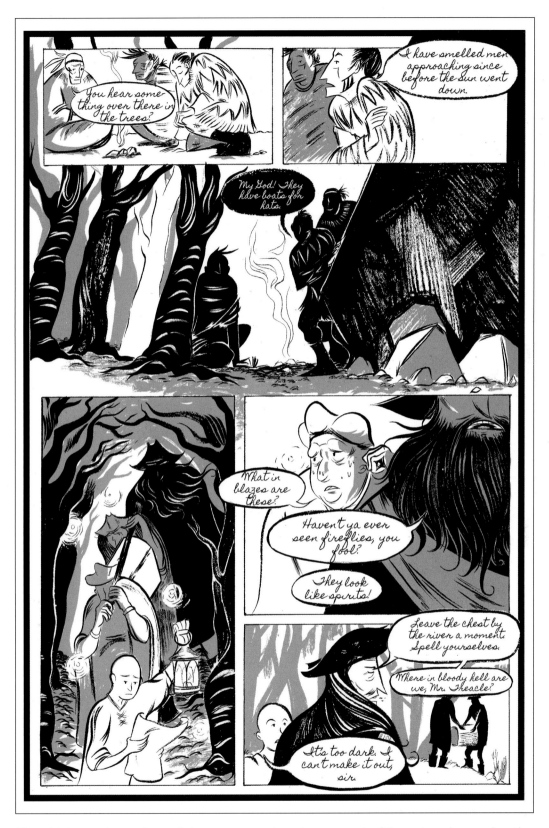

Though it is tempting to play to all the stereotypes about the way people of the past may have spoken, the dialogue remains relatively straightforward, giving nothing that would pull the reader out of the period. The characters are intended to be real, rather than stereotypes.

Text can be especially tricky if the story is set in another time period or another culture. The story on pages 74–76 is mostly set in the eighteenth century and involves Cherokee and pirates. The visuals create an interesting atmosphere, while the text generates a matter–of–fact, unadorned way for the reader to understand the attitudes of the people involved. The text of the pirates contains a formality and an archaic sense of grammar that goes beyond just having the pirates say clichés like "Yarrrr" and "Shiver me timbers." The text conveys the spirit of the story just as the art conveys the atmosphere. The text should contain as much energy as the visuals. At times, text may even become the main action, especially if two characters are, for instance, arguing or falling in love. Plus, text is often the prelude to visual action within a story. (Usually, characters don't launch into battle without discussing it first.) Text can be dialogue, thought, narration, or sounds. Text amplifies, explains, and smooths the physical actions of the characters.

Too-Much-Text Syndrome

Text in a comic book occupies physical space. Beginning writers often write too much text for the space available. As a general rule, the more text, the less information the art itself can convey. Text, however, can deliver information much more quickly than the artwork, particularly abstract concepts too difficult for the art to show. On the other hand, having too much text, makes it difficult for the artist to leave enough "dead space" for the words, especially if there are numerous panels on the page that are packed with visual information. Writers who have problems with this are not visualizing the story as it will appear on the page. Thumbnails can be very helpful here. Include word balloons in the thumbnails to approximate the text you've written. Unlike movies or stage plays, text takes physical space on the page.

As mentioned earlier, comics writers create text outside the art in four basic forms: dialogue, narration, thought, and sound (SFX).

Dialogue

Dialogue is everything said aloud within a comic. In an average-size panel (five to seven panels per page), it's a good idea—as much as possible—to keep the number of balloons down to no more than one or two. There are, of course, always exceptions.

Here are some things to consider when writing dialogue:

1. All of the characters shouldn't *sound* the same. A writer can develop an ear for voices by becoming a careful listener, not just to what people are saying, but *how* they're saying it.

2. Unless a particular publisher tells you to do otherwise, introduce dialogue in a script with a character's name followed by a colon.

```
Jane: Did you bring the cake?

Oliver: Yeah, I got it, a big one.
```

3. If a character who is speaking is not seen, the dialogue is said to come from "off panel" and should be denoted this way:

```
Oliver (off panel): Can we have
a piece?
```

A word ballon is an iconic part of comics graphics.

4. Try to avoid long speeches, especially in a single panel. Limit the amount of dialogue in an average panel to no more than forty words. (This is not a law by any means, but it will help keep you out of trouble as you generate dialogue.)

Narration

Narration in a story is almost always done via captions. Captions are ordinarily boxes as opposed to balloons. Captions can occur anywhere within a panel, but they are most commonly found at the top. Sometimes captions are not placed in boxes but float within the artwork itself. Captions can also function as a character's thoughts. In flashbacks, captions can be the dialogue of the person recounting the events, like "voice-over" narration. Be very careful to avoid confusion. Do not shift between captions that serve both functions. Often captions are the voice of a narrator who may or may not be present in the events of the story. When captions are used as narration, the rules of narration apply.

FIRST-PERSON NARRATION

A first-person narrator usually knows the thoughts of only a limited number of characters in the story. First-person narration is characterized by these pronouns: *I, me, my, myself, mine, we, us, our, ourselves.* A first-person narrator may not remember things clearly, may be crazy, or may outright lie.

Not all captions are in boxes,
though they are frequently used.

A first-person narrator gives the story a feeling of immediacy, bringing the reader closer to the material.

SECOND-PERSON NARRATION

Second-person narration is characterized by the pronouns *you, your,* and *yours* and was once very popular in detective or horror comics as a means of building suspense (for example, "You go into the room not knowing what to expect, and suddenly you see him, a hideous monster! You can't get away. You're trapped!") The narration tends to draw the reader into the story, inviting him to experience the story almost as a character. Second-person narration isn't used in comics much these days.

THIRD-PERSON NARRATION

Third-person narration, sometimes called "omniscient narration," means the narrator knows all aspects of the story. The omniscient voice is characterized by third-person pronouns: *he, she, it, him, her, his, hers, its, they, their, theirs.* The omniscient narrator can relate the deepest thoughts and fears of a character, can allude to future events, or can correlate the past with present events of the story. It is possible, of course, to create variations on third-person narration, such as limited omniscient, where the narrator only knows or is sympathetic to one character.

Thought and Thinking

Thought represents the language that goes through the mind of a character within a scene. Thought balloons may express delusional ideas or mistaken ideas, but thoughts are generally truthful. Thoughts can be used quite effectively to indicatecontradictory impulses within a character.

```
Mary: Are you enjoying the concert?

Joe: Yeah!

Joe (thought): Worst concert ever!
```

Thought balloons are another iconic graphic of comics. Thought almost always has bubbles instead of a pointer.

More Thoughts on Captions

Beware of using the omniscient narrator to explain the story to your readers. Overusing the omniscient voice destroys subtext. Readers don't need to immediately know all of the answers. Allow the reader some sense of discovery within the story. A third-person narrator can certainly provide clues, however. Too often the omniscient narrator becomes the voice of bald exposition.

As a rule, do not rely on color-coding captions, shading captions from one source in pink while shading those from another in blue. This trick usually indicate poor writing. Try to avoid situations where multiple narrators speak simultaneously in caption boxes. The distinction of who is speaking between one caption and another should be clear from the context.

Captions can help create story compression, since words take less room than art, but the more the telling of the tale is forced into narration (caption boxes, voice-over dialogue, long expository speeches), the more a reader's sense of discovery diminishes. Ultimately, the story works best if it has a *visual* center of interest.

Thoughts often set up dilemmas within characters. Thought balloons are unique to comics. There are comics writers who avoid using thought balloons. Some editors discourage their use as well. Many writers and artists insist that *thought* should be expressed in caption boxes rather than balloons (or that thought should not be used at all). Therefore, thought balloons can be sources of contention among creators. If thought balloons *are* used, however, they can provide another level of awareness within the narrative. The thought balloon represents ideas that only the reader and the particular character doing the thinking share. If you are free to choose, then there is no inherent problem with thought balloons.

Sound Effects

Sound effects are a form of *onomatopoeia*, words that sound like what they are. Sound effects (often made-up words) generate a soundtrack for your story. Gunshots, for instance, are an obvious example often associated with comics. Gunshots may be written with words such as *Blam, Pow, Bang, Budda Budda-Budda*, or *Ratta–tatta–tatta*, or other yet-to-be-invented words. You have to create the *actual sound*, not simply state that there is a sound (e.g., "sound of a gunshot")—as in a film script. It is up to you to phonetically determine what set of letters comes closest to reproducing the desired sound. Be creative. Try to be fresh rather than using the same sound effects found in every comic, especially for unknown sounds. A good rule to follow is to provide sound effects for nonsynchronous sounds (the reader doesn't see what is causing the sound) or for unusual, loud, or emotionally jarring sounds.

Sound effects come in many styles and sizes, depending on the intensity of the sound and the nature of the sound.

Other Instances of Text

Text can also appear as graffiti, billboards, written notes, or as things seen on phones and computer screens in a story. As with sound effects, this type of text is embedded in the artwork itself. It can be effective in allowing the reader to understand things that are not necessarily spoken, but have a significant impact on the story. Such text can be designated in the scene description. Sometimes this type of text may be only partially shown.

Correlating Text

It is entirely possible for a single panel to contain narration, dialogue, thought, sound, and visual information at once—all telling the reader different things. By manipulating information on all levels, you can create a very interesting degree of complexity for a character, even in just one panel. Consider the following bit of script for instance:

> Panel description: Mary carrying several packages, exhausted, struggles to climb the steep stairs.
>
> Caption: Finding a cheap walk-up in New York was lucky.
>
> Mary: You can do it.
>
> Mary (thought): Why'd I move here?

The scene sets up a very complex character, with conflicting thoughts.

Basic Dos and Don'ts

Here's a list of dos and don'ts I've come up with after seeing the mistakes that people often make with text. Most of it is common sense that somehow gets overlooked in the heat of writing.

DOS

1. Show instead of tell. If the art is showing it, don't tell it in words.

2. Consider the space the text requires. The more text, the less visual information you can have in the panel. Balance art and text together. Be wary of generating pages that feel or look crowded with text.

3. Check spelling, punctuation, and capitalization within the text. Obviously, in dialogue, characters don't always speak in a manner consistent with proper usage, but when in doubt, have characters speak properly.

4. Use the text appropriate to the narrative and to the market that your story is aiming for. Profanity in dialogue, no matter how accurate to the character, narrows the potential markets for your story. Plus, profanity has the possibility of distracting or annoying the reader, especially since it remains on the page after it's "spoken."

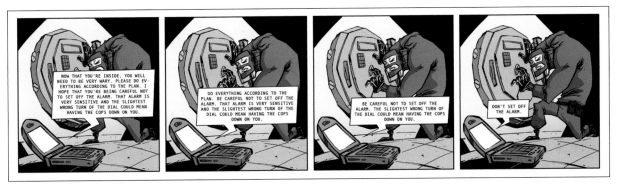

Beginning writers frequently overwrite the text. Text obscures the artwork, slows the pacing, and often doesn't explain the story any better. The last panel reads clearly even with minimal text.

Basic Rules for Characters and Dialogue

Here are a few more specific points to consider when creating dialogue.

1. Vary the dialogue from character to character. Characters should have distinct voices, as much as possible.

2. It should be very clear which character is saying what. Avoid ambiguous pronouns. Who and what characters are referring to should be clear.

3. Do not place too heavy an emphasis on phonetic spelling of names or words. A little bit of that goes a long way.

4. Do not write dialogue that sounds overly literary or unnatural for conversation. Such dialogue is often referred to as *stilted* or *wooden*.

5. Avoid gratuitous dialogue. In real life, characters may say "Good morning!", "Hi! How are you!", "I'm fine, how are you?", and so on. Unless it is important to the story, cut such dialogue.

6. Be sure any words uttered sarcastically or ironically come across as intended. It should be crystal clear within the context of what's being said. Remember, there is no actor to deliver the line. Sarcasm can be hard to decipher unless the context makes it understandable.

7. Do not write actor's prompts or cues along with the dialogue. For instance, do not say "Sarah (angrily): Please close the door." If a character is angry, it should be obvious in her actions. Anything a character is doing should be in the scene description so the artist can draw it.

DON'TS

1. Do not lean on textual narration to tell the story.

2. Do not shift person in narration. If the narration begins in first person, it must remain in first person.

3. Do not arbitrarily suggest shifts in font type, size, or characteristics. It can be done, but have a reason for doing so.

4. Do not use clichéd dialogue, unless deliberately trying to create an effect. Dialogue should have energy, just as the visual component of the story does.

Editing Text

Every letter you add to a word balloon or caption box drains space away from the art in the panel. Here are a few basic ideas for making your text more concise and even more powerful:

1. Be sure that wordy constructions like "due to the fact that" are simplified to "because" or, better, "as."

2. Try to eliminate "be" verbs—*is, am, are, was, were, be, been, being*. Instead, use active verbs. For instance, rather than saying, "That is the monster that was created by him." Simply say, "He created that monster."

3. Use contractions. Rather than saying "He will be happy I am coming." Try "He'll be happy I'm coming." Contractions are a form of *colloquialism*. They make speech sound less formal and more natural. (On the other hand, if the desire is to make a character sound more bookish and learned, say, a college professor or a minister, it might be a good idea to eliminate the character's colloquialisms.)

TEXT OR VISUAL ACTION?

Here's a reality check: most readers don't enjoy long captions and heavy dialogue balloons, no matter how well written they may be. Visuals are almost always more exciting. However, readers also want to know what's going on. Words concisely explain *why* an action is happening or put the action in some kind of context. Words clarify things. Attempting to avoid words can be as disastrous as having too many.

A balance has to be struck between too many words and not enough.

On the other hand, don't overexplain things. Nothing kills the reader's imaginative engagement with a narrative as much as always being bluntly told exactly how things are. Storytelling in pictures and words is never fully enthralling unless it stirs the reader's own creative involvement. Your job is to supply enough in the text and the images so readers will imaginatively connect the parts of the story.

If a writer attempts to pantomime an argument between characters, emphasizing gestures over the point of the argument, the writer is probably underestimating the reader's desire to know what exactly is going on.

Consider the following example. Try to imagine that the old man involved is suspected of having already murdered numerous people:

Pl. 1 — A well-meaning, grandfatherly man smiles as he hands a young man a cup of tea.

Old Man: Here you go. A nice cup of tea.

Young Man: Thanks.

Pl. 2 — The man looks concerned as he gently ushers the young man into a chair.

Old Man: Now don't let it get cold. Sit.

Pl. 3 — Extreme close-up of the cup and the liquid inside.

Old Man (off panel): It'll be good for you.

Pl. 4 — The young man gratefully drinks the tea as the old man looks on.

Pl. 5 — Close-up of the old man now with a Mona Lisa smile.

Old Man: There's no problem a good cup of tea can't fix . . .

Putting the image and the text together generates involvement. Story energy, at least in part, means engaging the reader's participation. Text, too often, becomes a thing that kills participation. Of course, at some point, the reader should learn whether assumptions about the story were or were not accurate.

No Dull Scenes

Creating energy in a scene is of paramount importance. Energy requires presenting the reader with something unexpected. Text supplies the reader with the idea of what a character wants in an abstract sense, while art reveals, in a concrete sense, what the character gets. If a character gets exactly what he expects, then for the reader, it feels as if nothing is happening in the story. A story with pretty art but not much discovery begets the comment, "The art is great, but the story sucks." By "story," most people mean the *text of the story*—the things revealed in captions, dialogue, and thoughts. The truth is, if a reader isn't enjoying the experience of the story, the art and the text have failed, no matter how well wrought either may be alone.

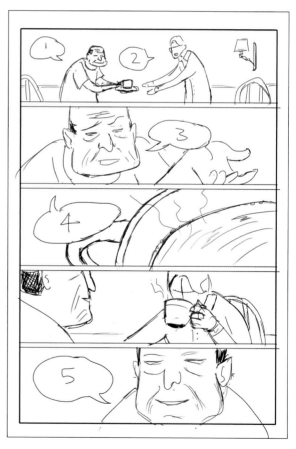

Through the juxtaposition of dialogue and images in the above example, the reader will likely draw the conclusion that something is going on beneath the surface. At no point, however, does the narrative bluntly state what is happening. The effect is to engage the reader's own imagination in the scene.

The story must have a point, and each page in the story should have a role in developing that point. It is, of course, possible for a wordless comic to have a point, but it is more challenging to provide true complexity. Action can be interesting in itself, but text places the action into a more sophisticated context. Of course, action does not always mean fight scenes, but what characters do within a panel sequence. What characters do is more interesting if it is tempered by insight into their feelings.

The Mood of the Story

Breaking the mood of the story is sometimes mistaken for creating energy. The mood or tone of a story is an intangible, but felt, aspect of writing. It involves your attitude toward a subject. That attitude is reflected in the atmosphere generated in the art, and the text you use in the story. Your attitude should be consistent. Within the scene descriptions, you can, of course, directly tell the artist that the story is tense, somber, bleak, or ridiculous. The types of situations portrayed and the *word choices* used by the characters should fall

into line with whatever mood you want to create. In the effort to create energy in the form of surprise, some writers break the tone of a story via the text. Surprises, however, should occur to the characters, not to the readers, and they should take place without breaking the mood of the story.

Consider the following script:

> Pl. 1 — Est Shot: A dark, scary-looking castle crypt with lots of cobwebs and a group of frightened girls with a flashlight—think *Charlie's Angels*. They seem to be looking for something.
>
> Girl 1: The talisman could be in any one of these crypts!
>
> SFX: Scrunch!
>
> Pl. 2 — The girl with the flashlight is shining it towards the back of the crypt, past all the scary looking figures of stone knights and lichen-encrusted lady figures lying on top of tombs, many shadows.
>
> Girl 2 (whispering): Something's moving back there . . .
>
> SFX: Scruuuuunnch!!
>
> Pl. 3 — The girls' surprised faces.
>
> Girls (all): Gasp!
>
> Pl. 4 — OTS of girls, a comical floorshow of skeletal knights and ladies in rotten dresses with arms linked doing a cancan dance.
>
> Knights and Ladies: Oh . . . we are the ghosts of Arden . . . We love to make a show! We are the ghosts of Arden . . . Please dance with us, Ho Ho!

A hero can beat up any number of characters. If, however, the only thing for the reader to understand is what is being seen, with no sense of anything more to discover, the story rapidly loses the reader's interest.

Talking Heads Syndrome

Talking heads is a derogatory way of describing a story with static characters whose sole actions consists of talking for long stretches within the story. The term comes from the idea that the panel just focuses on the characters' head shots surrounded by word balloons. In the case of a talking heads scenario, the characters should do something, if only small movements, to punctuate the dialogue. The text in the form of balloons or captions should reinforce the idea of action. The text shouldn't *be* the action. Talking heads syndrome can be eased by more organic scene consideration and better editing. Sometimes the information being told can be better conveyed via the characters' actions. Conflict should drive all text and all imagery. Too much text in a comic is often a symptom of a passive character, one who encounters conflict and fails to act.

A dramatic story can certainly have some comic relief, but if a story is edgy and filled with angst, then it feels gimmicky when something completely absurd occurs and the story abruptly shifts to parody.

SEEING AND HEARING THE STORY

Ideally, you should *hear* the story (think of the words) while simultaneously *visualizing* it (seeing the art) in your imagination. The best method for achieving this is to tie the visuals and the text together from the start. Some writers, however, create a sequence of images, then go back and fill in dialogue. Sometimes the story may actually be drawn before dialogue is added. As a rule, however, the further the visuals get from the immediate impulse of the scene, the more difficult creating the text of the story becomes.

On the other hand, some scenes with a great deal of exposition become what are called *talking heads* scenes, in which characters do nothing but relay information via dialogue

Consider the script on the next page. Because the writer is generating actions for the characters, the scene gives the reader more to pay attention to than just the conversation. A minimal amount of action livens up the scene. The action almost seems to complement the things that Alex says. Since readers want to see something happening as much as possible, the writer attempts to create some small form of action in the scene. Mary discovering that the creamer is empty and trying to get the waiter's attention generates interest that helps keep the dialogue interesting.

Pl. 1 — Mary and Alex sit at a diner having coffee. Alex is looking at his phone.

Alex: I got another text from Lana. Why does she keep texting me?

Pl. 2 — Mary leans over the counter, trying to get the waiter's attention.

Alex: I don't think she understands how I feel about this. There are reasons that I can't share the details of my business with her.

Pl. 3 — Alex sits pondering as the waiter pours fresh coffee into his cup.

Mary (off panel): Maybe you should tell her that.

Pl. 4 — Alex and Mary, as Mary reaches for the cream.

Alex: I did tell her. I don't understand why she can't understand the concept of confidentiality of clients.

Pl. 5 — Alex talks, as Mary discovers that the creamer is empty.

Alex: I can't always tell her everything, but she seems to hold that against me.

Mary (off panel): Maybe you didn't tell her the right way.

Pl. 6 — Alex talks as Mary ignores him and tries to get the waiter's attention again.

Alex: What other way is there to tell her?

A Balance of Text and Image

A well-written comics script should have a unique interplay between action and text, that which is seen and that which is read. Filling a story with action does not necessarily mean filling it with energy. Action must have context and a point in order to maintain interest. The reader has to understand what is at stake. A fight sequence can easily become dull if it is simply redundant, one the reader has seen many times in many stories. Energy means surprise—not someone leaping out of a cake, but events that are different from a thousand other stories that have come before. If the hero wins, if the hero loses, that is not a surprise. What is surprising is *how* the character wins or loses and why the character wins or loses—and what winning or losing actually means to the hero. It is virtually impossible for action alone to reveal everything that needs to be known about a character and the world in which that character exists. A comics writer has to strike a perfect balance between generating images that are intriguing and text that gives the image a purpose.

CHARACTER DYNAMICS

The word *comics* **immediately conjures up images of superheroes and** monsters. A *character*, however, can be any sentient being that appears in a story. The requirement is that the character must be capable of thoughts and (probably) emotions, even if the character turns out to be a ham sandwich or a fiery lava monster or a bunny rabbit. Characters drive narrative in comics.

< Characters come in all shapes and sizes. Characters are
 one of the most important components of any story.

BUILDING CHARACTERS

For many writers, the first ideas about a story are inspired by the *design of the characters* rather than the development of a plot. Batman, for instance, was inspired by a certain look. When Bob Kane and Bill Finger began working on the character, they drew from many things they'd seen (Zorro, Dracula, and others) and things they'd read (the works of Edgar Allen Poe, for example).

At the end of *Amazing Fantasy* #15, the comic book in which Spider-Man made his first appearance in 1960, a caption box reads: *"And a lean, silent figure slowly fades into the gathering darkness, aware at last that in this world, with great power there must also come—great responsibility!"* Ever since, the ubiquitous phrase "with great power comes great responsibility" has been connected to the realm of superheroes who struggle not just with outer threats but also with inner demons. It is implicit in the statement that no one actually wants great responsibility. It is always a burden. Responsibility always creates complexity, a dilemma, a choice

between two equally difficult paths. Characters who struggle with dilemmas are always interesting.

The range of characters portrayed in comics is huge, and "power" and "responsibility" take many forms. Every character needs some kind of power (an active desire to accomplish a goal) and some kind of responsibility (what's at stake if the character fails?). All "power," whatever it may be, is great to the character that wields it, and all "responsibility," whatever it may be, is great to the mind confronted with the consequences of failure.

Character Types

In comics, there are three basic types of characters: *round* characters, *extras*, and *flat* characters.

ROUND CHARACTERS

Round characters are active characters with desires and flaws. They are fully realized and three-dimensional. As your story progresses, the reader comes to know a great deal about these characters.

EXTRAS

Extras, on the other hand, serve no role in the story except as props, part of the scenery. They are simply the population of the world. Sometimes they are there to be horrified at whatever is threatening the world, like the citizens of Tokyo in the original *Godzilla*. *Godzilla* wouldn't be very interesting if a deserted city were being devastated by the monster.

FLAT CHARACTERS

Flat characters serve an important function in the plot, but ordinarily don't have ambitions of their own in the story. Flat characters are sometimes called *two-dimensional* or *static*. Such characters may be stereotypes in the classic sense of the word, characters that shouldn't be developed and are meant to be taken at face value. The "nosy neighbor" or the "meddling butler" are types of flat characters. Flat characters serve the purposes of commenting on the other characters in the story, conveying information, and sometimes being the object of the main character's concern. If you assign goals and desires to flat characters, your story may

The look of the character is important, but fully delineating a character doesn't simply mean drawing the character looking dynamic. In the realm of modern comics, characters usually have dimension, more than one side.

become confusing. Flat characters may have distinct personalities, but these characters do not develop, do not change, do not learn anything significantly new concerning their own personalities. When Joe Simon drew the first character sketches of Captain America in 1941, he included a note at the bottom of the drawing that, in part, read: "I think he should have a kid buddy or he'll be talking to himself all the time." Sidekicks such as Bucky were created to help clarify the motivations of the hero.

Characters that appear flat can also play off of reader expectations based around sterotypes. *Stereotype*, in dramatic terms, is any character that has been seen often enough that readers begin to form expectations as to the character's actions based on what is already known about the character from other narratives. The butler, the mother-in-law, even characters like cab drivers, policemen, and preachers may be thought of as stereotyped characters.

However, if such a character is given a secret, then that character can rise above the position of flat character. Sometimes apparently flat characters turn out to be villains or even heroes, depending on how the story is set up. You can then generate interest based on the novelty of such a character, and the revelation of the secret. The character of an accountant, for instance, is often considered a stereotype. Consider the panels below, however:

Panel 1 — A very proper-looking accountant sitting at a desk with ledgers and an adding machine.

Accountant: So you the shaper, huh? Real sweet.

Panel 2 — The accountant, we discover, is talking to a creature that looks a bit like Swamp Thing who has a set of wet, weedy tracks following it in.

Accountant: You gonna work out just fine . . . heh heh.

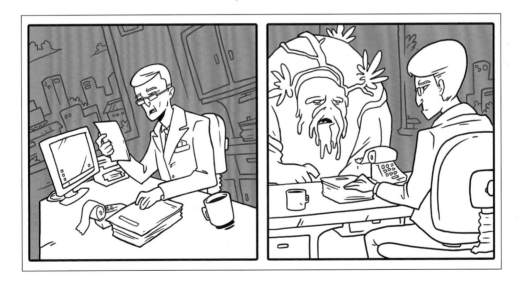

An accountant seems like a stereotypical character, but notice how the dialogue and the actions of the "accountant" create a surprisingly interesting character.

DEVELOPING THE MAIN CHARACTER

Your main character should have some kind of surprise, something hidden, something that makes the character unique and not exactly what the reader expects. The progression of the story should cause the characters to reveal their secrets. For a main character, this is essential. If a character is simply taken at face value, it flattens that character, resulting in a stereotype rather than a character that inspires empathy or interest from the reader. In the realm of writing comics, a three-dimensional character will possess the following:

- A look, including costuming, hair style, and attitude

- Outer conflict, short-term plans for the interior and/or exterior world in order to achieve a *goal* of some kind, the main thing the character wants within the story

- Inner conflict, including everything the character worries about inside, usually the thing that the character keeps secret from the world (a character's weakness is often a character's secret)

Empathy vs. Sympathy in Main Characters

Empathy implies that the reader understands the motivations of the character, why the character is doing what the character is doing. Sympathy, on the other hand, means that the reader likes the main character, roots for the main character on some level. Generally, readers empathize with villains and sympathize with heroes. The reader, however, should always understand the motivations of characters.

Main Characters Need Flaws

When creating a character, consider who the character is and what the character is most worried about. What is the worst thing that could happen to the character? The main character of most stories has some kind of weakness, often hidden. More than two thousand years ago Aristotle used the word *hamartia*, a Greek word meaning "mistake," to identify the necessity for a flaw or error in a character.

Without a flaw, the main character quickly becomes stale, dull, and redundant. The flaw a character possesses is often what the plot of a story is built around. Superman is, in fact, a prime example of an initially perfect character. With no flaws, however, the novelty of his powers quickly wears off. Superman's first major vulnerability was his feelings for Lois Lane, a flat character in the beginning. She was there for him to worry about. He couldn't be physically hurt, but she could. She created inner turmoil for Superman, as he was torn between his desire for her and his responsibility to maintain his role as Clark Kent. When Kryptonite was introduced into the comics in 1949, Superman suddenly had a direct Achilles heel. He was

In *The Illiad*, Achilles was impervious to harm, except for the famous heel.

vulnerable to its effects, and because the device humanizes Superman, it makes him a much more interesting character. Readers identify with a flawed character more than an unflawed character.

NAMING CHARACTERS

All characters should have names. It seems simple enough. Naming characters often eliminates confusion as to whom you are referring. Do not underestimate the implications of a name, however. It is the first thing the reader will understand about the character, and it ties in with all of the underlying baggage that goes along with a name. A character named Santa Claus immediately brings to mind everything that the name implies.

Naming Dos

1. Give specific names for your important characters, even if the reader never sees the name mentioned on the comics page. By avoiding generic names like Man 1 or Woman 1, you make it easier for the reader to keep up with who's who in the script.

2. You can find ideas for character names in a phone directory or through many sites online.

3. A name ought to suggest something about the personality of the character, but (usually) shouldn't be too obviously allegorical. A name like Dr. Evil certainly suggests that the character is not going to be a good person, but may be a bit obvious and probably a cliché.

Naming Don'ts

1. Do not create confusing names or pretentious spellings of ordinary names. If a character is to be called Robin, do not spell the name Robyne just because you can.

2. Avoid giving characters names that require a pronunciation guide—*Batawanakatallvkelilipatta*, for example. The names should be quick to comprehend and, hopefully, memorable.

3. Do not name all the characters something that begins with the same letter or that has the same number of syllables—Lola, Lala, and Lula. Doing so is not only annoying but also confusing.

Of course, you can break all of these rules if you have a very good reason for doing so.

CONTROLLING IDEA AND CHARACTER

Comics stories should have a controlling idea. The controlling idea is partly the writer's attitude towards the subject matter and partly the point the story is trying to make about the world. A character should connect with something that you care about. For every character that appears in your story, think through the point of the character's existence. Remember, in the real world random people appear without any particular purpose; however, stories are contrived, and if a character appears, the character must have a definite purpose. Sometimes characters are generated out of things that are already popular, but having a character just incidentally being a demon, without that aspect of the character serving any function in the story, equals poor storytelling. A character shouldn't be a demon just because the artist likes to draw demons. The reader expects demonliness to matter in the story and will be disappointed if it doesn't.

Whatever the main character wants becomes what your story is about. What the character wants is the character's *motivation*. If a character doesn't want anything in particular, then the character's motivations are poor, and the story itself will suffer. When identifying what a main character wants, don't simply say, "Trouble" or "To kick ass." Think about the character three-dimensionally. Knowing a character comes down to knowing how that character will react in a given situation. Developing lists of information about what a character's favorite food may be or what a character's favorite color may be is often useless in determining what a character will *do*. What a character *does* determines who a character is. A character's reactions are based on

how badly a character wants something and where the character's unique strengths and weaknesses are. The conflict can, of course, be interesting (dinosaurs, giant robots, or evil masterminds), but what makes a conflict sustain is that it challenges the character's hidden flaws or hamartia. No character should be defined by powers or attitudes alone, and no character should exist simply as a tour guide for a fantasy realm. The story itself should be trying to say something about the world, if only in a small way, and the characters should bring that out.

Read the excerpt from a student script below. Think about the motivations of the characters.

```
Damsel in Distress

Page 1

Panel 1 — View from the bushes of a cave with smoke coming out of it.

Panel 2 — A knight (Sir Hugh), broadsword in hands, bursts into the clearing, yelling.
He wears chain-mail armor and a round helmet. A tabard over his armor has his coat
of arms (red and white chevronny with a gold sea lion passant guardant).

Panel 3 — View from inside the cave, looking at Sir Hugh dramatically posed in the
entrance.

Sir Hugh: Fair maiden, fear no longer, for I have come to slay the beast.

Panel 4 — Switch to view of inside of cave, where Alice and a dragon glance up at
the distraction. Alice, young woman (seventeen to eighteen years old), sits next
to a dragon, pouring liquid from one bottle to another. She is short (5'3" or a bit
shorter) and has freckles. The dragon is roughly the size of a pony, but his long
neck and tail each extend several yards from his body. He wears a necklace or
collar of some sort. The cave is crowded with magical devices, potion ingredients,
chemistry-esque bottles, and a wizard's staff and hat.

Sir Hugh (off panel): . . . which holds thee captive!

Panel 5 — Alice ignores the knight and talks to the dragon while continuing to pour.
The dragon glares at Sir Hugh and shoots a puff of smoke out of his nostrils.

Alice: Odds bodkins, Ancel! Why do they always assume I want to be rescued?

SFX: snort!
```

Page 2

Panel 1 — Switch to a tavern. A bunch of men are standing around the table where Sir Hugh sits, a bowl of stew untouched as he speaks. He is out of his armor now, but still has his coat of arms on his tunic, and he has his sword on him. He is well built and fairly handsome. The men are merchant class, and thus are wearing fairly nice clothing.

Random Guy #1: So you just *left*?

Sir Hugh: What else could I do?

Panel 2 — Alice, now dressed as a guy, edges toward the group and Sir Hugh. She's cut her hair into a pageboy cut. She wears a tunic and hose. The patterned part of her dress now forms the tunic of her outfit. The merchants look amused and smug, and Sir Hugh looks annoyed.

Random Guy #2: It seems that brave Sir Hugh did run from the beast!

Sir Hugh: She did not wish to be saved! It was most . . . unnatural.

Panel 3 — Shot of Sir Hugh, waving his spoon as he talks.

Sir Hugh: She **must** be bespelled! What else would make the wench speak so unnaturally?

Panel 4 — Shot of the listeners, with Alice visible.

Alice: She could have merely been an illusion.

Random Guy #1: Indeed, what did the maiden look like?

Panel 5 — Sir Hugh waves his spoon at Alice and Random Guy #1.

Sir Hugh: I must say, she was a fair sight more beautiful than either of ye.

Panel 6 — A very tall, lanky mage is suddenly standing behind and to the side of the listeners. He wears the hat and holds the staff from the dragon's cave, and he has the same collar/necklace that the dragon wore. He wears a robe over his clothes.

Mage: Are you discussing the dragon that lives in the mountains?

Here's the essential cast of characters:

- Alice (main character?): smart-alecky assistant/apprentice/lover (?) of dragon/mage, Ancel

- Sir Hugh (antagonist?): well-meaning but not very bright knight who views dragons strictly as creatures from whom ladies (like Alice) need to be rescued

- Ancel (main character? Villain?): dragon/mage, smarter than anyone around, possessing power to transform from dragon to human and to morph in and out of places at will

- Random Guy #1 and #2: flat characters verging on becoming extras; exist to goad Sir Hugh

Damsel in Distress begins with an interesting reversal of expectation. The misguided rescuer, Sir Hugh, attempts to save Alice from a dragon. The writer knows that readers will be surprised when Alice *does not* want to be rescued. The damsel in distress is a stereotypical character and the novelty of playing against that role creates interest and sets the plot into motion. Of course, the story is obviously intended to be lightly humorous, but the plot should still place enough dramatic pressure on the characters to force them to divulge something. Without that, the characters tend to flatten out. We don't learn much about them, and the story seems less interesting.

Consider the characters of *Damsel in Distress* again.

Sir Hugh: Sir Hugh wants to rescue Alice. He apparently has no ulterior motives. The reader, however, who *is* aware that humans are motivated by greed, love, or ambition, might wonder *why* he wants to rescue her. If it's simply because that's what knights do, then he becomes a flat character rather than an antagonist. A reader can't help but wonder, *What's in it for him?* (Wondering such things is not a flaw of the reader.) The reader must suppose that Sir Hugh is the kind of character who would naturally step in and help in such a situation, wanting nothing in return. In the tavern, however, he wants approval, but trying to get it makes him seem goofy, as if he doesn't have any special motivations. Without knowing his motivations, it's tough to empathize with the character.

Alice: Alice, the apparent protagonist, seems to want only to be left alone. Alice wonders, *Why do they always assume I want to be rescued?* The word "they" implies that there have been other attempts. She seems bored and annoyed with Sir Hugh. She obviously must be someone of importance if knights keep trying to rescue her. How did she end up with the dragon? What is her relationship with Ancel? It is worth noting that the dragon never shows her any particular affection. Did she seek him out because he's the best at science or perhaps alchemy, and she wants to learn such things? By the end of the story, she has become a sidekick, Watson to Ancel's Holmes.

The first rule of protagonists is that they must want something in particular. Alice's motivations aren't clear. In fact, Alice does not initiate any activity. She only reacts—first to Sir Hugh, then to Ancel. She is a passive character. A passive character would have a difficult time sustaining the reader's interest.

Ancel: Of all the characters in the narrative, the reader knows the least about Ancel. Ancel appears to be a very powerful character who can transform from dragon to human (or perhaps into any shape he chooses) at will. It is not clear what he's working at there in the cave or what his relationship with Alice is. Ancel already seems to have everything he wants. Ancel does not appear to have any secrets that he is trying to conceal and shows no evidence of an Achilles' heel.

The story setup has a great deal of potential, but unless the characters develop by revealing what it is that they want, then the narrative will to wander, relying on changes of location and magic to hold the reader's interest. None of the characters have any particular responsibility. With some motivational modifications, however, the story could potentially be much stronger: (1) *What if Ancel were removed from the story and Alice alone dealt with a more highly motivated Sir Hugh* (the teenaged science student against the combat-hardened knight), or (2) *What if Alice really wants to get away from Ancel but can't because of whatever her amazing secret might be*, or (3) *What if Alice really wants to test the boundaries of Ancel's affection for her (or possibly Hugh's desire to rescue her)?* It is never clear what the consequences of failure may be for the characters in the story. There doesn't seem to be any real motivation for Alice or Ancel to turn up at the tavern, since they've already won.

Consider the following revision of the first page of the script that attempts to reveal the characters' motivations a bit more by generating more definite wants and responsibilities:

Damsel in Distress

Page 1

Panel 1 — Sir Hugh, an elderly knight, in chain-mail armor and a round helmet, broadsword in hand, bursts into the clearing in front of a cave, yelling. Smoke wafts out of the cave entrance. Maybe some skeletons and skulls with armor are scattered around for good measure.

Sir Hugh: Dragon or devil, I, Sir Hugh, challenge thee! Release the girl!

Panel 2 — View from inside the cave, looking at Sir Hugh dramatically posed in the entrance. Two silhouetted heads in immediate foreground.

Sir Hugh: Fair princess, fear no more. Your father, the king, sent me to slay the beast . . .

Panel 3 — Switch to view of inside of cave, where Alice and a dragon glance up at the distraction. Alice, a young woman (seventeen to eighteen years old) is sitting next to a dragon, pouring liquid from one bottle to another. She is short (5'3"" or a bit shorter) and has freckles. The dragon is roughly the size of a pony, but his long neck and tail each extend several yards from his body. He wears a necklace or collar of some sort. The cave is crowded with magical devices, potion ingredients, chemistry-esque bottles, and a wizard's staff and hat.

Sir Hugh (off panel): . . . that holds thee captive!

Panel 4 — Alice ignores the knight and talks to the dragon while continuing to pour.

Alice: Odds bodkins, Ancel! He sent another one! / You must think I'm a terrible apprentice.

SFX: snort!

Panel 5 — Alice walking toward the entrance of the cave.

Alice: Wait. I'll get rid of him.

Silhouettes create a little more mystery as to who the characters may be, building suspense.

This statement provides a clue that her father is someone important.

Here Alice clarifies her relationship with the dragon.

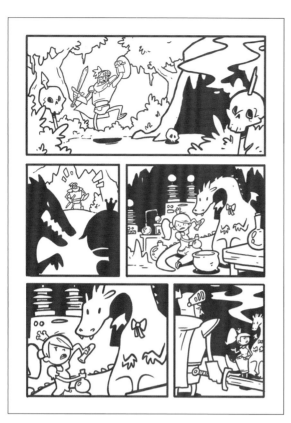

The artist clearly picks up on the humorous aspects of the story and creates a look for the characters that accentuates those aspects of the story.

The revision creates characters whose actions and dialogue eliminates some of the ambiguity about what kind of characters they are. It's strongly hinted at here that Sir Hugh has a greater sense of responsibility, as he has been sent by her father, the king. The reader gets a better idea as to what Alice wants: instruction from Ancel. If Alice is to be the main character, she needs some kind of weakness. It could be that she really loves her father. If Sir Hugh brings news that he's ill, then she might be compelled to return with him. Of course, Sir Hugh could be lying. Or maybe her father has died and she faces the dilemma of becoming queen or remaining to study with Ancel. The story could go in many directions, depending on how those aspects of the character are handled. As the characters' wants and shortcomings are defined with more clarity, the story feels more interesting.

Getting to Know Your Characters

Write about people that you know—or would like to know. Any character that you do not understand will become a *flat* character. The problem with using characters that you have only "met" in video games, movies, books, and television shows is that they start out flat and only get flatter as you struggle to push them into a plot. When you use these characters in stories, their two-dimensional qualities are magnified because you don't understand any of the *secrets* that are relevant to the storyline. The limitations of a character are one of the most important points to know about them. Sometimes those are only developed as the story goes along. It has often been said that writing about a character is one of the best ways to get to know him or her. As the demands of the plot push the character into taking greater risks, the writer must make decisions about the character's willpower, strength, likes, and dislikes. In effect, the writer gets to know who the character really is.

Character as Component, Not as Literary Device

The character and the plot of the story need to be organically connected. Once the character begins dictating the direction of the story, the controlling idea gets out of the writer's hands. This can be dangerous. The characters must be part of the controlling idea, not dictating the controlling idea. Students often tell me, "But my character wouldn't do that!" Given the right circumstances, however, a character may do something risky or downright crazy. The real question is "*Could* the character do that?" The characters in a story, especially the main character, should *feel* pressure as the plot builds. Remember that most of a character is hidden, only brought out by the circumstances of the plot. The plot should test the character, forcing the character to do something surprising.

Of course, the character should take the plot to the conclusion your story was intended to deliver, but not by following the actions that seem most obvious. The conclusion of the story and the nature of the character should work together. A character should have a secret that prevents the character from doing what might appear to be obvious to all the ordinary people on Earth or from dealing with results in the way that might seem obvious.

Comics Are Not Video Games

Video game characters and story characters serve different functions. These days, video games have gotten much more sophisticated than in years past; however, the characters involved in video gaming are designed to be conducive to playing the game. There's nothing wrong with that, but it doesn't work so well in narrative that is created for the sake of reading. Gaming characters tend to exist in order to place the player in the game. A player is not going to be terribly surprised at what a character does. The game presents scenarios that challenge the player in the outside world, not so much the characters in the game. That is the nature of gaming. In stories, the opposite is the case. Characters in the gaming world are, by nature, flat. It is up to the player to make them otherwise. When writers are inspired by the gaming world, the characters they create have a tendency to flatten out. Comics writers can certainly be inspired by the characters in video games, but in a story, the character's inner life needs to be developed as well as the character's outer conflicts. The character needs to feel independent of the reader. There is, of course, a need for skilled writers within the realm of electronic gaming, but that is a different discipline from writing for comics.

In the gaming world, characters are extensions of the player, though playing itself may necessitate understanding certain character motivations.

Comics Characters Aren't Movie Actors

Another important aspect of comics characters is that they do not move and do not literally sound like anything. Everything about a character is presented in a frozen moment, and all of the dialogue is in the form of text. It's hard to draw a character experiencing a "bittersweet" emotion or a rapid sequence of quickly changing emotions. The story should provide room for characters to react. Whatever emotions a character possesses are limited by what art itself and the talent of the artist can reveal.

> Panel 1 — Aaron, a thirty-something dad, gives a *ta da* flourish as he presents Jenny, a nine-year-old girl, with a new bicycle. It has a big bow on it.
>
> Aaron: Happy Birthday, Jenny.
>
> Panel 2 — Jenny is shocked, her jaw is hanging open.
>
> Jenny: For me?
>
> Panel 3 — Jenny smiles brightly at the new bicycle.
>
> Panel 4 — Jenny's smile fades.
>
> Panel 5 — Jenny stares blankly at the bike.
>
> Jenny: I haven't ridden since the accident.
>
> Panel 6 — Jenny starts to cry.

ART AND CHARACTER DEVELOPMENT

Comics is a visual medium, which leans heavily on the look of the characters. This helps to foster the feeling that a character need only provide a certain look for the story. The *look* of a character is hugely important in comics, but looks alone will not carry a story. Comics characters, no matter who they are, are not simply placeholders for interesting actions. The characters, even if they are part of a gag comic strip, are what the story is mainly about. What the character looks like is important, but it should be only *part* of who the character really is, even if the character is a Smurf.

The changing emotions on Jenny's face require an entire page to develop.

Characters Make the Story

Obviously, creating characters that are believable and capable of driving the narrative is one of the most important jobs of the writer. Characters may drive the story, or the story may be initiated based on the plot idea and the concept. In either case, characters must be convincing and appropriate to the story. Even when the concept involves dinosaurs, giant robots, or superpowers, characters are still important.

All stories are about characters in one form or another. Writing comics involves understanding who characters are, what their motivations may be, what they are capable of, and what their weaknesses are. For a comics writer, the extra dimension of art is an additional consideration. The look of a character is important. A cartoony, heavily caricatured character rendered with big feet and a big nose is humorous and doesn't inspire worry about the outcome of the story. Of course, such a character, given the right set of circumstances, can invoke an uneasy sense that something grotesque is going on, the way Robert Crumb's characters often do. It's almost impossible to create a story without confronting all the possibilities for your characters.

Genre Characters

Particular genres set up expectations as to what characters will look like and how they will behave. A writer has to create with an awareness of those expectations.

A detective story must have a detective, a superhero story must have a superhero, a romantic comedy must have lovers. Readers already have a set of expectations about how those characters are supposed to behave, making writing genre fiction challenging. Writers who are successful at genre fiction understand the genre thoroughly and know how to manipulate reader expectations within the genre, giving the reader something new by bending the rules without breaking them.

Just because a character is a genre character doesn't mean that the character must become a cliché. George Romero may have invented zombies in the film *Night of the Living Dead*, but Robert Kirkman successfully reinvented them in *The Walking Dead* comic series in 2003. In an interview with John Dewar of *Inside New York* (an online entertainment magazine) in 2013, Kirkman talks about his inspirations for the series. According to Kirkman, "Zombie movies end one of two ways: either all the characters die or most of the characters die and the few that live ride off into the sunset. . . . I always wondered where those people went, how they continued to survive, find food, get water, protect each other, and be able to deal with the zombie threat long term for years and years."

The characters in Kirkman's comic book series (and the television series of the same title) may exist within the horror genre—more specifically, the zombie genre—but Kirkman uses those types to explore the reality they would face in a world where zombies were not an aberration but a constant fact. In other words, he explores those characters as fully three-dimensional characters, not stereotypes.

WORLD BUILDING: PROPS, STRUCTURES, AND ATTITUDES

The physical world of a comics story can be that of a planet in another galaxy, the bottom of the ocean, or the frozen tundra of Siberia as easily as it can be an ordinary living room. As the writer, however, you have to not only think of these elements, but also consider their impact on your story.

< The world of your story does not have to be reality, but for most stories it needs to have consistency just as if it were reality.

SETTING SHAPES NARRATIVE

Stories tend to be stronger and more memorable when the setting affects the conflict of the characters. In other words, the story could only happen in this particular environment and possibly *because* of this environment. Conflict in a character can either be internal or external, but it arises when a character's desires come into conflict with the world of the story. You can divide setting in a story into various categories:

- The physical world of the story (buildings, cars, clothing, air, water, earth, and maybe fire)

- The historical setting of the story (and the length of time that elapses for the characters in the telling of the story)

- The social and cultural atmosphere of the story, including the customs, laws, and religion that govern the world

- The *look* of the world and the *style* of the art to be used (any aspect unique to comics itself—because the story is drawn, not written in prose or photographed, a style must be selected)

The mood of a story is greatly affected by how the world of the story is drawn.

THE PHYSICAL WORLD

Every item that appears in the background of a comics story is a *conscious* choice. Nothing happens accidentally. The world of the characters only exists because the artist put effort into drawing the things that appear there. The writer should consider the background as potentially having a major effect on the story. A great deal of what happens in a story can be shaped by carefully juxtaposing character with setting. Taking a character out of usual, comfortable surroundings and placing that character in an unfamiliar and hostile world is a story device used frequently.

A writer can supply pictures to the artist as reference material for the physical aspects of the story. You can do this for any story, but it is especially needed where the costumes and weapons of a specific historical period or fantasy realm are concerned. For example, if you want the artist to distinguish between a World War II vintage B-17 as opposed to a B-29, it is acceptable for you to include some images of the relevant aircraft with your script. No artist ever complains about receiving images from a writer. Do not, however, expect the artist to use the images as anything more than a springboard for sketches and further research.

Characters who complain about being poor while existing in a lush world with fruit hanging from every tree and fish jumping in the streams seem comical. If the characters' problems exist apart from the setting, the story feels unconvincing.

THE HISTORICAL SETTING

A story has to have a *time frame*, a historical period in which it is set—*even if it is set in a fantasy realm.* Fantasy stories have to have a consistent set of laws. It is certainly possible to have technology (props) from various time periods present within a fantasy story. Gotham City, for instance, is an alternate reality, but it has its own history and set of rules. For the most part, it's not so different from the world with which the reader is already familiar. In *Dark Knight Returns (DKR)*, however, Frank Miller establishes a Gotham City in which the media, specifically television, is the supreme source of influence and information for all citizens. Batman himself is characterized as aging, past his prime, out of touch with new styles of entertainment and the apparent degeneration of society. The setting of *DKR* plays an important role in the story, especially as it seems to carry part of the controlling idea behind the story—media out of control. The alternate universe created is concrete, consistent, and has an impact on the story. The period and society in which the story takes place must be clear in your mind as you write.

Length of Time Actually Covered in the Story

A story can be about the entire history of the world or the life cycle of a flea. The amount of time that is supposed to elapse in your story needs to be part of your plan. You must also be consistent about the ages of characters, how long characters spend in a given place, and how long characters have known each other. These parts of the story can become confusing, especially if you skip around a great deal with flashbacks or flash-forwards.

Elapsed-Time Conundrum

Confused readers are unhappy readers. Keep a notebook with timelines for when characters did certain things in your story and be sure that spontaneous story edits don't lead to contradictions.

In comics, there is no such thing as a quick jump in time. All edits are done in panels, and each panel generates more or less the same time lapse, unless some extraordinary measure is taken, for example, giving the panel cloudlike borders—a technique that feels gimmicky to many artists. Time confusion in a story is most often created unintentionally by glitches in editing and conflicting thoughts within the mind of the writer. It is easy to lose track of when things happen in relation to one another. When multiple events are happening within a short time of each other, and especially when they are part of the *action syllogism* (one action causes the other), you must make the time relationship clear to the reader. Problems can be solved by careful editing and revision.

How long, for example, does it take for a character living in the fifteenth century to sail around the Cape of Good Hope in a Spanish galleon to reach India? Using technology from the 1400s, the journey could take weeks or months—potentially years. When the character arrives, time should have passed.

The script should stress the fact that a character on a long voyage has aged considerably along the way, if the story is dealing with consistent reality.

You can often portray the passage of time in an outward physical manifestation. Maybe show that a man, for instance, has grown a beard, or lost weight, or (if enough time has passed) has gotten gray hair and wrinkles. If a character doesn't age, that could become a plot point; maybe the character is immortal. Superheroes were once exempt from aging, though in *Dark Knight Returns*, as noted on page 105, the details of Batman's age become a major plot point in the story.

THE SOCIAL AND CULTURAL ATMOSPHERE

You should also consider what the people of the world *think* about. The laws, customs, religion, and rituals of the world impact characters. You may need to clarify that one social group may have different customs than another. Today, for instance, Japanese society has a different set of customs than American society, and American writers and artists who attempt to create stories with a Japanese setting often fail to understand the *culture* behind the *look* of those stories. The same holds true for writers creating fantasy stories. Characters seldom exist apart from a culture. The details of social mores can be an excellent springboard for a story idea.

In the backdrop of any story, consider some of these basic ideas:

- Religion: Do the people of this world have any specific beliefs in gods or supernatural forces? How much do their beliefs impact their lives?

- Laws: What kind of laws do the characters abide by? Are there strict rules and harsh penalties for violators? Or is the world a lawless place where the weak are at the mercy of the strong? Laws are usually a part of the state or government, or lack thereof.

- Customs: What are the traditional ways things are done? Is there an older generation in this world that disagrees with the ways of the young?

- Manners: What is considered polite, rude, or downright obnoxious in this world?

- Values: What does this society think is worthwhile? Money? Physical beauty? Art? Intellect? Strength?

- Gender roles: Does the society have different expectations for males versus females? How are marriages made? How are children raised?

Research may be required, not just to depict the physical world of the story, but to understand the sensibility of the world as well. The devil is in the details, but great stories are generated based on details. If a story is supposed to be set in the Roman Empire, one naturally imagines that the characters *behave* accordingly. The characters' actions, speech, and sensibilities should be in keeping with the Roman chariots and the throng of people watching, say, the gladiatorial match at the Coliseum. The characters may speak English, for instance, but the moment the character says something that runs contrary to what the reader instinctively perceives to be a Roman sensibility, the illusion is broken and the story loses some credibility or becomes farce. Quite often the details of the social setting are exactly what the story ends up being about. In a world, for instance, where all marriages are arranged, a character who refuses to go along with that custom will endure conflict that may become the basis for a story.

REALITY, CARTOONS, AND ART STYLE

You may also think of the art style as part of the setting. Kurt Vonnegut once said that writers should write as if they are telling the story to someone in particular. A comics writer should first tell the story to the artist who will draw the story. The reason for that is that the style of the art may have a huge impact on the story itself. Consider the art style when visualizing the page. The style of art must fit your story. There is a huge difference, for instance, between the characters created by Sergio Aragonés and those created by Geof Darrow. The stories created by and for these artists are much different. You will also do a better job of creating the script if you know for whom you are writing.

The Reader and the Setting

The reader doesn't have to spend time thinking about the setting. The setting should be functional and should seem natural for the characters in the story. If the reader doesn't understand every detail of the setting, that's okay—as long as the characters in the story do. For instance, in *Sin City*, Frank Miller creates a world of gangs and prostitutes where terrible things routinely happen. The world has its own rules and all of the people living in that world are well aware of what the rules are. They only talk about the rules, however, when it is absolutely necessary. The reader understands the rules by the way the characters behave. The reader feels an edgy discomfort as serial killers and drug lords do things that don't much surprise the hard-boiled people living in that world, but may be foreign to the reader's personal world. The reader accepts the world of the story because the world is consistent and the characters react to it consistently.

Mise-en-scène

The term *mise-en-scène* derives from the stage. The term is French and it translates as "placing on stage." It refers to the way scenery is placed or used on stage. The term is also used in film to refer to just about anything that contributes to the look of the background or the characters, including costuming and the way the camera moves through the scene. The term also applies to comics. Certain types of settings create expectations in the reader. If a character pulls out a knife in a dingy alley, the reader anticipates some sinister use for the knife. If, on the other hand, a knife is picked up in a barnyard with a flock of geese in the background, the reader may have an entirely different set of expectations. Comics writers who understand how readers react to certain types of scenery can play off of the scenery and twist reader expectations.

Having an idea not just of the character description but also of the way the character should be rendered is important in comics. It influences the way the reader takes the story. What is funny for a cartoony character may seem frightening for a realistically rendered character.

Consider the following excerpt from *Dust* by
Eryk Donovan. Notice how the world of the story
is carefully connected to the plot.

Page 4

Panel 1 — Ford holds up a dirty plastic bottle filled with brown water as Erving
looks on in awe.

Ford: It's not often we get rain. Dad said we always collect the rain, and test
it for isotopes.

Ford: Maybe today it'll be clean.

Panel 2 — Erving frowns and crosses his arms, looking away from Ford, deciding he
doesn't care.

Erv: Yeah, well, Dad's dead and you left without telling me. It was scary.

Panel 3 — Ford looks genuinely concerned now, and kneels down next to Erving,
putting his hand on his shoulder.

Ford: Hey, I'm sorry, bud. I should have left a note.

Ford: I won't do it again 'kay?

Erv: Okay.

Panel 4 — Ford stands up and pulls some keys from under his dusty poncho as he
walks toward the pumping facility door.

Ford: If you help me test this out, I'll make you a sandwich!

Panel 5 — Erving looks pleased.

Erv: Sure! Can it have cheese on it?

The characters do not have to talk about what their world is because they fully understand it. Clues are given so the
reader knows that it is not an ordinary world. It's obvious that water is a major problem here.

The reference to a sandwich signifies that the food of this world has something very familiar about it. It is not so far
from our own world.

In an unfamiliar world, such as the postapocalyptic world of *Dust*, pains must be taken to ensure that the reader understands the nature of the world and how it affects the relationships among the characters.

The style of art can be instantly seen to fit the story. If the characters were caricatures and less realistic, the story would create a confusing disparity between subject matter and the image portrayed.

Page 5

Panel 1 — Inside the dimly lit pumping facility. FORD sits in a metal chair before a table filled with chemistry apparatus, testing the rainwater. ERVING sits on a metal crate near him, munching on a sandwich and looking on. A makeshift bunk bed sits in a corner near a battered wardrobe. Over the top of the wardrobe, a rifle hangs against the wall. The room is filled with pipes, valves, and pressure readers and other sorts of water machinery. This is a one-of-a-kind water pumping facility, built by Ford's father, and now cared for by his two sons.

Erv: Ford, why do we test the rainwater?

Erv: Don't we have all the water we want right here?

The fact that it is a "one-of-a-kind" facility should be included in the dialogue below somehow. There is no way to know that just through the art.

continued

```
Panel 2 — Erv bites into his sandwich.

Panel 3 — Ford fiddles with some of the water testing apparatus, jotting down notes
in an ancient black leather ledger.

Ford: When the bombs went off, water everywhere was poisoned.

Ford: Most water isn't like the water we have here, Erv.

Panel 4 — Erving grins widely as he talks with a mouth full of sandwich.

Erv: Yeah, 'cuz Dad was smart!

Panel 5 — Ford looks at Erving seriously, putting down his pen.

Ford: Dad was more than smart, Erv. He was a genius.
```

The discussion here is largely exposition, but is necessary in order to understand the world of the characters. It would be too difficult to show this part of the story without resorting to distracting flashbacks or backstory.

The world of the story establishes what the characters are up against—problems with water. The reader instinctively understands that, without water, life ceases.

The world of the story is more than just looks. *Dust* falls into a category of storytelling known as "postapocalyptic," conjuring up stories such as *Xenoxoic Tales*, *Tank Girl*, *DMZ*, *Astro City*, or *Y: The Last Man*. These stories are ultimately never just about survival, but center around characters altered by their changed worlds. *Dust* hints at a certain social order in a futuristic world. The social setting ties in with values that the reader can identify. If the environment of a story, however, is so far removed from the reader that relationships between the characters can't be logically understood, then the story is in trouble.

THE BACKSTORY BLUES

Nobody loves backstory—except for the writer. It can be very useful for a writer to sit down and actually work through the details involving the rules of the world in which the character exists. In the complex graphic novel *Daytripper* by Fábio Moon and Gabriel Bá, a variety of scenarios of life and death repeat against different backdrops, all concerning the same character. The story is set in Brazil, and the reader understands that the character is the same person with the same basic backstory. The backstory in Moon and Bá's novel is vital to understanding the character's reactions in each instance, but it is woven carefully into the narrative. The reader retains it without realizing that it is happening. Here's a general list of things that you might consider backstory:

- The character's past, including past relationships, connections with other characters, family history, incidences of cowardice or bravery, and so on

- The history of the society, including plagues, earthquakes, wars, religious upheavals, political intrigues, laws, and important news items

- Details of technology (or the lack thereof) or changes in technology, including weaponry, vehicles, gadgets, and newfangled things that people don't know how to operate yet

- Physical aspects of the world, for instance, people breathe methane here, the ocean has monsters in it, there is a neighboring enemy country a few miles away that has spies and is always scheming, and so on

Often these things need to be understood or set up in order for the narrative to make sense. Getting the information across to the reader is always tricky. Most readers don't have lots of patience for explanations because they interrupt the momentum of the narrative. Here are a few basic rules for providing backstory information:

- Characters should have a logical and compelling reason for discussing it. Avoid having characters explain things to each other about the world of the story strictly for the reader's benefit.

- Only give information to the reader at the time the reader needs it, or to set up something that will happen later. Avoid a wholesale essay about what the world is like in the form of a caption or a long speech by a character.

- Any time characters must flat out tell the reader what the world is like, have the characters do something interesting while they give the information, rather than using a talking heads scenario (see page 86).

- As much as possible, have the characters' actions and reactions relate the kind of world the story takes place in.

If pointless information is given, and especially given in the wrong way, the reader can get rapidly bored or confused. If not enough information about the world of the story is supplied, the reader may be left wondering what all the fuss is about. You should always step back from the story and put yourself in the reader's shoes in order to gauge whether or not you're conveying the right amount of information at the right time.

Backstory vs. Subtext

Subtext means things understood without being spoken. Most of the time it isn't necessary to explain how a character feels. Unless the character doesn't have ordinary human reactions to the world (whether or not the character is a human), those aspects of the story can be implied. Characters are more interesting if they don't say exactly what they are thinking. Here is a list of things that might be better left to the subtext of a situation:

- Feelings: If a character is betrayed, for instance, the character doesn't have to state that she is hurt. The reader instinctively understands as much.

- Desires: If a character wants to rule the world, he probably doesn't tell everyone about it. Often characters lie about what they want, or don't realize what they want.

- Actions: Character A may stand up for character B when character B is not around, but will deny it later. Or character A may have great faith in character B's ability or intellect, but may not say so. Or character A stabs character B in the back, but smiles to character B's face.

Subtext tends to sharpen the reader's interest in the story and lends the characters a natural feeling of complexity. Subtext can be thought of as implied backstory.

Consider the following script. How much backstory is implied?

Subject D

Page 1

Panel 1 — Interior shot, the inside of a small square "room" (the back inside of a large trailer van). Two scientists work in this tightly enclosed area. Claude; a man in his late 30s, brown hair slicked back over his head, large glasses and wearing white gloves, white pants, and a long white lab coat. Devin; a younger, shorter man with dark curly hair under a white hat and black sleeves sticking out from under a white lab vest. Computers and displays, counters, video equipment, random tools, etc., line the walls of the room. The two are not sloppy, but due to space constraints a general messiness has occurred. Claude sits at a rolling chair in front of a computer with multiple monitors; we can only see him from behind. Devin looks into a large locker/refrigerator, leaning on it with his hands and an entranced expression—we cannot see what lies inside.

Caption: First test run with subject D. Operation quarters are . . . less than comfortable.

Devin: Yes, I . . . / . . . I can't wait to see her in action . . . / . . . after so much work . . .

Claude: Huh.

Panel 2 — View of the freezer, all-glass front, that Devin looks into. Devin's hands pressed against it are clearly seen in the bottom left and right corners of the panel. In the middle bottom, the man's breath against the glass is apparent. Inside of the freezer stands a girl, "Subject D," in her mid-20s. She looks like a corpse; eyes closed, face expressionless, completely pale, dark circles around her eyes, rather gaunt. She wears rather revealing clothing: boots up to her knees, very short shorts, gloves that go up to her mid-biceps and attach with straps to a collar around her neck. The only thing covering her breasts are rectangular strips that literally stick

The scene description is lengthy, but it sets up the slick, sci-fi nature of the story. We can assume that these guys are in the midst of some kind of experiment, and probably backed by some large corporation or government, though none of that is explicitly stated.

onto her like opaque tape. Her hair falls dark and wild, framing her face while a large braided ponytail comes to between her ankles.

Devin: If this works—think of what *else* she could do . . .

Panel 3 — Shot of Claude looking over his shoulder at Devin angrily. The computer monitor behind him shows a window full of programming text.

Claude: Get away from there—I'm going to boot her. / You're sick, you know.

Panel 4 — Devin takes a step back from the freezer, raising his hands in front of him as if to say "I give up." He grins slyly.

Devin: I'm just lovesick. / You think it'll work?

Panel 5 — Claude looks back to the computer, typing on the keyboard; still upset.

Claude: It better. / You know how they're on our case . . . / if we don't show progress soon . . .

Panel 6 — Insert of Claude hitting a large extra button on his keyboard; located above the number pad.

SFX: click

Panel 7 — Extreme close-up on Subject D's eyes, opening. They glow a very light color, and would almost look blind if not for the very dark ring around the iris.

The hair that hangs to her ankles feels odd, given that she ultimately proves to be a fighting-bot. Could the hair contain a weapon—razor sharp knives that she can swing with a flick of her head? It almost feels that, given the practicality evident in Claude, some comment might be in order here.

The two guys, socially, inhabit a familiar world. Devin reacts to the android girl in a predictable way. The story reveals the contrast of high-tech sci-fi set against the very low-tech impulses of the guys.

The lingo here suggests that the characters are likely not doing this for the first time. The subtext suggests that Subjects A–C might not have been successful.

The sci-fi, futuristic aspects of *Subject D* come through in the backgrounds here that are packed with scientific equipment. The casual attitude of the scientists suggests that they have done this sort of work before.

Using Mood and Atmosphere

Manipulating the backdrop of the story means manipulating the mood of the story. By strategically placing items in the backdrop of your story, or by highlighting them, you can manipulate the reader's set of associations. Comics writers should also consider how the setting affects the reader's reaction to characters. Many beginning writers look for a setting that has lots of sensation, but more experienced writers often manipulate the reader's reactions by juxtaposing the action of the story with the backdrop.

Consider the use of a somewhat banal setting in the story below:

```
Running Girl

By Phil Sevy

Page 1

Panel 1 — A woman's feet run down the sidewalk.

Panel 2 — The running woman, young and pretty, listens to music through her
earbuds—an ornate hairpin keeping her hair pulled up and in a bun. Loose strands
fly in the wind.

Panel 3 — She stops next to a drinking fountain beside a kid's jungle gym.

Panel 4 — As she bends down to get a drink, we can see a smarmy-looking man in
a white suit sitting on a nearby park bench.

Panel 5 — He walks over and offers her a bottle of Gatorade. She looks up from her
fountain and smiles.

Man: This might work better.
```

Feet on a sidewalk couldn't be more ordinary. The fact that the reader doesn't see the whole woman might suggest some kind of mystery.

A hairpin that will be vital later is established (set up) early on. Again, it suggests something mysterious about the woman.

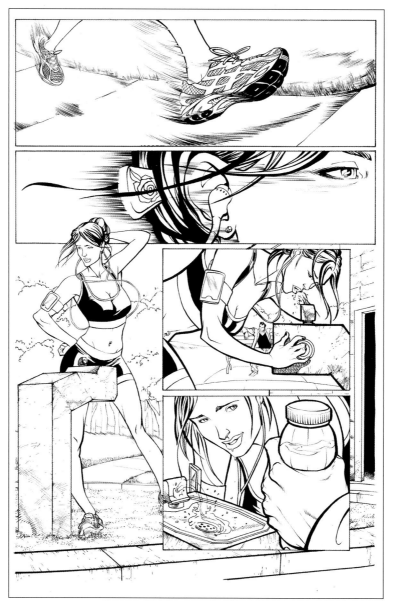

Since the world shown in the art is ordinary, the danger that will be revealed is even more interesting.

The introduction to the story is set in an ordinary park. Hints that things are not going to be ordinary are found in some of the shot choices (running feet) and objects that are highlighted (the ornate hairpin). When the woman, in the next couple of pages, proves to be a killer with a knife hidden in her hair pin, it is surprising but, on reflection, not without some element of setup.

If the story were set in a back alley or a dingy, haunted house, the events of the story would already be projected into the reader's mind.

SETTING AS SYMBOL

A *symbol* is any part of the world of the story that takes on a meaning greater than the thing itself. Readers understand symbolism on a subliminal level. I don't recommend that any writer consciously try to think up a symbol. Symbolism occurs when the writer's absorption into the world of the story has become so complete that she figuratively connects parts of that greater world of the plot with parts of the lesser world of props and structures. When the controlling idea fully engages with the execution of

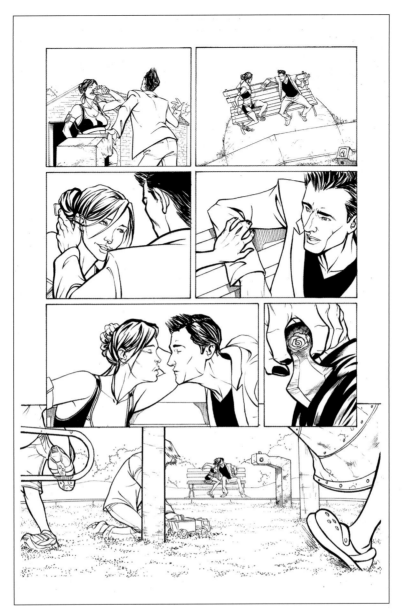

The setting of the park and the people exercising there are probably familiar to most people. Since only ordinary things usually happen there, it is purposefully disconcerting when the woman begins to pull a knife out of her hair.

the story, symbolism becomes possible, and even likely. It happens as the writer works and reworks the story. If the writer happens to notice, then she may try to push the symbol a little more by looking for opportunities to bring it out in the story.

Public Symbols vs. Private Symbols

Public symbols are those that are obvious. They have existed for so long that many have lost the association with whatever concrete reason they may have for the emotional connection they produce. Colors are an obvious example of this type of symbol.

Red, for instance, symbolizes danger, passion, love, warmth, or possibly anger. There's a reason that fire trucks and ambulances are red and have flashing red lights. It probably all connects with the idea that blood is red, but most people don't think about that when they see the color.

Certain emblems are also instantly recognizable. A swastika, for instance, is forever associated with all of the Nazi atrocities in World War II. The recipe for an evil villian is often simple: give the villain a swastika armband. This occurs in Indiana Jones movies and Hellboy comics. Such symbols carry deep connections with things most of us have been seeing

all of our lives. There are too many public symbols to attempt to account for them all. They can be powerful emblems in visual storytelling.

Probably more interesting to comics storytellers are private symbols, or things that only take on meaning within the context of a story. There are four important ways that this can occur in comics: (1) motifs, (2) associative symbols, (3) correlative connections, and (4) visual similes and visual metaphors.

Motifs

A *motif* is simply a repeated pattern. In comics, motifs can be created in a number of ways: lighting, colors, words, even panel arrangements. A comic book with lots of open panels tends to give a feeling of open spaces, while one with tight panel grids gives a closed in, perhaps even claustrophobic feeling to the story. Chris Ware's *Jimmy Corrigan* sometimes repeats colors, patterns, and graphic panel layouts. The effect is monotony that is suggestive of the tedium his characters tend to face.

Associative Symbols

Associative symbols are created when a certain object or idea is always connected with a particular character or situation. The object, in effect, becomes that person, so that whenever it appears, the reader thinks of that person. Sherlock Holmes's deerstalker hat and pipe are so closely connected to Holmes that they conjure up all of the feelings that Holmes himself does. Associative symbols are also connected to events or time periods. In *Watchmen*, the smiley face button worn by the Comedian connects to who he is. Alan Moore's story ties the Comedian with the vacuous smiley face itself. The smiley face had become something of a public symbol in the 1980s as emblematic of the sterility of emotion and lack of honesty connected with the mindless smile.

Correlative Connections

Correlative connections are created by juxtaposing images or situations. The last thing seen affects how the reader sees the next thing shown. This concept is especially interesting in comics storytelling. Comics readers do not think one panel at a time, seeing the next and forgetting the last. In comics, readers visually cross-reference scenes. The eye moves back and forth between the panels. Visual images make powerful memories. If a man is shown eating a steak immediately after the reader has witnessed a bloody massacre, the reader will naturally connect the two images (to the detriment of the steak). If a character is shown feeding a goldfish, and then immediately thereafter feeding a family, the reader will tend to make a connection between the family and the fish. Of course, what this might mean depends on the context of the scene.

Visual Similes and Visual Metaphors

Similes and *metaphors* are simply comparisons. In prose writing, a simile is characterized by the word *like* or *as*, and a metaphor more directly states that one thing actually is another. For example, "She eats like a horse" or "He's a real bear."

In comics, this relates to the portrayal of scenes. For example, a simile might be created by showing a group of old people in a nursing home having a birthday party with hats and cake and games, making them look like a group of children. The image lends a certain poignancy to the event. The reader will see the hats, cake, and games and correlate that with a scene normally associated with children. On the other hand, if the old people become different people when they put on the hats, if they begin to frolic like spring chickens, eat cake, play games, dance, sing, pin the tail on the donkey, then they have *become* children—except they are still old people. In the first case, the idea is simply suggested to the reader; in the second, at least while it lasts, it becomes true. The distinction ultimately isn't that important, only the impact such scenes will have on the reader is important.

What's So Great about Symbols?

There is no law that says a writer must create a symbol. In fact, whether or not something actually is a symbol in a story may be debatable. If, however, you consciously manipulate symbols, then you are attempting to consciously manipulate the reader's participation in the narrative. If you can do this successfully, the reader will perceive the story as more unified, and, therefore, more interesting. Painters and poets routinely incorporate such connections into their work.

The use of figurative imagery in comics can be especially powerful because of the static visual nature of the medium. Images persist. Most comics writers (and some artists) would do well to spend time considering all of the options that imagery presents.

Characters do not exist in a vacuum. The writer has to know the setting of the story as well as the characters who exist in that setting. The setting plays a role in the unity of the story. There is something annoying about reading a story in which characters do things that they could do in any world. I've often seen scripts in which the world of the story involves time travel, dinosaurs, or distant planets, but the characters seem completely oblivious. The world around the characters should be part of what creates the conflict. If the conflict is completely between the characters or internal and only vaguely connects with the world, then the story feels flawed. It would be a mistake to think of the physical location, history, customs, beliefs, and even the artist's style as just decorations for the story. The more they play a significant role in the story itself, the more unified and stronger the story will be.

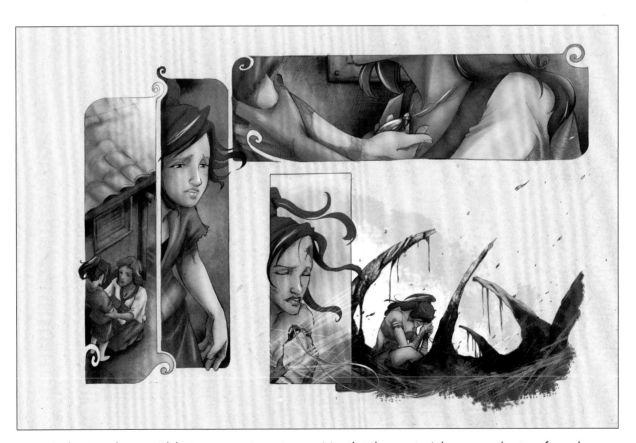

In the story above, a girl destroys a monster, not recognizing that the monster is her own mother transformed. The necklace causes her to understand what she has done, however. Associative imagery such as this works well in comics.

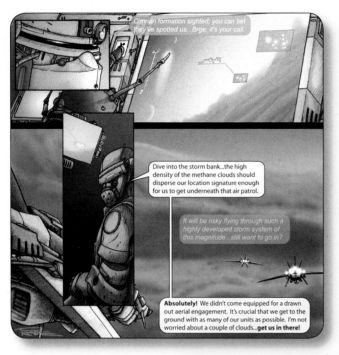

PACING THE STORY, PART 1: ROOM TO BREATHE

Not all comics are action-adventure stories, but all stories have pacing, regardless of genre. Put in its simplest terms, *pacing* is about deciding what parts of the story the reader will spend more or less time absorbing. Pacing a story can be difficult. The story should move as quickly as the material allows, but you have to be careful to provide the information necessary for the reader to understand what is happening in the story. Pacing exists between the reader's needs, what the story demands, and the creator's imagination.

Even in a fast-paced action-adventure story, you must find a way to communicate vital information without compromising the pacing. The reading should feel natural, no matter what the story is and no matter how many or how few pages the story must occupy. In comics, time passes in the gutters. That's the place where the reader's imagination fills in the material between the snapshots. You can tell a story in only a few panels if the material in the gutters easily transitions between the pictures with *story logic* (i.e., if it's clear how the images relate to each other). The more time you spend in a scene, the slower the pacing, but if the level of action within the scene is high, it will appear to move more quickly.

< Pacing is a factor in all comics. The pacing in a story is dependent on what the story is and what the genre may be.

STREAMLINING THE COMPLICATIONS

The connection between images forms in the reader's imagination. The reader shares a fundamental knowledge of how the world works. If the reader sees a man strike a match, then witnesses a forest fire, the reader may logically conclude that the man with the match caused the fire (see art below).

The equation is incredibly simple. The danger of such simplistic storytelling is that it doesn't answer any of the questions a reader has and, therefore, deprives the story of a point. Why did the man do such a thing? How did the man feel about it? The reader doesn't learn anything. Is the man some kind of pyromaniac? Was the fire an accident? Plus, what if the man didn't start the fire at all, but it only looks that way? In any logical equation, the *apparent* cause is not always the *ultimate* cause—or the *only* cause. The quick pacing of the story might force the reader to draw misleading conclusions, which isn't necessarily a bad thing if the writer is purposefully misleading the reader by withholding certain information. However, if there are no questions, if the logic of the story is exactly what it seems, then the story probably isn't interesting.

Answering the reader's questions often requires more than two panels—but how many? If you spend more time than necessary in a given scene, the story is said to *drag*.

The need to move the events of the story forward quickly has to be balanced against the need for story information. Consider the reworked sequence below:

Based on the *action syllogism*: *after this, therefore, because of this*, the reader *gets it* after only two panels—the quickest possible pacing in sequential art.

The page above provides more visual information about the man, but doesn't add or detract anything from the logical conclusions as to what's going on.

A great deal of time is spent on getting out the matches in the second example on page 122, but we still don't absolutely *know* that the hiker actually started the fire. That assumption, however, is probably the reader's logical conclusion. The time spent having the character rummage through the backpack for the matches slows down the scene and draws emphasis to the search, making that a memorable event in the narrative. Dwelling on a particular scene emphasizes it in the reader's mind. There should be reasons for spending so much time on something that could be easily cut. The writer may be trying to establish the arsonist's ritual, or to set up something that will come up again later in the story. If the writer has no logical reason for a sequence, it should be cut.

Consider another version of the scenario:

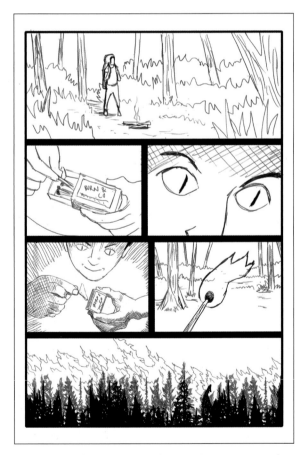

The new information given here makes it seem much more likely that the man is a deranged arsonist. Information has now been added at a point where it lends more weight to the conclusions the reader may draw.

With the previous example, we're pretty sure that the man set the woods on fire. We still don't know why.

Of course, the story could go in a completely unexpected direction. Consider yet another version of the story in the form of a script:

```
Panel 1 — The hiking man has just
struck a match. A huge shadowy figure
lurks in the trees behind him.

Panel 2 — A sound distracts him—he
stands holding the burning match
and looking over his shoulder at
the noise.

SFX: Crunch

Panel 3 — The man's eyes go wide.

Man: !

Panel 4 — A dragon emerges from the
trees, head poised, smoke coming
from his nostrils.

Panel 5 — A panel of nothing
but fire.

SFX: Fwoom!
```

Notice that the pacing is more or less the same, requiring the same number of panels, but the answer is different. The fire is now, apparently, started by a dragon, not by the man at all. In this instance, the writer completely changes the nature of the story with the adjustment.

THE JOY OF DISCOVERY

The visual narrative should give what is necessary—but only what is necessary—in order to provide the reader with answers and take the story where it needs to go. The story doesn't need to answer questions that the reader isn't asking. The fun of any comics story is not simply in *looking at it*, but in feeling that something has been *discovered*, as the narrative moves from panel to panel. Poorly paced stories often have long stretches of panels in which nothing new is discovered. *Discovery* doesn't mean what the reader is *told* but what the reader *figures out* by putting together the evidence presented.

A reader will naturally *slow down* as important discoveries are made. If your story is filled with nothing but information that the reader isn't participating in gathering, then the story will wear the reader's patience thin.

Of course, writing is a process of discovery for the *writer*, too, especially in the initial drafts of a story. Part of the problem with writing anything is that certain details of the story occur to the writer as the story is set down. The writer may include details that turn out to be dead ends. Badly paced stories result when a writer does not go back and edit the narrative.

WHY PACING DOES NOT OCCUR NATURALLY

Editing to enhance the pacing is vital. Editing out deadwood is one of the most important tasks any writer performs. *Deadwood* is writing that either distracts from or interferes with the reader's attention in the story. Deadwood isn't just unneeded exposition, but can be an action scene if the scene doesn't move the story forward. As with most aspects of writing, the key to good pacing is knowing what your story is about. That way all the parts will connect to the story's progress. That seldom happens on the first pass, in other words, in the first draft of the story. Any part of the story that does not reveal something new and move things forward should be eliminated.

As I mentioned earlier, the basic rule to keep in mind is: *Whatever a story spends time on is what the story is about*. If the writer dwells on a particular part of the story for page after page, those pages *become* the story. The reader remembers those images, and they may choke whatever the story is actually supposed to be about. Getting rid of unnecessary panels allows the story "room to breathe." Most often, long tedious explanations are what should get edited. If the proper visual clues are given, readers will come to the conclusions that the writer desires, usually without the need to talk about it. Exposition, whether visual or textual, should be as brief as possible.

COMPRESSION VS. EXPANSION

In a comic book, you can compress or expand time. You can edit a scene down to just a few basic panels, or stretch time so the reader notices things that would never be seen in real life. Consider the following script:

Script 1

Panel 1 — A young woman on a couch looks up from her reading to discover that she's surrounded by thugs intent on beating her up.

SFX: Grrr!

Panel 2 — The woman walks away. The thugs in a heap behind her, totally defeated.

Much like the man with the match on page 122, it's hard to tell what happened from just the two panels. Unless the writer is intent on making the woman's abilities a mystery, the scene needs more time spent showing (not telling) *how* she defeated the thugs.

The logical assumption is that the woman did something to defeat the thugs surrounding her. The visuals, however, provide no clue as to how. The quick jump makes it seem as if she instantaneously defeated the bad guys. Even if the story creates a humorous mystique about the girl, there should at least be a hint as to her abilities.

Consider the slightly revised page below. The writer sidesteps showing what she actually does with the gun once she has it, but that isn't likely to be something the reader would wonder about. Now the reader knows that she used a gun. The scene is kept short and quick while answering the reader's questions and allowing the reader some room for imagination.

Script 2

Panel 1 — A young woman on a couch looks up from her reading to discover that she's surrounded by thugs intent on beating her up.

SFX: Grrr!

Panel 2 — The woman points to the window.

Woman: Hey, there's an ice cream truck outside!

Panel 3 — With thugs momentarily distracted, she kicks one of them in the head, knocking him out.

Panel 4 — She grabs the unconscious thug's gun.

Panel 5 — The woman walks away. The thugs in a heap behind her, totally defeated.

Deciding how long to spend in a sequence may mean balancing the visual information needed with the amount of space—and how much of that information a reader wants and needs. This scene shows *how* the woman actually gained the upper hand.

Consider a final revision that might help
smooth out the pacing of the events a little more:

Script 3

Panel 1 — A young woman on a couch looks up from her reading to discover that
she's surrounded by thugs intent on beating her up.

SFX: Grrr!

Panel 2 — The woman points to the window.

Woman: Hey, there's an ice cream truck outside!

Panel 3 — The thugs are distracted and look toward the window.

Thugs: Ice cream?

Panel 4 — She kicks one of them in the head, knocking him out.

SFX: Krak!

Panel 5 — She grabs the unconscious thug's gun.

Panel 6 — The woman walks away. The thugs in a heap behind her, totally defeated.

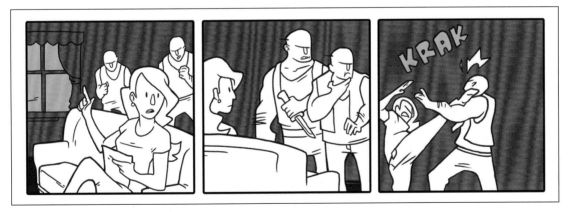

A slight revision in that sequence, turning panel 3 into two panels, helps with the timing of the scene,
adding a brief pause before the woman goes into action, and leads to a more satisfactory chain of events.

Separating the moment of distraction from the goon getting KO'd creates humorous timing. The reader has to wait a little longer for the outcome, and it feels more natural for the characters to have time to react. The page has six panels, a workable number for the artist, and the scene is now completely satisfactory for the reader.

Page Count and Pacing

In creating a comics narrative, one of the first considerations is the pliable nature of fictional time set against the nonpliable reality of the actual page. Pacing a comic is often a compromise between competing realities: story needs versus page count. In the rare case where you have no page limits and have complete control of the pacing, *you should still set a page count*. The page count should be based on your best estimate of how big your story is, how much space it requires, and what the story-consuming market will bear. A professional comics writer knows how many comic book pages a story will be. Putting boundaries on the space to fill is the first major creative step in pacing a story. A big story takes more room, but how much more?

Many of DC Comics and Marvel's monthly books have 20 pages per issue. For graphic novels, such as those published by companies like Oni or NBM, 150 to 200 pages is a fairly common page count. Page counts are usually even numbers (often multiples of 4, e.g., 20, 24, 32, and so on), though even that is not always the case. Checking to see how many pages the kind of book you are writing may run can be a solid clue as to how much room your story has in which to unfold. Knowing how much space you have for your story can be a big factor in deciding how long you will spend in a given scene. When important information is glossed over in the visuals, text may need to be supplied to explain things for the reader. Text, however, slows the pacing of the story. It's a better idea to narrow the scope of the story you are attempting to tell so that the pacing will work well within the page limitations. Readers prefer a small, well-told story to a large story crammed in and badly paced.

ART DISTENSION

Here's a fact that every comics writer should understand: *art swells the story*. This is known as *art distension*. I always tell students that they should add roughly *15 percent* to the page count estimate for art distension.

Artists always seem to need more room than the writer thinks.

Writers tend to write compactly, packing as much as absolutely possible into the page. Experienced comics writers understand that a reader doesn't want a *packed* page, but a *comfortable* page. Artists instinctively understand this notion. They must have adequate room to draw all of the details called for on the page. Artists want to make the story fit on the page in the way that *looks* best and reads well. Therefore, in setting up a projected pacing for the story, think practically. Any panel that has complicated action or multiple layers of visual information (things happening in foreground, background, and middle ground simultaneously) is going to require lots of room for the artist to develop. Keep it simple.

Here's an excerpt of a script that's part of an eight-issue series I'm currently working on. The script is from issue 5, a place where comics stories sometimes run into trouble and get bogged down. Notice the subtle revisions made from script to art to enhance the pacing.

Girl From the Gulf: Under the Sea

Issue 5 of 8

Page 1

Pl. 1 — Will, deep underwater, already looking like a drowning victim as he clings to a metal strut on the oil rig, arms and legs spread out, hovering there.

Pl. 2 — (Inset) He's desperately looking up toward the surface—he's going to drown in a matter of moments.

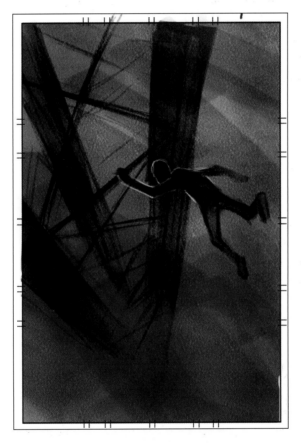

Paring the page down to just one panel opens the page up, slows the scene a bit, and gives the character's predicament more emphasis.

An "inset" panel is any panel that is fully encompassed within another panel. In the corresponding art, the panel has been struck from the script to open up the page and heighten the intensity of Will floating in an immense expanse of water.

continued

Page 2

Pl. 1 — He's suddenly lit from underneath. His face reveals the desperation of a person who's sure he's going to drown—he desperately needs to breathe.

Pl. 2 — (Foreshortened from above) Under his feet is a bright light coming from way down below.

Pl. 3 — It's getting closer.

Pl. 4 — Will's amazed face as a hand grabs Will by the shirt, yanking him into a vehicle (we don't really see much of it here). He's on the razor-thin edge of drowning.

Pl. 5 — He's in, but struggling now, panicking. (We still don't know what he's in—it could be a Volkswagen at this point.) The door closes. (The ship has feathery gill-like things trailing back to extract air from the water.)

SFX: click

Pl. 6 — The water inside the bubble-like canopy immediately drops. Air's coming.

SFX: Shrrrrruuuup!

Whenever the perspective on a character is special, it should be indicated via the scene description. Normally, the script functions without shot calls, but in this case it suggests the extreme situation and, therefore, is mentioned. It tends to lend urgency to the panel.

Since Will is on the brink of drowning, drawing out the pacing this way also draws out the length of time that he has to hold his breath, making it feel more painful for the reader. Jumping too quickly to him being saved would spoil the effect.

After the static images of Will simply floating and waiting, the sudden increased tempo comes as a pleasant release for the reader.

Only after six panels is Will's salvation finally given.

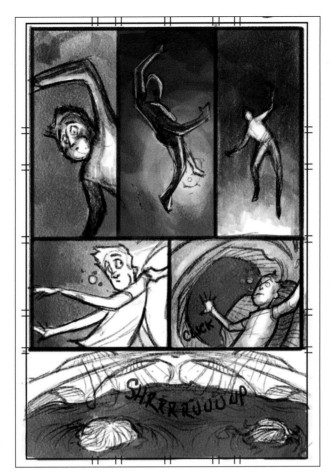

The tier of panels at the top of the page sets up a rhythm that draws out the suspense as the light gets closer and Will gets more desperate.

Page 3

Pl. 1 — Will is now sitting inside a cockpit in a sleek-looking craft with Mara beside him. The water level is just dropping below his mouth—he's wild-eyed and has already swallowed seawater. He's coughing it up, it's spraying out of his mouth and nose.

Will: Phlllllg! Ahuk!

Pl. 2 — Will calming down now, gulping air, begins to notice the inside of the vehicle, small light displays and glowing controls. The water is now down below his waist.

Mara: You okay?

Will: What is—gasp—this thing? Cough cough!

With the understanding that Will is no longer in trouble, the scene slows to a more leisurely pace. The dialogue helps to slow things down.

continued

Pl. 3 — Mara grabs a blue-glowing ball that looks like part of a video game. There are only a few controls and they are all extremely simple, friendly-looking organic shapes.

Will: Hrrr . . . Maybe I drowned, and this is what things look—kaff—like when you're dead.

Mara: You didn't drown, dumb ass.

Pl. 4 — Instantly Will is slammed hard against his seat by g-forces. It's as if the afterburners in a jet fighter just kicked in.

Will: I don't—know—kaff! I think I did. Huk—!

Pl. 5 — We see the whole vessel finally—it looks something like a dolphin without a tail, though a little wider and flatter perhaps, but very organic looking. The craft arcs through the water at incredible speed.

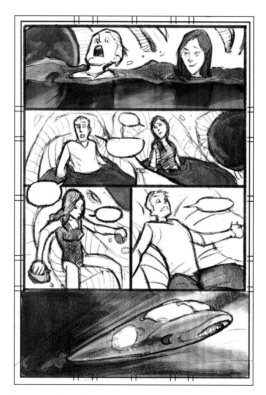

After the initial tension, the rhythm here is a little slower, until the ship kicks into motion and sets up another surprising beat of the story.

The reader is allowed some time to absorb the strange new surroundings. At this point in the story, Will is leaving normal behind and entering a strange new world. He needs to slow down enough to notice that, and so should the reader.

Having the g-forces of acceleration cut off what he's saying is an interesting shift in pacing the script. The slow moment is over, back to fun and games.

TALK WHILE DOING

One technique that effectively keeps a scene from dragging during exposition is to have the characters in the story talk while they are simultaneously doing something visually interesting, but not entirely related to what they are talking about. The two characters in the story on the previous page, for instance, are plunging deep into the ocean in a very interesting underwater craft. As the story progresses, they will physically move into unfamiliar territory, and as they do so, they discuss the state of things between them and Mara explains more about who she is. If that information were given anywhere else, say, in a booth at a restaurant, the scene would feel very slow. The strangeness of what is happening, along with nearly drowning, forces honesty out of Will. It's impossible for him to doubt anything she says. The exposition becomes much more interesting. Whatever exposition the scene affords is tempered by the excitement of discovering a new underwater world.

TIME EQUALS UNDERSTANDING, RIGHT?

More time in a given scene means more emphasis on the scene, but does time spent in a scene equal more clarity of understanding? A scene should be well focused, not necessarily long. In fact, spending more time in a scene often has the effect of confusing the reader by incorporating misleading details. Editors use words like "rambling," "wandering," or "meandering" to describe scenes without a clear point. Each scene should be set up almost like a story unto itself, with a point and a miniclimax, and a definite purpose to the pacing. Using a page outline allows for careful planning of scenes. Sometimes the page outline should be created after the fact. In other words, write the scene, then go back and outline the basic parts of the story spine. Analyze how each scene fits into the story, and how each panel fits into the scene itself. Identify the *turning point* in the scene, the point where whatever the scene is created to divulge has happened. Once that has occurred, the story should move to the next scene. As many writers say, come in to the scene late and leave as soon as possible.

STORY TIME IS RARELY *REAL* TIME

Story time is constantly stretched or compressed. Of course, that's not news to anyone attempting to write a story. Events that took one hundred years of actual time can be compressed into four pages. The words "cut to" are magical, allowing you to skip over tedious details and get to the exciting parts of the narrative. On the other hand, an event that took only a few moments in the real world may need to be developed to create the appropriate drama for the story. The reader doesn't just want to know *what* happened, a thing that could be told in a minimal number of panels, but *what it means*. The reader wants to *learn something*, not just about the sequence of events, but how this particular character handled them. Beginning writers often mistake information for discovery. All too often writers focus on the fantastic elements of the story without making it clear how these have an effect on the characters in the story.

The following page features a portion of a science-fiction story set in a futuristic world where two teenagers are beset by predatory enemies and are struggling to survive. Writer/artist Dan Glasl manages the pacing well and generates a sense of the impact the events have on the characters. Action scenes are allowed to develop in a way that satisfies the reader and gives the story "room to breathe."

```
Angels

Page 4 (4 Panels)

Panel 1 — Brynn and Cassidy sift through the shelves of the pharmacy.

Bryn: I don't see it.

Cassidy: Leary said it was supposed to have a giant "Q" on it.

Panel 2 — Bryn holds up a squeeze bottle looking at it askance.

Bryn: This one has a big K and a Y on it./ You think that's for Kentucky?

Panel 3 — Cass holds up a bottle with a big grin on her face.

Cassidy: I found it, Bryn!

Bryn: Good, now let's go—

Panel 4 — The kids look up in fear as a roar echoes through the pharmacy.

SFX: ROAR!

Cassidy: What the hell was that?

Bryn: Cass . . .
```

The script has a nice sense of timing. It could be tempting to have the characters dwell on all the things they might possibly find in an abandoned pharmacy. Here the script establishes who the characters are, then "cuts to the chase" very quickly in panel 4.

The sound effect at the end punctuates the page and leaves a bit of mystery as to what is about to happen, forcing the reader to go to the next page. Here the pacing shifts from the ordinary to the extraordinary. The SFX leaves the reader wanting to discover what the sound may be as badly as the characters.

continued

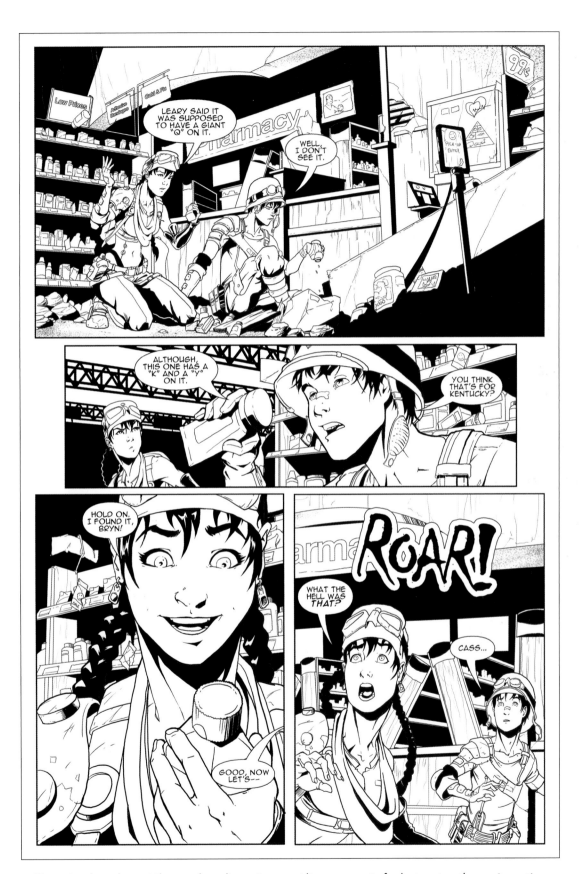

The script slows down at the mundane discussion, providing a moment of calm to set up the coming action.

Page 5 (5 Panels)

Panel 1 — The kids panic as a giant man with a nasty hook for his left hand, the Auto Parts Ax, and a bull headdress bursts through one of the display shelves behind them.

SFX: Crash!

Bryn: Run!

Panel 2 — OTS of the Minotaur as he sees the children running away.

Panel 3 — The children round a corner, Bryn sliding across the floor as the Minotaur's ax smashes a display.

SFX: Crunch!

Panel 4 — Bryn and Cassidy stop dead in their tracks, desperately looking for a way out.

Cassidy: What now?

Panel 5 — The children find themselves at a dead end next to all the BBQ and outdoors stuff.

Bryn: Climb!

Good action here—both the unsettling (and unexpected) look and the kind of action give the scene a high degree of tempo.

The over-the-shoulder shot firmly connects the monster with the kids, so the reader knows what he's after and where he is. The running children increase the excitement of the panel, forcing the reader to move quickly to the next panel to see what happens. Notice that there are no words to slow things down during these high-intensity action panels.

Again, the relatively low panel count and the high level of tempo in the scene allow the story to open up and feel highly exciting. The one word of dialogue hints at a direction for the story. Ending the page with the kids apparently trapped forces the reader to turn the page to once again discover what their fate may be.

continued

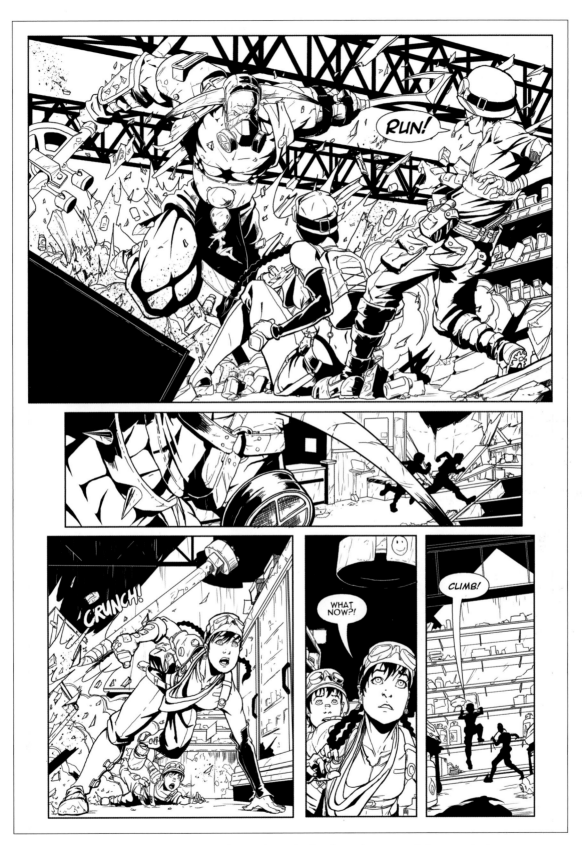

Notice that the many things that are being broken keep the tempo of the scene high.
There's the feeling that things are flying in all directions.

```
Page 6 (3 Panels)

Panel 1 — The Minotaur charges at the kids as Bryn pulls Cassidy up to a higher shelf
in the distance.

Bryn: Give me your hand!

Minotaur: Roar!

Panel 2 — The Minotaur slams into the shelf below the children as Cassidy falls from
Bryn's grip. Make sure to somehow work into this panel a couple packages of shish
kebab skewers next to Bryn.

SXF: Krunch!

Bryn: Cass!

Cassidy: Aieee!

Panel 3 — Cass falls to the ground by the Minotaur's feet.

SFX: Whump!

Cassidy: Woof!
```

The Minotaur's dialogue here could be written as a sound effect (SFX), but the general rule is that if the sound is coming out of a character's mouth, it should be written as dialogue. If the sound were coming from off panel, or disembodied somehow, it could be written as SFX.

The story lets the reader know that Cassidy is in danger. In the onrushing action, the fact that Cassidy's hand slips from Bryn's grip is significant, driving home Bryn's responsibility in her fall. The script also carefully sets up the skewers that will be important later, as Bryn will make use of them as weapons against the Minotaur. The script can't rush past these details.

Open up action scenes in your script so they afford the reader an enjoyable experience. Readers don't simply want to know that they beat the monster and got away. It would be a mistake to underestimate the reader's need to know *how* they got away. The story of *Angels* is about survival, and time should be spent on how the characters managed to do that. There has to be an unexpected logic to how that happens. In this case, the characters are in a pharmacy, and it makes perfect sense that there would be some potential weapons among the household products. The character could have simply picked up a shotgun from the sporting goods section, but that would have been much more predictable. Plus, based on the logic of the scene, there simply wasn't time to go shopping for the appropriate weapon.

The phrase "room to breathe" implies many things. It does not just mean open the story up for the sake of doing so. Keep in mind the effect your story is trying to achieve and tie that effect in with the pacing of the scenes. Pacing is a matter of working the rhythm of the panels against the tempo of the scene. In the next chapter, I'll discuss this concept more fully.

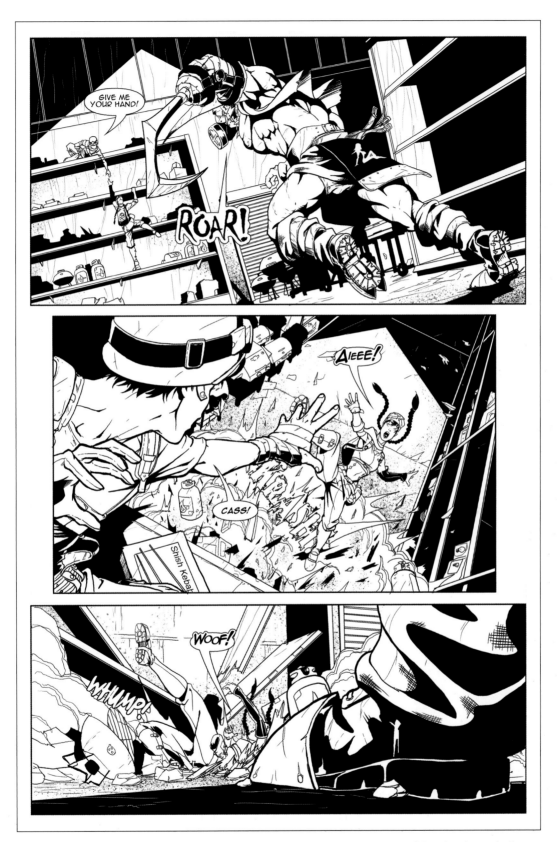

The dialogue here is held to a minimum to keep the pacing quick, and the story is careful to detail visual information that explains how Cassidy got into her predicament, and the weapons that Bryn will use on the next page.

PACING THE STORY, PART 2: BREAKING THE RULES

The use of panels and page graphics obviously makes pacing a comic book different than pacing a movie, but the fundamental issues are the same. The timing of comics images is vitally important. A comics writer makes a choice as to how many panels will be devoted to a particular scene and controls the way a reader moves through each page.

< A *polyptych*, or pan shot, directs the reader's attention at a set pace across a wide area.

TEMPO AND RHYTHM IN COMICS

Pacing is controlled by a manipulation of the tempo and the rhythm of the story. For comics, tempo and rhythm take on a specialized meaning.

Tempo

Tempo in music means the rate at which music is played. As it relates to storytelling, *tempo* is the level of activity that occurs within a scene. Characters may be running, throwing punches, or turning cartwheels—the greater the level of activity, the higher the tempo. Characters may also be quietly watching the sun set, reading a book, or sleeping. Those would be low-tempo scenes. The pacing of a story is affected by the amount of activity implied in the snapshot presented by each panel. The greater the level of activity, the quicker the pacing.

A full-page panel (splash page) should contain plenty of visual information. The page slows the rhythm, but creates a quick tempo for the scene.

Therefore, pacing is not just about the number of panels on the page or how long the writer dwells on a scene, but also about what's happening within each panel. As a general operational rule, consider that the smaller the panel, the less possibility for a high tempo within the panel. The larger the panel, the more possibility there is for a higher tempo. There are, of course, many exceptions to this rule. It explains, however, why fight scenes often occur in full-page panels, sometimes called *splash pages*.

Rhythm

The *rhythm* of a comics page is directly connected with the number of panels there are on the page, and how many panels the writer chooses to devote to a particular part of the story. Generally speaking, the more panels on a page, the less visual information in each panel, and the less time the reader will spend viewing each panel. The rhythm, then, might be thought of as how quickly the reader moves to the next panel. If the page contains fifteen panels, each with only a small increment of visual information, then the reader's eye will give each panel only a split-second's attention. The reader will look at a full-page panel longer in order to absorb all that may be contained there. More information can be expected in a large panel. If you suggest a full-page panel for a shot of something insignificant, the reader may well be confused. In some cases, of course, a writer

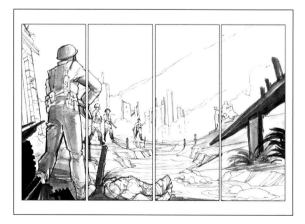

A polyptych (pan shot) simultaneously opens a scene up and creates a deliberate rhythm, forcing the reader to scan across the scene at a set pace.

may deliberately play with that expectation, forcing the reader to ponder something small by placing it in a large panel. For the writer, this concept is on the threshold between writing and drawing the comic, and should be used carefully.

Large panels should serve a logical graphic purpose within the story. A full-page panel, for instance, creates a dramatic variation from the ongoing grid of panels contained in the story. Sometimes you can use large panels to simply break up the monotony of a story in which each panel is the same size. In any full-page panel, or double-page panel, rhythm within the story slows to a crawl. The story ceases its forward momentum, even if the tempo of the scene is very high, as the reader ponders the visual information. Too much reliance on such devices causes the story to feel like a sequence of lavish illustrations, rather than a narrative progression.

Large panels can be used effectively to establish new physical or emotional circumstances for the reader, such as those that might occur at scene shifts or act shifts. Full-page panels are also often used at the beginning of a story or graphic novel to establish the world of the story. Additionally, large panels provide a means to insert the title of the story and the credits. The choice to use a large panel, in any of these ways, should not be purely arbitrary, but a matter of consideration. You may choose to leap into the story with a quick pace and a disorientating arrangement of panels, if it's that kind of story. A story could easily begin with a sequence of small close-up shots of a ray of light growing beneath a door. Eventually, the writer will reveal the world of the story, but not until has captured the reader's attention.

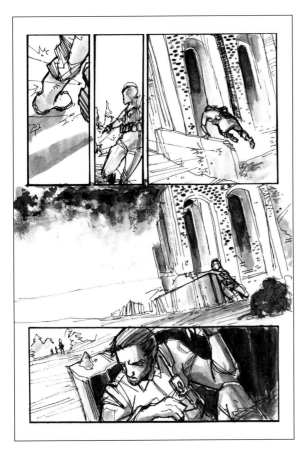

Breaking the page down into tiers of panels controls the rhythm of the page and causes the reader to linger over certain panels while moving more quickly through others.

Placing a raindrop in a full-page panel forces the reader to contemplate this object. The effect might be poetic somehow, but it's more likely to feel like a glitch in pacing, something that doesn't merit so much room.

Splash pages are often the place where inexperienced writers and artists insert "cool visuals." It is important for the full-page panel to have a focus. In the example above, for instance, it's impossible to see what the point of the panel is supposed to be.

AND NOW THE MOON IS OURS !!

What if NASA were secretly funded by the Illuminati? Here, the high tempo of the rocket launch juxtaposes with the low tempo of the mysterioius, somber men to create the experience not just of who the Illuminati are and what they look like (interesting visuals unto themselves), but the dramatic tension that the juxtapostion of these scenes generates.

An Above Average-Panel Count

Some pages of comics break with the idea of having an average of five to seven panels per page. The three comics pages on the next page by artist David Gildersleeve all demonstrate various aspects of rhythm and tempo in comics. There are twelve panels on each page, which is a high panel count. In the first scene, an entire day is compressed into a single page. In the second, the music from the ice cream truck draws the boy through what amounts to only a few moments. In the third, the actual time isn't clear, but the focus is more on the boy's internal thoughts as evidenced by the dreamlike quality of the fireflies. In each case, the panels create a slow, gentle rhythm. Here, you may define *rhythm* as how long the story remains in the same scene. With a low tempo, or level of visual information and activity, in each panel, it's possible to have more panels on a page.

If you are going to create a high panel count, then you have to know what you are doing with the rhythm and the tempo of the panels, and, as always, you have to know what your story is about. In the first two examples, the first four panels are really just one master scene, divided into several panels (for more on creating a pan shot, see page 66). Subdividing the scene in this way forces the viewer to *read* the scene, or move through it at a certain, deliberate speed, rather than just taking it all in at once, similar to the way a poet draws a reader's attention to specific parts of the world that might otherwise go unnoticed.

DON'T WASTE STORY TIME!

It is equally important to know what *not* to emphasize.

Readers want the cinematic experience involving the rhythm and tempo of scenes, not to read information in captions or to have a character state it as if the story were a prose novel. Of course, a reader will tolerate a little of that when necessary. But is it necessary? That becomes the question. If a writer expands time, forcing the reader to linger over a scene by slowing the rhythm and tempo, then the information being given should be new and surprising.

DAY OF THE BIKE

ICE CREAM MAN

LIGHTNING BUG

There are twelve panels on each page above, but the rhythm of the panels is such that each page does not feel crowded.

How to Enjoy Conflict

The more that time is expanded in a scene, the more immersed in the experience the reader becomes. Including a sequence of panels to show a relatively small action that would take only a matter of seconds in the real world allows the audience to enjoy reading the sequence. The audience is allowed to *experience* the conflict. The details of whatever is portrayed, frozen in the panel forever, are things that the reader would *never* linger over in the real world—where

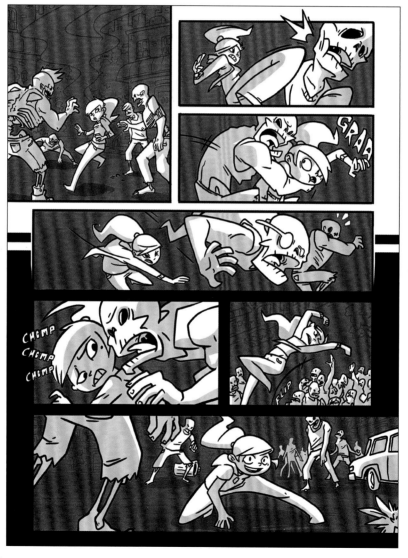

Placing emphasis on small details works well in comics. In the page above, the threat builds up to the moment when the woman avoids the danger in panel 5. The zombie's teeth snapping at the woman is the pivotal moment on the page, the action punctuates the danger. The sequence doesn't cover a lot of narrative ground, but focuses on that moment. A mistake too many writers make is failing to pinpoint the critical moment where change occurs.

things go by too quickly to be observed. Movies sometimes attempt to do this, but the slow-motion effect is one the audience becomes aware of. The expanding and contracting of time in a comics sequence, however, feels natural. It's something that sequential art does exceptionally well. When your story takes advantage of altering reality in this way, it can be very interesting.

STORYTELLING CRUISE CONTROL

In creating pacing, you decide how the reader will experience the story—and present that idea to the artist. You can step on the accelerator and zoom through a story, or you can hit the brakes, move the story along slowly and do some sightseeing along the way. Of course, there are only so many pages in which to tell your story. Problems in the writer/artist relationship often arise when the writer isn't thinking clearly about pacing, but is more focused on stuffing material onto the page. The artist, on the other hand, *seeing* the visuals developing, is eminently concerned with the pacing. In the struggle between getting more information on the page and having the material on the page read in a comfortable, deliberate way, you should always opt for the latter. The amount of material in the story may need to be reduced if pacing begins to be sacrificed. That is a painful decision for most writers.

Many artists, seeing a high panel count—meaning more than five to seven panels per page—instinctively grow unhappy with the script, fearing that the writer has crammed too much information onto the page. All too often, that is the case. Therefore, you should know exactly why you

are asking for a particular panel count on a page. Consider all of the angles for story pacing before settling on one way of arranging your material. A conversation with the artist would greatly help in such a case; however, at the very least, a note to the artist at the top of the page or the beginning of the script explaining why certain choices were made is a good idea. The logic of the page should be clear to everyone involved in creating the page. Otherwise it may not come through to the reader at the end of the process, especially if the rules are being bent or broken.

Redundancy

In a visual medium, readers absorb and understand what they see at a rapid pace, much more quickly than in prose. Once the reader has seen an image or an action, she doesn't want to look at it again and again unless something about it changes. Inexperienced writers often cause the rhythm of the story to drag by spending too much time in a single physical location or by having characters do the same things over and over.

You should be wary of ever setting up a scene description that reads "same as previous panel." In a script, such a repetitive scene often denotes creative laziness on the part of the writer. Having a panel where absolutely nothing changes is almost always a mistake. Even if there is only a minute change, something must change from panel to panel. If you shift to a second panel simply because the first contains too much dialogue, consider cutting down the dialogue, or develop an appropriate new visual to accompany the dialogue.

Consider the following script excerpt:

Pl. 1 — Long shot of a man on a mountain in Peru with goats around him.

Pl. 2 — Moving closer. The goats are grazing.

Pl. 3 — Close in on the man. The goats are looking up at the man.

Man: I am somebody!

Pl. 4 — Pulling out again. The man puts his hands on his hips and looks proud. The goats are looking at one another.

Pl. 5 — The goats are grazing again. The man walking away in the distance.

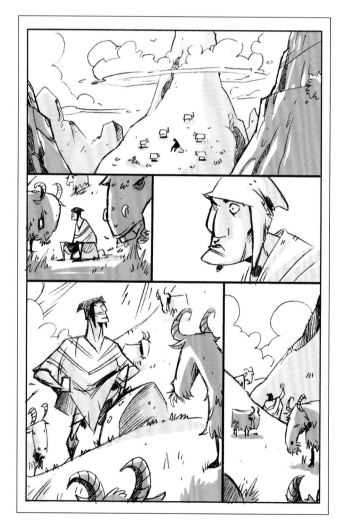

Sometimes movement may mean zooming in or zooming out.

The panels on the previous page have a logical movement toward the man and the ultimate moment of his declaration. Once the tension is released, the art draws the reader back out again, away from the man. There is a subtle implication that his declaration is pointless, given the fact that the goats don't seem to care and that he seems to be disappearing into the mountains. The page, thus, has a clear logic. The pivotal point of the man's statement determines the rhythm of the panels. In this case, the script does contain several shot calls because they have very specific meaning.

Reactions

Reactions are a good reason to stay with a scene rather than cutting away from it. Many writers gloss over reactions. If a character has big news—"I just found a gold bar!"—then the character hearing the news may need a moment to process the information: "What did you say?" Stopping the text, however, and allowing the visual to run silently for an extra panel, carries a message of its own. Maybe someone has been rendered speechless. Consider these two scenarios:

Constructing the scene all in one panel, as in Scenario 1, moves the plot itself across the page as rapidly as possible, but alters the dramatic aspects of the scene. In this version, Rusty's reaction seems instantaneous, as if he's already expecting what Jim is saying. In the second version, Jim seems to be brooding over Rusty and his news. Changing the rhythm of the scene pulls a different reaction from the reader. Sometimes speeding up the scene sacrifices the drama and the point of the scene.

No Cheap Tricks in Comics

Many writers have seen the gimmicky visual storytelling tricks used in film. In horror movies, a monster may abruptly leap up, causing the audience to gasp with terror. In comics, these devices don't work. The reader will scan ahead, anticipating the interesting things that are about to happen. The effect of trying to surprise the reader in a comic book is *minimal*. Instead, use comics art in the way that works best: let the reader see the danger, and focus on surprising the *character* in the story, rather than the reader.

```
Scenario 1

Panel 1 — Two men sit at a seedy bar. One of them (Rusty) is excited, bug-eyed, can
barely contain himself. The other (Jim) stares down morosely into a bowl of pretzels.

Rusty: I just found a gold bar!

Jim: You're lying!

Scenario 2

Panel 1 — Two men sit at a seedy bar. One of them (Rusty) is excited, bug-eyed, can
barely contain himself. The other (Jim) gazes down morosely into a bowl of pretzels.

Rusty: I just found a gold bar!

Panel 2 — Rusty stares at Jim, expectantly. Jim continues to gaze into the pretzels.

Panel 3 — Jim cuts his eyes over at a confused Rusty.

Jim: You're lying!
```

Scenario 1

Pl. 1 — A man sitting in his living room watching TV.

Pl. 2 — The man is amazed when a meteor crashes through the ceiling.

Scenario 2

Pl. 1 — A meteor out in space heading toward planet Earth.

Pl. 2 — A man sitting in his living room watching TV.

Pl. 3 — The meteor's fiery entry into the atmosphere, maybe the dim patch of a city down below.

Pl. 4 — The man oblivious, watching TV.

Pl. 5 — The ceiling suddenly exploding as a meteor crashes through the ceiling.

Pl. 6 — The stunned man staring at the meteor as the weather report plays.
TV: It's going to be warm in the city today . . .

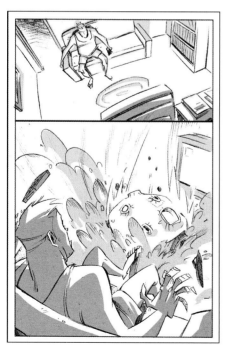

1: It is almost always better to set up what is about the happen, so the reader knows.

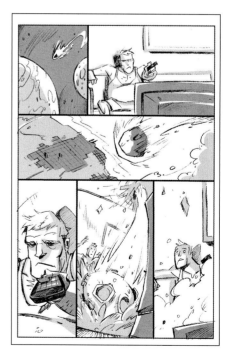

2: The high tempo of the fiery meteor is juxtaposed with the low tempo of the man in his living room to create tension between the two scenes.

In the second example on page 150, crosscutting between the meteor and the man means that the reader knows something that the man in the story doesn't know. When the meteor crashes through the ceiling, the surprise is placed on the character rather than the reader. Setting up what's coming is best done with visuals rather than with text. Visuals involve the reader and generate the appropriate excitement. If a caption simply states that there is danger lurking ahead, the text has the effect of slowing down the tempo of the already placid scene even more. Pacing the scene in an optimal way, then, means that six panels are devoted to what initially took only two panels. The scene has thus been expanded and *developed*, and the effect is much more satisfying to the reader than just getting through it all as quickly as possible.

Mixing Text with Tempo and Rhythm

Text slows the pacing of the narrative. The more text a writer uses, the more the writer is putting on the brakes. It is a good idea to limit the amount of text given in any particular panel, not just because comic

Let the Artist Lay It Out

You should work out how many panels will appear on the page, but the writer can't ultimately tell the artist how to lay out the page. A competent artist can look at the number of panels called for on a page and intuitively understand whether or not the number will work, based on the content and logic of the story. A good artist may listen to a careful writer's suggestions, but the artist has the last word on panel layout.

books look better that way, but also because text connects with pacing, and heavy text means slow pacing. If characters talk a great deal, the chances are they are not *doing* much else. Break up large blocks of text across the panel, if possible. Text can become part of the rhythm of the story, if it is managed carefully.

Consider the use of text in the following excerpt from *Fluffy*.

Panel 1 — Establishing shot of a busy veterinary clinic: Jerry, 25, dressed in flannel and denim, weary looking (he's been up all night), In the background, people try to keep their pets in line as they wait to be seen. The place is generally hospital-like, sterile, and official.

Jerry (thought): Fluffy's been sick for a while now. Everybody else in here takes much better care of their pets . . .

Panel 2 — Jerry looks at the other pet owners.

Jerry (thought): Why didn't I bring Fluffy in days ago?

Panel 3 — Scene shows Jerry's face, eyes bloodshot and anxious.

Jerry (thought): This is going to be bad . . .

Vet (off panel): Are you Jerry?

continued

Panel 4 — Jerry looks up at the vet, a young woman in green scrubs and a smock with a pattern of kittens and puppies all over it.

Jerry: Y-y-yes.

Vet: I have some . . .

Jerry (thought): I'm sure I'm not going to want to hear what she's about to say. I'm a terrible pet owner.

Panel 5 — Jerry's anxious eyes open wide, ready to hear something horrible.

Vet (off panel): . . . bad news about Fluffy.

Jerry (thought): Fluffy is going to die!

Panel 6 — Jerry's squeezing his eyes shut and looking down at the floor.

Jerry: Oh?

Jerry (thought): What am I going to do without Fluffy? This is terrible. I'm the worst pet owner on the planet!

Panel 7 — The vet motions toward a door off to the side as Jerry looks up in surprise, brightening a little.

Vet: She's got a terrible case of fleas. We'll need to treat her right away.

Jerry: Oh. Okay.

Jerry (thought): Oh, thank god. Fleas I can handle. What a relief!

The thoughts of the character are spelled out, which slows down the pace and distracts the attention of the reader from the visuals, simultaneously obliterating subtext, leaving the reader with no conclusions to draw, nothing to be *experienced*. The dialogue undermines the sincerity of the character's emotions. The amount of time the reader spends in the scene and the lack of emphasis on the character's physical reactions decreases the degree of sincerity the scene generates and distances the reader from the character rather than pulling the reader in closer.

Here's a slightly edited version:

Panel 1 — Establishing shot of a busy veterinary clinic: Jerry, 25, dressed in flannel and denim, weary looking (he's been up all night). In the background, people try to keep their pets in line as they wait to be seen. The place is generally hospital-like, sterile, and official.

Panel 2 — Jerry looks at the other pet owners enjoying their happy pets.

Panel 3 — Shot of Jerry's face, eyes bloodshot and anxious.

Vet (off panel): Are you Jerry?

Panel 4 — Jerry looks up at the vet, a young woman in green scrubs and a smock with a pattern of kittens and puppies all over it.

Jerry: Y-y-yes.

Vet: I have some . . .

Panel 5 — Jerry's anxious eyes open wide, ready to hear something horrible.

Vet (off panel): . . . bad news about Fluffy.

Panel 6 — Jerry's squeezing his eyes shut and looking down at the floor.

Panel 7 — The vet motions toward a door off to the side as Jerry looks up in surprise, brightening a little.

Vet: She's got a terrible case of fleas. We'll need to treat her right away.

Jerry: Oh . . . okay.

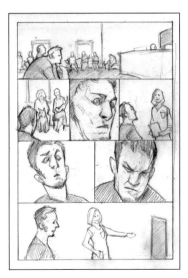

The edits in the script open the door to more dramatic artwork that gives the
character convincing emotions and allows the scene to move more quickly.

Removing the text gives the art more room. The reader can experience the story rather than being told the character's precise thoughts. Though Jerry never leaves the vet's office, the variations in his worry about the cat form a good rhythm in the panels, drawing the dialogue out over more panels and increasing the number of reactions. The things on Jerry's mind—"My pet is going to die." "This is horrible." "Why did this have to happen?"—become subtext, rather than being overtly stated. Space is a major consideration in comics, but storytelling is the most important consideration. If the reader is supposed to become involved with Jerry's emotions concerning his pet, the pacing of the second version does a better job of involving the reader's imagination as the reader considers what might be going through Jerry's mind.

Tempo-Enhancing Comics Devices

Certain devices—such as *skewed panels* (tilted panels), actions that break the panel borders (parts of the art projecting through the panel border), and whether or not a page is a *bleed* (where art extends to the edge of the page), as well as colors to be used in the story—may also play a role in the level of tempo connected with pacing the story. However, most of these devices may go beyond what the writer is capable of controlling, though she may ask for these things. To some extent, these devices depend on the artist's particular style and level of skill.

FORMULAIC COMICS NARRATIVES

I have already discussed the three-act structure most comics stories follow. Some mainstream comic book stories follow what has come to be known as the formula for creating comics. Although the word *formula* is most often used in a negative connotation, it simply refers to a way of building reader interest by manipulating the tempo and rhythm of a story. Having a formula for a story isn't necessarily a bad thing. A formula is simply an armature on which to hang a narrative.

You can outline the pacing formula as follows:

1. Something happens quickly that hooks the reader. Most mainstream comics follow that Hollywood adage: *Something important must happen within the first five minutes of the movie or the audience is lost.* For a comic, something important should happen in the first two or three pages. This usually means that the tempo is high and the rhythm is quick at the beginning.

2. Only after the story hook is firmly planted in the reader's mind does the story slow to establish expository information and begin to fill in the gaps of the reader's understanding. This means a low tempo and a slower rhythm.

3. A pattern then establishes itself, increasing the time spent on action and decreasing the time spent on exposition as the story moves toward the climax.

4. The climax of the story is almost all contingent upon quick pacing, as the pressure on the characters of the story mounts to its greatest intensity.

5. The story will likely slow down immediately after the climax—to let off pressure for the reader, tie up any remaining loose ends, and provide the reader with a denouement that releases the emotional tension the pacing has built through the climax.

There's only a problem when structure substitutes for imagination. The more important consideration is the degree of creativity and imagination that goes into the narrative.

Suggestions Department

Pacing the story begins with the first word written in your script. Openings for stories often fall into recognizable categories. How you choose to begin tends to set up how the pacing progresses throughout the story. Monotony is the writer's enemy. Here are some possibilities for varying the opening.

- *Begin the story with the main character in action.* In this instance, the hero of the story is probably busily engaged in doing whatever the hero will likely be doing through the story. Opening this way gives the reader a clue as to what to expect later in the narrative. The action can be in the form of a *teaser* (something that introduces the character, but does not directly relate to the outcome of the story).

- *Begin the story with the main character doing something he won't typically be doing throughout the narrative.* This type of opening works well for "ordinary people in extraordinary circumstances" scenarios. The reader needs to understand what the character's ordinary life is before plunging into the extraordinary one. In this case, the pacing may be a bit slow to start with, but needs to increase rapidly from the moment whatever is extraordinary begins. If the hero is a known character—say, Superman— then the reader already anticipates that the tempo will pick up soon. Hero nonaction may also be very effective for creating a subplot, a concern of the protagonist that is outside the central problem of the story. The kung fu master, for instance, may grow bonsai trees. The story may begin with the master pruning his bonsai. The story might return to it from time to time throughout the narrative. Such divergences from the main action of the story provide another level of interest and allow for breaks in the pacing.

- *Begin with something remote from the hero.* The hero may, in fact, not be introduced until after the story begins. For instance, the story may begin with whatever the antagonist is doing. Some event may be set up that the hero, when introduced later, will have to react to. However interesting the protagonist may be, keeping the story always focused on what she does runs the risk of monotony.

- *Employ various time alterations.* The story can start *in medias res* (in the middle of things). This technique works particularly well in stories that have a slow build to the climax. If you begin with a scene taken out of sequence, probably from someplace very near the climax, and move it to the beginning, the slow buildup is effectively eliminated. If the story opens with an exciting point in time, it draws the reader through the slower parts of the narrative, altering the reader's perception of the pacing of the story. If done effectively, the reader will want to discover what is going on via the low tempo parts of the narrative most likely visited in flashbacks. Such storytelling presents the possibility of confusion, of course. You must be careful to keep the time frame of events clear for the reader.

- *Employ a framing device to tell the story.* A film like *The Princess Bride* provides a good example of this type of story. The sick child is read a story by his grandfather. Art Spiegelman's *Maus* is a well-known graphic novel that uses such a device. Spiegelman's talks with his father lead to the story of the Nazi death camps. The relationship with the father is the framework inside of which the story is told. The implications of using a framing device are important for pacing the story. The character to whom the story is told may interrupt from time to time, breaking the monotony of the narrative and perhaps asking questions that have been in the reader's mind in a way that does not require lengthy expository diversions within the inner narrative.

INNER VS. OUTER CONFLICT (AND PACING)

It would be odd in an action-oriented sequence to have a character ponder what's happening or to insert captions with explanations. The inner conflicts and the complicated motivations of a complex character, however, require more understanding from the audience than, say, Superman fighting an alien robot. If a character is trying to find personal happiness, the reader must

first understand who the character is, why the character is not happy, how the character actually defines happiness, and what plan the character has for achieving his goal. Slowing the pacing of a personal story may mean not hurrying through the emotional changes registered in a character's gestures and reactions.

Consider the story thst follows. What drives the pacing here?

Excerpt from *Heavy Armor Tax Collectors* by Jason Clarke

Page 1

Panel 1 — Mattie points at Roy, a greasy guy carrying a briefcase, as he runs toward a metal ladder at the edge of the roof.

Mattie: Mira, that perp's making a dash.

Panel 2 — Mattie yells over her shoulder.

Mattie: Cover me!

Panel 3 — Mira opens fire with her rifle.

Mira: Gotcha covered!

SFX: Blam Blam Blam Blam

Panel 4 — Granny watches from XRAY ONE as Mattie dashes across the roof after greasy guy who has flung away the briefcase in his mad dash.

Granny: Pilot! Swing us around to the north side of the building!

Panel 5 — Mattie runs Roy, the greasy guy, down. She reaches for him, his collar just out of her reach. He looks back in fear. The toothpick that was in the corner of his mouth falls out as he runs.

Mattie: Ggrrr!

Panel 6 — XRAY zooms along the edge of the roof. Granny hangs half out the door. She's scowling.

Panel 7 — Granny jumps from the side door. John inside the cockpit looks back in horror.

John: You crazy old bat!

The tempo of the opening scene is high. Beginning in the middle of an action scene grabs the reader's attention.

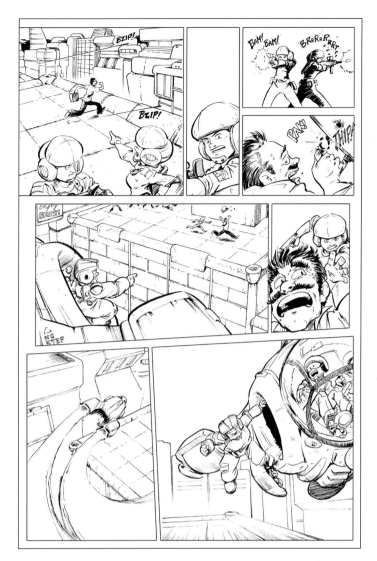

Notice that, in the art, an extra panel was added between panels 3 and 4 of the script. The detail in the extra panel shows the result of the bullets that are flying. Because the amount of visual information in the panels is relatively small and text is kept minimal, the page can contain eight panels.

Page 2

Panel 1 — XRAY flies by as Granny soars through the air like a cat leaping onto a mouse. Granny's predatory eyes are focused on Roy (the greasy guy). Simultaneously, greasy guy's neck gets snagged by Mattie's grip on his collar just as he was leaping onto the raised edge of the roof, and Roy's attention is on Mattie. Mattie, however, stares in confusion at the sight of Granny flying through the air toward Roy. All three figures should be in midair like a moment frozen in time.

The large panel easily accommodates the high level of activity within the panel. The writer also eliminates all text, creating a very quick sense of pacing.

continued

Panel 2 — The three bodies collide . . .

Panel 3 — . . . and spin apart in separate directions.

Panel 4 — Greasy guy is flung to the ground alongside the rooftop stair access.

Panel 5 — Granny hits the gravel roof awkwardly on her ankle (breaking it).
SFX (small): krak

Panel 6 — Granny's face gorks out in pain.

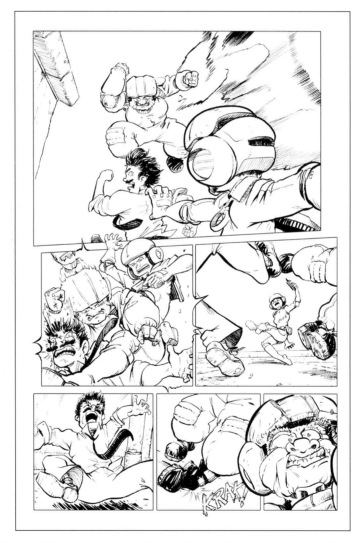

The action here is intense. The script gives brief descriptions and tends to emphasize the rhythm of the action.
Having only five panels allows them to accommodate the number of characters in each scene. With more panels, that
would be impossible, and with fewer, the scene would lose the rhythmic element of the quick, multiple actions.

Most of these panels have very little dialogue to slow down the excitement of the action. The creative use of camera movement and graphic elements such as *Dutch angles* (i.e., where the panel is not tilted, but the art inside it is), also suggests an increased level of tempo. It is important to note that the artist added those extra panels without the script calling for them. In many cases, the artist will take a scene and run with it, adding details and angles that he feels visually help the scene go where the writer intends. If the writer succeeds at getting the story across well, the artist can be a great asset.

WHAT TO DO ABOUT BAD PACING

Bad pacing doesn't mean that your story doesn't have pacing but rather that you are somehow not in control of the pacing, or the pacing doesn't fit what the story is about. Pacing is one of the most difficult aspects of the script to revise, especially if you are trying to simultaneously figure out what exactly the story is or how to make material fit into a tight page count. If possible, step away from the story for a while and come back to it with a fresh eye. Read through it carefully and think about the amount of space that is taken up by any given part of the story and how quickly a reader will move through that part. If adjustments are needed, here are some things to consider.

Reconsider What the Story Is About

If you can dispense with any scene of your story, or find it is irrelevant to the point of the story, then you must cut it (not should, but *must*). Do not try to rationalize the need to include scenes or panels that your creative instincts feel uneasy about. Such scenes are always pacing nightmares that don't flow out of or into other parts of the story very easily.

Cut Down the Scope of the Story

You don't have to tell an epic tale, especially if you are trying to pack an epic tale into a short amount of space. It is far more important for the writer to tell a good story where all of the scenes have "room to breathe." That may mean reducing the scope of the material in order for it to fit comfortably in whatever pages have been allotted.

Reconsider the Number of Pages

It is sometimes possible to add pages to a story. If the story seems to be getting bigger, but is of enough interest, it is possible to push the boundaries of the story by adding additional pages—or possibly even an additional issue. Only add them if they lend relevant interest. If the story is being written for a publisher, you should contact the publisher and make the case for additional pages in order to develop the story. Publishers always want a good product, and if a publisher can be convinced that a few more pages will make for a product that is more satisfying to the reader, then the pages may be approved. Of course, they may not. It depends on the book, the reason for the request, and the limitations the publisher faces.

Pacing can be one of the most difficult aspects of the book to edit. One reason is that you can have a difficult time seeing pacing issues in your own work. Too much dialogue, too many panels on the page, too many splash pages, too many static scenes without much tempo, too much story for the allotted pages—these are all issues you can easily overlook for the sake of being finished. Becoming comfortable with poor choices, however, isn't an option for anyone who wants to be a professional comics writer. Try to get someone else to read your work. At the very least, read your own work aloud, picturing the scenes in your head. Try thumbnailing the pages. No writer wants to write a bad script. The trick is to recognize what part of the draft is bad and what part you should keep. It requires that you understand what your story is about—often the most difficult part of writing.

PUTTING TOGETHER A SYNOPSIS FOR SUBMISSION

Being a great comics script writer does not necessarily prepare a person to write a great story synopsis. In fact, the skills involved are almost antithetical. There is very little information on what, from a practical standpoint, needs to be done to write a synopsis for submission. If you're trying to get published, however, writing the synopsis is the point where you have to prove that you understand the product you are selling and prove your commitment and confidence in it. The story synopsis is needed regardless of whether you are planning to send a pitch to a comics company or self-publish or possibly set up a Kickstarter (a site that facilitates "crowdfunding" for independent projects).

Creating a story synopsis requires a high level of skill at summarizing ideas while not losing whatever is interesting about those ideas.

< Editors at comics companies get thousands of submissions each year.
The synopsis is a vital part of selling the story.

WHAT IS A STORY SYNOPSIS?

A *story synopsis* is a summary of the events of the story. The words synopsis and summary can be thought of as synonymous. Each means a shortened version of the comic book or graphic novel that you either have written or intend to write. Even if you've written a graphic novel that's 150 pages long, or have a 12-issue series in mind, the story synopsis must encapsulate the entire story in just a page or two of double-spaced prose. The story synopsis should include the beginning, middle, and ending of the story. Most publishers require a story synopsis when a writer or artist submits work for potential publication. It saves the publisher time in understanding what the story is about. Unfortunately, there are very few instructions to be found for writing the synopsis.

It is important to understand what is (and what is not) being asked for in a synopsis before attempting to write it. Too often writers create a kind of short-story version of the narrative, attempting to include lots of descriptive information and sometimes even dialogue between the characters. Often they're actually writing what might be called a *treatment*,

a word most often connected with the film industry. Treatments for movies condense the full-length screenplay into a short-story version of the script with elaboration on the key scenes. These can be lengthy. Most comics publishers allow the writer only one or two pages in which to summarize the story. Many writers have a difficult time deciding how to condense the story enough to meet the requirements.

Most writers understand the general idea: squeeze the story into a tiny pill. Publishers want a story idea that sells itself in as short a space as possible without taking up much time in their day. They have a clear idea of *what they do not want*: a great deal of reading to get through. Even if the publisher's submissions guidelines indicate that a synopsis can be up to five pages, a smart writer will always keep the one-page synopsis standard in mind.

In the story synopsis, publishers want to see a complete story, beginning, middle, and end. The quick blurbs about the plot of a movie, book, or video game on the backs of DVD cases or on Amazon, for instance, are careful not to give away the ending, and aren't adequate models for what is required. When publishers ask for a synopsis or summary from a writer submitting an idea to them, they want something straightforward that states what happens in simple language and clearly reveals the main concept of the project and its ending.

LOGLINE AS PLOT ARMATURE

The logline is a good place to start building your story synopsis. A *logline* is one sentence that explains the gist of the concept and the conflict for the entire story, and sets up the hook of the story. The logline is often a test of how well you understand what your story is about. An inability to come up with a clear logline may be a warning that the writer doesn't know what the central conflict of the story is. If the story doesn't have a clear central conflict, reexamine the story itself.

Check the Submissions Guidelines

Most comics publishers will have a set of submissions guidelines posted on their websites. It's an easy matter to find those. Read through the guidelines before sending a story idea or a pitch packet, even if you have already talked to a publisher about the story. For most publishers, the submissions guidelines suggest a one-page, double-spaced synopsis that contains a beginning, middle, and ending. Submissions guidelines for individual publishers are updated from time to time, and a writer should check before sending anything.

Logline Examples

Here are two examples of loglines recently generated by students.

1. *Manipulated into killing the world's greatest hero, a vigilante named Nightshade must battle through his mind and sacrifice everything he stands for in order to save the world from being enslaved by Princess Aphrodite—but when you've destroyed everything you stand for, how can you be trusted to do the right thing?*

 Here it is obvious that the development will deal with superheroes and epic struggles. The hook of the story has also been established, a superhero with a devastating inner conflict.

2. *When Henry's son is killed by his previous employers (The Council) in a bid to make him compliant enough to build them a superweapon, he must find the strength to fight them with the help of a girl with mechanical limbs and the very weapon The Council is after: The Gauntlet.*

 The main conflict here involves a dilemma connected with building an ultimate weapon, which also becomes the story hook. The main character is established, and so is the main story conflict.

 Both examples above reveal the importance of having artwork accompany the story synopsis. Artwork should be sent with any submission to a publisher. If the writer is not an artist, then it's essential to find someone to collaborate with on the project before attempting to submit the story. The artwork provides the potential publisher with solid ideas about the look of the proposed story. The look of the art is an important factor in fully understanding the story synopsis.

 The logline, of course, is important for the writer, whether or not a publisher asks for it, because it becomes the key to building an effective story synopsis for the publisher.

If the logline works properly, it will focus the writer's idea about the story.

Many writer/artists look for something about the narrative to serve as a "brand" for the story. Here the image of the eponymous Gauntlet is a great emblem of the story idea.

Building a Plot Synopsis from a Logline

Once a logline for the story has been defined, the story synopsis can be developed in stages of greater elaboration around the three-act structure. If the writer lists the three acts of the story, then assigns a sentence to each one, a summary of the story can be easily constructed in a bare-bones form. Consider the following hypothetical logline: *Santa decides to move from the North Pole to the Himalayas because of global warming, but trouble starts when he ends up on the abominable snowman Rollo's turf.* From this point, using three-act structure, a rough plot scheme can be formed:

Santa vs. the Abominable Snowman

(Act I) Because of global warming, Santa moves from the North Pole to the Himalayas and starts building his toy factory, angering Rollo, the abominable snowman. (Act II) Santa tries to appease him, but that only angers Rollo more. Rollo sends for allies, more yetis. A war is brewing. Elves are being roughed up and Christmas packages destroyed. Finally, Mrs. Claus is kidnapped. (Act III) All-out war breaks out. When Mrs. Claus tries to break up a huge battle between elves and yetis taking place high on K2, she nearly falls over a cliff. They all pull together to save her, and learn respect for one another.

Acts are only listed here to clarify. These are not required in the final version you intend to send to a publisher.

From this point, details can be added up until the one-page limit is reached, but the synopsis has now been solidly formed with all of the major turning points clearly established, including the story ending. The details could include interesting subplots or small actions that work inside the limitations of the story synopsis.

A second version of the story synopsis might look like this:

Santa vs. the Abominable Snowman

(Act I) Because the polar ice caps are melting, Santa moves from the North Pole to the Himalayas and starts building his toy factory, angering Rollo, the abominable snowman. With the elves and the toy-making operation comes noise and confusion that irritates Rollo. (Act II) Santa tries to appease him, but when Rollo is attracted to Mrs. Claus, talks between them break down. Now angry and jealous, too, Rollo sends for allies, more yetis. Christmas is approaching and elves are being roughed up and Christmas packages destroyed, putting Santa behind schedule. When Mrs. Claus is kidnapped, Santa has no choice but to fight for his new home in the Himalayas. (Act III) All-out war begins. When Mrs. Claus tries to break up a huge battle between elves and yetis taking place high on K2, she nearly falls over a cliff. They all pull together to save her, and learn respect for one another.

Again, the synopsis has been kept short, but the subplot builds and its role in the main plot is further revealed. It may be possible to keep adding a few more details until the one-page limit is reached.

In your story synopsis, maintain an objective point of view, without commenting on the actions of the characters; focus on the causal series of events that lead to the conclusion. If you build your logline using the steps described on page 162, you can summarize a story of virtually any size. Of course, a story synopsis always defies a writer's instincts. It is unembellished, unadorned, and feels flat. It's missing all of the good lines and all of the coolest visuals of the script. The body of the story, however, will be built in the script and the art. For now, the clean bones of the story must show. Structural flaws, if they exist, show up here. Whether or not anyone is interested in moving forward with the Santa story above, what the story is about is quite clear.

Developing the Hook

Before the story synopsis is complete, you should think through not just the sequence of events, but *why* anyone would be interested in seeing them. What unique point of view or device that no one has ever seen before is being put forward? If the answer is "I don't know" or "I'm not sure," then it's likely that a publisher will not be interested in the story. Even if the story is self-published, it will have a difficult time finding an interested audience without a unique hook. In *Santa vs. the Abominable Snowman* on page 164, the fact that Santa is being displaced by global warming and that he is forced to contend with yetis for turf provides a fresh angle on Santa that ties in with contemporary concerns. Ask yourself these questions: *Why did I write this story? What about this story excites me, the writer? How much enthusiasm do I have for the project?* The answers to these questions shouldn't be muddled or confusing, but clear and coherent. The synopsis should articulate the hook clearly in the events that unfold.

TECHNICALITIES OF THE SYNOPSIS

Here are a few basic rules about writing a story synopsis. You will notice that many of these are simply rules of good style that I have already covered in connection with script writing.

- *Double–space and use twelve-point type!* This is not an option. It might help to think in terms of words instead of pages. One page is ordinarily about 300 words. When publishers state *one-page synopsis*, they mean double-spaced (not 1.5 spacing) and twelve-point type with regular one-inch margins. Use a font that is easy to read.

- *Story synopses are always written in the present tense.* Even flashbacks are referred to in the present tense. Think of the story as something that is in a state of continual happening.

- *Use the active voice as much as possible.* There are good reasons for doing so, but the most important is that it keeps things concise. A good way to remain in the active voice is to avoid *be* verbs (*is, am, are, was, were, be, been, being*). They indicate complicated verb constructions and wordy passivity that can lengthen the synopsis. Active verbs also emphasize action, an important consideration in a comic book story.

As the publisher scans a written synopsis, various elements of the story should be abundantly clear: setting, main characters (hero, villain), and the story structure (what happens, including the ending).

Setting

You can often give setting as a fragment or an introductory clause. "April 1865, New York City," for instance, works just fine. The setting is probably the first line of your synopsis. If no time frame is given, the reader will assume that the story happens in the place most familiar—the modern world, probably an urban environment. Even at that, it is usually a good idea to state what part of the world your story takes place in. If some particular detail in the setting becomes a key element in the story, it may be

necessary to elaborate a bit more. If the world of the story requires a great deal of explanation, you may want to set up a page called "World of the Story," separate from the synopsis. It can help to clarify things without taking up room in the synopsis itself. The synopsis should mainly be concerned with who did what to whom and why. You can usually include such a page with a submission (sometimes called a "pitch packet") without it being considered part of the one-page plot synopsis. However, be careful to avoid overindulging in backstory. Usually a few words in the synopsis will suffice.

Characters

Just as in your scripts, you should identify characters in the synopsis as you mention them. You need only do it once and should keep the chapter descriptions to just a few words—the same as in a script. For instance, "John, small, skinny, nervous, the hero of the story, enters the bank." Only mention particulars of the character's demeanor or description if they have a bearing on the story. In a synopsis, all details take on a heightened importance. It isn't essential to mention or describe every character in the story, only the main characters. Having too many names in a synopsis creates confusion. Some writers actually provide a separate character sheet that details who the characters are, what powers they may have, and what their relationship to others in the story may be. It's a good idea to do this if there are numerous characters. It could become tedious to constantly explain characters in the synopsis.

Story Structure (Actions)

Structure is the single most important aspect of a synopsis. Discuss actions as they relate to "plot hinges" or important "turning points" in your story. Focus on big actions within the three-act structure. Usually the big actions can be outlined easily. In order to write a story synopsis, be sure the three-act structure is absolutely clear within the space allotted. (See chapter 3 for a review of three-act structure.)

Ongoing Series or Multiple Issues and Story Endings

A writer who proposes a multi-issue series will need to consider where the issues break. The act and scene structure discussed in earlier chapters is a great asset in considering where the issues should break. Breaks normally occur along the boundaries of major act or scene shifts.

Here are some ideas about how to break down stories with multiple issues or chapter breaks:

- *Insert an issue break at the point of a major story revelation.* This frequently occurs at the end of Act I, at the second act's midact climax, and at the point where Act II becomes Act III. The story does not always break up neatly along act boundaries, but these might be good places to consider going to a new issue. Always leave something to be discovered in the next issue.

- *Create an issue break at major scene shifts, where it makes sense to do so.* It's a good idea to create a cliff-hanger or a suspenseful moment that has yet to be resolved between these points of the story. The break might occur at a point where something has been revealed, but the character's reaction to the revelation has yet to fully develop. The idea is to bring the reader back to the next issue to see what happens.

- *An issue break might occur at the juncture between major shifts in physical location or scenery, where it makes sense to do so.*

- *Issues should only break after something major has occurred in the story, especially where it concerns the first issue.* It is critical for the first issue of a story arc to grab the reader's interest. Publishers know that a bland first issue may not bring readers back for the second issue.

If you propose a series that has multiple issues, you should summarize the entire series, not just the first issue, in one or two double-spaced pages. If you propose a series that has no actual ending, you should summarize the first story arc, the first segment of story that contains three major acts and a climax. The point is, your story must contain some

kind of substantive closure, even if the characters will go on to have other adventures.

Avoid Common Mistakes: What *Not* to Include in a Synopsis

In constructing a synopsis of a comics story, be careful to stay within the boundaries of what is necessary as opposed to what is embellishment.

- *Do not include dialogue.* If characters get into a violent argument, it is not necessary to write the language of the argument.

- *Do not get overly detailed about the information given in the plot.* Save that for the script. In the *Santa vs. the Abominable Snowman* example on page 164, the setting is simply described as the Himalayas. For the purpose of the synopsis, the setting, the characters, and even the actions should be kept to the most minimal descriptions that will get the idea across without confusion.

- *Do not try to sell the story with language.* The energy of the plot should sell the story, not the eloquence of the adjectives. Avoid hyperbole (over-exaggerated language).

- *Do not include lengthy backstory in the synopsis.* Backstory is the number one reason that most writers cannot keep their synopses short. No matter how fantastic and interesting the world of the story may be, keep in mind that the focus should remain on the character's *conflict*.

- *Proofread the story synopsis.* Anyone submitting work as a professional writer should be sure that every comma and capital letter is correct. Do not count on the computer to catch mistakes. Take your time. Read the work carefully yourself with your own eyes. Get someone else to look at it.

PUTTING EVERYTHING TOGETHER

Writing a synopsis feels wrong. It feels as if you're leaving out the best parts of the story. A good story, however, hangs together even if it's just being given in a shortened form. If it doesn't hold together in a shortened form, then dressing it up is not going to help. The synopsis is a test of whether or not a story is worthy of sending off.

The One-Page Story Synopsis

Here is an example of a one-page synopsis created by artist Dave Wheeler:

The Misadventures of Wonderboy!

By Dave Wheeler

The Misadventures of Wonderboy is the story of a superpowered teen going through puberty and finding how to be a hero and a "normal" teenage boy. He makes this journey by going through the hell that is puberty while going through the motions of being a teen. He tries to hide his powers, but without knowing how to use or activate them, he will be lucky if he doesn't burn the school down. For every budding hero, there must be a villain—in this case, a victim of one of Wonderboy's hijinks with his powers.

Much of the language here contains hyperbole that could be trimmed from the synopsis.

continued

A former friend, Slice McWheatley, is now the maniacal, kitchen-hardware-wearing Captain Toast. The two will clash in a battle of mediocre proportions atop the very school that they attend.

A tale of a boy becoming a man is one story everyone can tell, a boy with superpowers becoming a superhero is Wonderboy's alone.

It would be more appropriate to simply say that they fight. Describing the battle this way undercuts the excitement of the climax, probably not something the writer intends to do.

The last sentence feels as if it's trying to sell the story. It would be best to simply state the outcome of the battle and how Wonderboy feels at the conclusion of the story.

Providing art that defines the look of the character is an important part of the process. Often, the look of a character isn't totally clear in the synopsis.

The *Wonderboy* synopsis is concise and gets the hook of the story across. The idea of puberty and superpowers at odds is a compelling hook, if perhaps a little cliché. The plot might be stronger if it emphasized the choice between doing what is right and sticking up for a former friend, even if the story is obviously humorous.

An act structure is present, but the outcome of the story feels uncertain. The plot does seem to indicate a humorous slant to the story, and the artwork further supports that idea. Humor can be compelling; however, the writer needs to be careful not to undercut the outcome. It might be best to suggest that the ending is surprising somehow, highlighting the unusual and imaginative weapons and strategies used by the combatants at the end. For instance, does Captain Toast have a pickle-shooting machine gun? That information would help to sell the story more than the exaggerated language.

The unadorned structure of *Wonderboy* looks like this: *A boy gets superpowers. He is then pitted against his former friend, whom he once inadvertently turned into a supervillain. The two ultimately fight*

on the roof of the school. In the course of the struggle within the story, the boy is compelled somehow to grow up. Remember, the ending is one of the most important parts of the story. Having a hero and a villain fight on the school roof (of all places) should be exciting. That would be a good place to add a few more details to the synopsis, if there is room to do so. Are the other students there? Do the football team, the cheerleading squad, all the teachers, and the school principal see what Wonderboy does? Or does it happen in the dead of night with no one around? Given the brevity of the synopsis, these elements could be easily added.

A *story proposal* is the formal presentation of a story idea to a publisher. The proposal is also sometimes called a *pitch packet*. The synopsis of the story is one of the main components of the proposal. Art for the story, usually including the first ten pages of art, is also an important part of the proposal or pitch packet. Putting together an effective proposal is often almost as much work as creating the story itself, especially for writers attempting to break into the field.

Take a look at the story proposal for *The Prophecy*, a proposed series by writer and artist Phil Sevy. He not only includes a synopsis, but considers the style of art and the kind of branding his story requires.

Below is the finished story art for the first four pages included in the pitch for *The Prophecy*. Notice how carefully he integrates the synopsis and the art.

Sevy's complete pitch packet for *The Prophecy* includes design elements and a page called "Preamble," which is the backstory, or world explanation. The plot synopsis itself is clearly labeled and designed to look professional.

continued

SYNOPSIS:

WE OPEN ON THE TWENTY-FIFTH ANNIVERSARY OF THE EVENT. ELI ENCOUNTERS AN OLD MAN, HENRY MCADAMS, WHO TELLS HIM THAT THE EVENT WAS A HOAX. USED TO THE OCCASIONAL SKEPTIC, ELI IGNORES HIM. THAT NIGHT, ELI FINDS HENRY WAITING INSIDE HIS APARTMENT. ELI ALERTS THE AUTHORITIES (THE POLICE) AND QUESTIONS HENRY. HENRY TELLS ELI THAT THE PROPHET HAS TO DIE FOR WHAT HE'S DONE. THE AUTHORITIES DRAG HENRY AWAY BEFORE ELI CAN QUESTION HIM ABOUT THE DEATH THREAT.

AFTER THEY LEAVE, ELI FINDS THAT HENRY PAINTED AN ENTIRE MURAL ON HIS WALL CONSISTING OF NAMES, NUMBERS, AND PHRASES. ELI TAKES A PICTURE OF THE WALL MAP AND HEADS OUTSIDE TO CALL HIS GIRLFRIEND BETHANY ON A PUBLIC PHONE (SINCE HIS PHONE ISN'T WORKING). WHILE ON THE PHONE, AN EXPLOSION ROCKS HIS APARTMENT BUILDING.

CLEAN-UP CREWS ATTRIBUTE THE EXPLOSION TO FAULTY MECHANICS IN THE BUILDING, BUT ELI IS WARY. HE GOES TO BETHANY'S APARTMENT AND SHOWS HER THE MAP AND TELLS HER ABOUT THE DEATH THREAT TO THE PROPHET. WHEN THEY DISCOVER THAT HENRY AND THE AUTHORITIES WHO ARRESTED HIM DISAPPEARED THAT NIGHT, THEY DECIDE TO INVESTIGATE THE CLUES LEFT ON THE MAP.

THEIR SEARCH LEADS THEM THROUGH THE UNDERBELLY OF THE "PERFECT" SOCIETY. ELI SEES HIS BELIEFS TESTED AT EVERY TURN — HIS OBSESSION FOR FINDING THE ASSASSIN PUSHING HIM TO EXTREMES HE WOULD HAVE NEVER GONE BEFORE.

THE SEARCH ENDS ON A MAN NAMED EDWARD PEAKS WHOSE DEATH, THIRTY YEARS EARLIER, IS CLOSELY CONNECTED WITH THE DEATH OF THE AMERICAN PRESIDENT — WITH THE EVENT.

BETHANY RETURNS HOME TO FOLLOW UP ON EARLIER CLUES AND TO DISTANCE HERSELF FROM ELI WHOSE ACTIONS HAVE PROVEN TOO MUCH FOR HER. MEANWHILE, ELI TRACKS DOWN PEAKS' ISLAND HOME THAT HAS SUPPOSEDLY BEEN ABANDONED FOR THIRTY YEARS. PEAKS STEPS OUT FROM THE SHADOWS. HE INTRODUCES HIMSELF AS ELI'S FATHER.

PEAKS EXPLAINS THAT DECADES EARLIER HE, THE PROPHET, AND HENRY DECIDED THE ONLY WAY TO SAVE THE WORLD WAS TO GIVE PEOPLE SOMETHING GREATER TO BELIEVE IN. THE THREE SPENT THEIR ENTIRE LIVES ENGINEERING THE EVENT. WHEN IT WAS DONE, PEAKS WENT INTO HIDING BECAUSE HE KNEW HENRY, THE PROPHET'S RIGHT-HAND MAN, WOULD KILL HIM.

FACED WITH THE REALIZATION THAT HE BUILT HIS LIFE ON A LIE, ELI RETURNS WITH PEAKS TO RESCUE BETHANY, WHO HAS BEEN CAPTURED BY HENRY. WHEN THEY GET HER TO SAFETY, ELI CONFRONTS PEAKS AND HENRY. HENRY EXPLAINS THAT THE DEATH THREAT WAS ALL ENGINEERED TO GET ELI TO FIND PEAKS. PEAKS REVEALS THAT ELI IS TO BE THE HEIR TO THE PROPHET — TO TAKE HIS PLACE WHEN HE DIES. ELI IS TO BE THE NEW INSTRUMENT IN THE HAND OF GOD.

FURIOUS AT BEING MANIPULATED SINCE BIRTH, ELI KILLS PEAKS AND MORTALLY WOUNDS HENRY.

ELI IS BROUGHT BEFORE THE PROPHET, WHO ADMITS THAT WHILE EVERYTHING WAS ENGINEERED — IT WAS STILL THE WILL OF GOD. ELI WON'T ACCEPT IT — HE'S GOING TO EXPOSE THE LIES. THE PROPHET EXPLAINS THAT IF HE TOPPLES THE HOUSE OF CARDS THE WORLD IS BUILT ON, THE WORLD WILL FALL TOO. ONE EVENT BROUGHT THE WORLD BACK FROM THE BRINK AND EXPOSING THAT EVENT FOR A FRAUD WOULD PUSH THE WORLD OVER THE EDGE.

ELI REALIZES THAT THE PROPHET IS RIGHT. THE PROPHET SAYS THAT THEY MUST REMAIN SILENT. IT'S THE BURDEN INSTRUMENTS OF GOD MUST CARRY.

OUTSIDE THE CITY, ELI AND BETHANY MEET UP. SHE SAYS THAT THEY CAN EXPOSE EVERYTHING SO THAT THE TRUTH CAN PREVAIL. HE ASKS HER TO JUST GO AWAY WITH HIM. SHE REFUSES — SHE HAS TO EXPOSE IT. HE BEGS HER. SHE STAYS RESOLUTE AND WALKS AWAY, DETERMINED TO REVEAL THE TRUTH.

HAVING LOST EVERYTHING HE BELIEVES IN, HE MUST DESTROY THE LAST GOOD THING IN HIS LIFE. ELI PULLS A GUN FROM HIS WAISTBAND AND FOLLOWS AFTER HER.

FORTY YEARS LATER, THE WORLD IS PEACEFUL. ELI IS NOT. GUILT-RIDDEN FOR DECADES OVER BETHANY'S DEATH HE TRIES UNSUCCESSFULLY TO KILL HIMSELF. WE PULL BACK AS HE BREAKS DOWN CRYING, MISERABLE IN A HAPPY WORLD.

THE END.

Such a presentation does not, of course, guarantee that a publisher will accept the proposal, but it will do a great deal to assure the publisher that the person sending the material is a reliable professional with confidence in his story. It will also allow the publisher to make a definite decision about a project. Sevy, a writer/artist, put a great deal of energy into creating not only the story, but following through and producing ten fully colored and lettered, professional pages to support the story idea. No matter how good the story synopsis or the script itself, selling the story comes down to the art. A good story, however, should inspire good art.

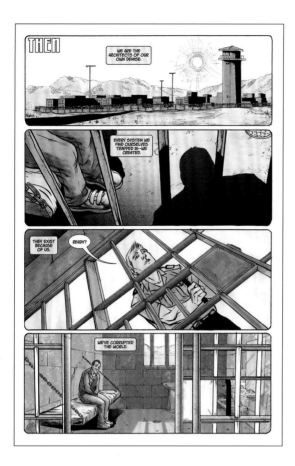

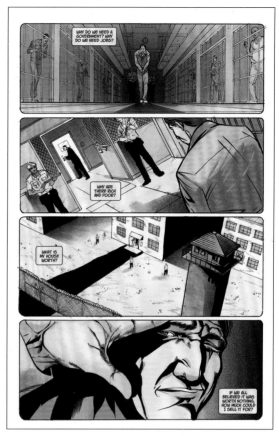

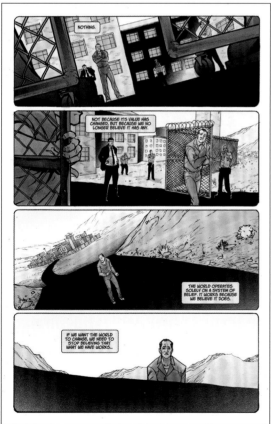

In order for a company to take a story submission from an unknown artist seriously, the submission usually has to include finished pages of the story. The pages here do a great job of selling the story in the synopsis.

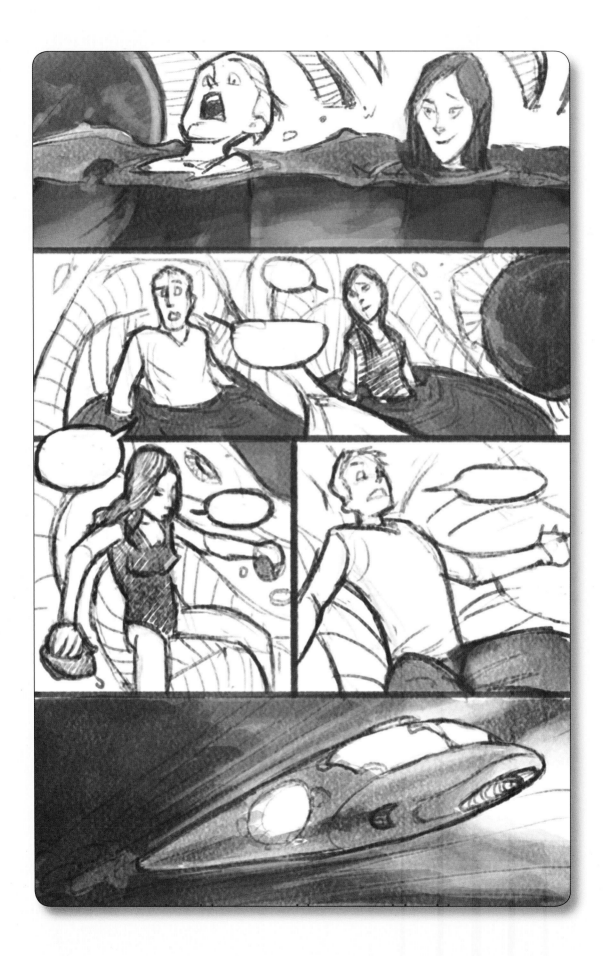

CONCLUSION

Writing comics is a demanding, challenging discipline. Those who set out to be comics writers do so because they like what comics have to offer. The old stigma that comics are for kids and that full-grown adults don't waste their time with them doesn't register with the new generation of creators overflowing with fresh ideas for the medium. Comics are viable, immediate, and tremendously rewarding to create. Comics communicate across languages and cultures. The field of comics is wide open and welcoming to just about any kind of storytelling.

Sequential art, however, has its own set of rules, just like novels, film, stage, and poetry. All art is demanding. That's what makes it art. Learning is half the fun. This book is a start, but I hope that you don't stop here. In this book, I've tried to emphasize the things that it takes many writers years to figure out. There are, obviously, more discussions to be had than are encompassed in these pages. I don't consider what I'm providing in this book to be iron-clad rules so much as suggestions based on my own experiences as a writer and as a teacher. Write what you want to write, and say what you want to say. All the how-to books in the world are of little avail if you don't stop talking about it, sit down, and put something together. Hopefully, what I'm telling you will help get the job done.

MARK SCHULTZ TALKS ABOUT WRITING COMICS

INTERVIEWED BY MARK KNEECE

Mark Schultz may be best known for his *Xenozoic Tales*, but he also co-created the undersea comic-book adventure *SubHuman* and has either scripted or drawn many comics icons, including Flash Gordon, The Spirit, Tarzan, and Superman. He has illustrated Robert E. Howard's collected Conan stories, and his interest in the sciences led him to write the science primer *The Stuff of Life: A Graphic Guide to Genetics and DNA*. Currently, Schultz writes *Prince Valiant* for newspaper syndication and continues working on his illustrated novella, *Storms at Sea*.

Mark was kind enough to share his thoughts on the art and skill of writing comics in an interview with me.

What was your first writing experience like?

What I did when I determined that I was going to try my hand at comics was I sat down and I studied a lot of Will Eisner's work, especially his Spirit stories and a lot of Harvey Kurtzman's work, especially his war stuff for EC. I wanted to tell stories in six-, eight-, ten-, twelve-page increments. I wanted to tell concise short stories in comic book format, inspired by EC stories. I found this book in the library, which I've never been able to find since (and I've looked for it online), called something like *Writing the Short Short Story*. It occurred to me that the amount of

story you could fit in about two prose pages equaled what you could do in six, seven, or eight pages of a comic. That book really did help me figure out the right pacing for a short comics story with some punch at the end of it.

Do you think the short-story format is better for writing comics than, say, studying prose novel writing would be?

If you can learn to tell a story concisely in a very limited number of pages—six to twelve pages—then I think you're way ahead of the game. If you can get a firm grip on that, then you can tell stories in just about any longer or extended format. You really have to be ruthless in constructing a short story, cutting out all the unneeded material and just boiling everything down to its essence.

Short stories are tough to write.

Doing an extended, graphic novel–length story at that point in my early career was incredibly daunting to me. I just liked those punchy, brief stories that delivered quickly, and it seemed like something I could sink my teeth into and understand. When I got comfortable with that, after two issues of *Xenozoic Tales*, then I was ready to move into stories that had a longer page count that allowed me to explore characters more.

Cramming too much visual information onto a page seems to be the number one complaint most artists have about writers. How do you decide where to end a page? Is five panels per page a magical number?

As far as the number of panels per page, I think that should be determined by the story. I'm a traditionalist and appreciate the grid more and more as I gain experience. Generally speaking, I think that anything less than three or four panels per page is a waste of space unless you have a solid storytelling reason to expand the size of your panels, and indicating more than six panels per page can start to make it difficult to clearly convey all the visual information necessary. Obviously, if the page involves nothing but head shots of people glaring back and forth, you can squeeze in a higher number of panels. But if you ask the artist to do a multifigure battle scene, you want to figure on fewer, bigger panels. And never forget to take the amount of text to be lettered into account!

If you're writing a comic about something that's really fantastic, that is not part of the real world, how do you *know* what you're talking about? How far can you go with just pure invention?

The stories that grab me and keep me interested and pull me through, the stories that I go back to and reread, are those that, no matter how fantastic the concept might be, still have a firm grounding in reality. There's some relationship to what I've seen in my life and how I know that the world works. For instance, if the story has the hero riding a horse, and I can tell that the author has never been on a horse or never spent time learning how a person mounts or dismounts a horse, when it's obvious the author is guessing, [then] it all falls apart.

If you don't know what a stirrup is, you probably don't know much about horses?

Exactly! Exactly! This drives me crazy in comic book writing, because I see it all the time. If you need to get your fantasy character on a horse (I've seen something of this sort done so many times), rather than the artist or the writer learning what is necessary to know in order to show the character getting on a horse, because it's a fantasy land, the character just magically levitates onto the horse. Then the writer and the artist don't have to deal with all that. It destroys it for me. I lose interest entirely. There's got to be a grounding in reality, and the more fantastic the elements you put into the story, the more important it is to have that strong grounding so people can relate to the real-world elements of the story, and suspend their disbelief and accept the more fantastic elements.

Do you think that it's important to have a point in writing? What does having a point even mean?

There's an awful lot of bad writing out there that doesn't have much of a point. And I think that a lot of storytellers get away with endlessly repeating a well-worn point, to cliché. If what you're writing has any chance of really resonating with people, and therefore lasting, it's got to have something of your personal perspective on the world and say something about the human condition, something that we can all relate to, no matter how fantastic and heroic your story's circumstances might otherwise be. It still has to be something that the reader can look at and say, "Oh, I've faced a similar issue or ethical decision in my experience." So, yeah, your work has to have something of a theme, and that should be driven by your personal passions. It's about exploring the big eternal themes through your very particular and specific interests, concerns, point of view, and life experience.

You're an artist as well as a writer. We know comics have to be visual. Everyone says it's mainly a visual medium, but what is the relationship between art and story in a comic? And what's the difference between good writing and bad writing as far as comics writing goes?

(Chuckles) Wow! Comics is a *narrative* medium. The medium can be used for many things, but I think at the heart, comics exist to tell stories. Sequential art doesn't exist to only show the transition from one state to another. A comic can show a block of ice melting into water, and that's an acceptable

formal application, but it doesn't really represent the potential of comics. Comics exist to communicate story. Story is a very important element of how everyone learns and grows as an individual. Comics—as you said—is also essentially a visual medium. The bulk of the information conveyed to tell the story comes from visual information in a comic. But, having said that, it is not purely a pantomime medium. The written word, in most comics, I think, carries equal weight. It varies, depending on the people telling the story—the creators. Ideally, there's an equal load of storytelling carried by both the written word and the visuals. I'm trying to get the right terms here because the application of the "written word" in a comic and the "drawings" are *both* visual elements. I guess that what I'm trying to say is that the script and the drawing that interprets the script have to be of equal importance, or close to it, to be really effective. They certainly need to work together.

As a writer/artist, how difficult is it to get some kind of feedback or perspective on how the writing is going?

I use an editor. As far as I'm concerned, that's what editors are for. When I was writing *Xenozoic Tales*, I would always pass my scripts through my editor, although because it is a creator-owned property, I didn't have to do that. [*Creator-owned property* means that even though a company may publish the work, the rights belong entirely to the creator.] But I wanted to have other people look at it. I didn't have to follow their advice if I didn't agree with it. And even before I show a story to an editor, I'll bounce ideas off of my wife, who is not a particular fan of genre fiction. It's good she's not a fan, because she's going to throw an answer back to me that comes totally outside of routine genre expectations. Sometimes that's really valuable. She'll come up with a solution that I never would have thought of in a million years. It's because she doesn't have that history of reading all the stuff I've read.

She hasn't read so many comic books that she thinks it's supposed to go a certain way because it always does?

Exactly! Right! She's completely divorced from subconscious expectations of what should happen in the story. So I go to her. I also go to friends if I'm running into story problems. I don't, of course, *have* to take anyone's advice, but if you can just get past the ego thing [where you think] that *Well maybe they don't think my idea is any good*, and just take people's suggestions for what they are, to me, it's invaluable input.

I've had people tell me that somehow stories have changed, that somehow things are done differently these days. Do you think anything fundamental in storytelling has really changed in the past few years? Is something different now than it used to be?

No. I don't think story changes. The elements of a good story, a story that grips people, holds their attention, and gives them a satisfying resolution, has remained constant since who knows when—I think probably since people were sitting around fires in front of their caves. I think there are certain elements that we respond to across the board. It seems to be cross-cultural. There are just certain fundamental storytelling conventions and rhythms that work over and over in all sorts of different contexts. I think the *formatting* of how stories are told today in many comics has changed, but all the storytelling elements are still there. For instance, I don't think that the elements that make Craig Thompson's *Blankets* work are really any different than what make Charles Dickens's *Great Expectations* work. They're both "coming of age" stories, and no different than what makes the biblical tale of Moses work, even back to the Sumerian stuff that led to the Moses story, all the elements are there. I think story sometimes gets confused with what is given as a plotline in video games.

I've discovered that there are two reasons that people read anything: to be entertained, and to learn. With stories, hopefully, you're doing some of both. Learning comes via conflict.

There's more and more emphasis on conflict being resolved by mechanical skill—and by mechanical skill, I mean, maybe the plot goes something like this: *The hero faces the obstacle (the villain), gets beaten, and then he learns he's got to be better at something, so then he applies himself, gets better at certain fighting techniques. There's a second battle, and he beats the villain and attains his objective.* Well, that's just pure, empty-calorie, entertainment. I think that the level of conflict you're talking about is one involving some ethical or emotional conflict that has to be resolved within the characters in order to get to the objective, the resolution. And if the character succeeds, then it's a heroic story, and if he or she fails, it's a tragedy. I'm grossly simplifying here.

In most good stories, there's an element of *sacrifice*, you have to give up something. The protagonist needs to abandon something in life that was very important, very beloved, to obtain something else.

Is there anything more that you might want to say about comics writing or the process?

For me, writing comics is about having a balance between logic and inspiration. I generally start with just a flash of inspiration for a particular scene within a story, and a lot of the time, it really grips me because there's emotional content to it. There's a real, climactic, emotional thing happening within that scene. It's about something that has not been clearly formed in my mind yet, and leads to something in the end that also hasn't been resolved in my mind. If it's strong enough, that flash of inspiration does develop into an entire story. But at a certain point, logic has to take over and string it all together in a way that makes sense, that's not just purely a stand-alone emotional impact. And then sometimes *you've* got to sacrifice. It's happened to me where that initial inspiration almost has to be gutted, tossed aside, or significantly rejiggered to make the story work—because in the end, it's the story that's important, not just that one inspirational scene or notion.

Mark Schultz's cover for *The Girl from the Gulf*, discussed in chapter 8.

ACKNOWLEDGMENTS

Thanks to the many people who contributed to the pages of *The Art of Comic Book Writing*. I would first like to thank my wife, Paula, who helped immensely during the time that I worked on this project. Jackie Meyer, Jonathan Osborne, John Lowe, and Angela Rojas also deserve special mention for their assistance and for helping to make all of this possible. Thanks to Kerri, who helped edit the chapters in the early stages. Thanks to Patrick Barb, who edited the book, sorting through so much material. Thanks to Chloe Rawlins for her design work. And a very special thanks, of course, also goes to Paula Wallace, the president of Savannah College of Art and Design, without whose visionary leadership no part of this book would have been possible.

CONTRIBUTORS

Among those who contributed work to the book, none were so diligent, tireless, and organized as Ariela Kristantina. A glance below at the large amount of art that she contributed should make it clear that she played a tremendous role in the production. She is a wonderful artist and a consummate professional. Phil Jacobson also contributed heavily to the book and deserves many thanks. Thanks to Phillip Sevy and Alexis Ong, who deserve special mention for their assistance in the early stages. Mark Schultz was incredibly kind with his time and assistance in allowing me to interview him for the book. Thanks to all of the fine artists whose outstanding work graces these pages. I would, of course, especially like to express my appreciation to the writers who sat through my classes over the last twenty years, and who eagerly consented to allow me to show work that was part of their learning experience and mine.

CREDITS

ii: Phil Sevy, *Prophecy* (text)

iv–v: Rob Carter, *Planetary Approach* © 2012 Robert M. Carter

viii: Gloria McAndrew (art) and Grace Allison (story), *Mortimer*

3: Gloria McAndrew (art) and Grace Allison (story), *Mortimer*

4: Geoffery Shaw

7–9: Ariela Kristantina

12 Jeremy Lawson

12–15: Ariela Kristantina

15: Morgan Beem

16: Ariela Kristantina

17: Anthony Fisher, *Lou, Sir*, A.J. Fisher, Freelance Artist, Inc.

20: Ariela Kristantina

21: Jeremy Lawson

25: Daniel Glasl, *Talos*

27: Daniel Glasl, *Talos*

28: Jeremy Lawson

29: Ariela Kristantina

34: Jeremy Lawson (art) and Jeffrey Vossler (story), *Boating on the Fourth of July*

35: Ariela Kristantina

37: David Gildersleeve, *Jabberwocky* (adaptation)

38: Ariela Kristantina

40: Paula Kneece (photo)

40: Dove McHargue, *Lord of the Skies*

41: Jeremy Lawson

43: Ariela Kristantina

45–46: Ariela Kristantina

52: Ariela Kristantina

55: Ariela Kristantina

56: Paula Kneece (photograph)

59–61: Ariela Kristantina

62: Phil Jacobson

63: Nicky Soh

64: Ariela Kristantina

64: Nicky Soh

64: Dove McHargue

65: Nicky Soh

65: Daniel Glasl

66: David Gildersleeve, "Going to School"
(see copyright below)

69: Chi Do (art) and Alyson Hopper (story),
Wolves, Dogs, and Men

71: Chi Do (art) and Alyson Hopper (story), *Wolves,
Dogs, and Men*

72: Anthony Fisher, *World War I Trunk—Cat—Ed*,
A.J. Fisher, Freelance Artist, Inc.

75: Allison Robke (art) and Mark Kneece (story),
Little Carpenter and Blackbeard

77: Allison Robke (art) and Mark Kneece (story),
Little Carpenter and Blackbeard

81: Jorge Corona

83: Phil Jacobson (art) and Meaghan Casey (story),
Silly Baby

84: Nicky Soh

85: Ariela Kristantina

86: Phil Jacobson

88: Ellie McKenzie, *Crime Fighting Girl* (photos)

90: Ariela Kristantina

91–92: Phil Jacobson

98: Phil Jacobson (art) and Susan Van Denhende
(story), *Damsel in Distress*

99: Phil Jacobson

100: Cassandra Anderson

101: Phil Jacobson

104: Ariela Kristantina

104: Jorge Corona

105: Chi Do

107: Phil Jacobson

109: Eryk Donovan, *Dust*

114: Del Borovic, *Subject D*

116–117: Phil Sevy, *Running Girl*

119: Ariela Kristantina, *Giant*

120: Rob Carter, *Planetary Approach*

122–123: Nicky Soh

125–127: Phil Jacobson

129: Ambrose Hoilman (art) and Mark Kneece
(story), *Girl from the Gulf* © Mark Kneece and
Ambrose Hoilman

131-132: Ambrose Hoilman (art) and Mark Kneece
(story), *Girl from the Gulf* © Mark Kneece and
Ambrose Hoilman

135: Daniel Glasl, *Angels*

137: Daniel Glasl, *Angels*

139: Daniel Glasl, *Angels*

140 David Gildersleeve, "Ice Cream Man"
(see copyright below)

142–143: Ariela Kristantina

143: Jorge Corona

144: Phil Jacobson

144: Nicky Soh

145: David Gildersleeve, "Day of the Bike,"
"Ice Cream Man," "Going to School," and
"Lightning Bug" Copyright © David Gildersleeve
from *The Art of Being a Kid* (glseeve.com)

146: Phil Jacobson

148: Jorge Corona

150: Jorge Corona

153: Ambrose Hoilman

157–158: Jason Clarke, *Heavy Armor Tax Collectors*
© 2013 Jason J. Clarke

160: Phil Jacobson

163: Phil Sevy, *Nightshade*

163: David Stoll, *Gauntlet* © 2012 David Stoll

168: Dave Wheeler, *Wonderboy*

169–171: Phil Sevy, *Prophecy*

172–173: Ambrose Hoilman (art), and Mark Kneece
(story), *Girl from the Gulf* © Mark Kneece and
Ambrose Hoilman

174: John Fleskes, copyright © 2013 John Fleskes

178: Mark Schultz, artwork copyright © 2014
Mark Schultz

INDEX

A

Action
 definition of, 11
 exposition vs., 43–44,
 83–85, 87
 importance of, 11–12
 per panel, 26, 62
 in scene descriptions,
 67–71
 syllogism, 105, 122
 in synopsis, 166
Active voice, 31, 165
Acts
 scenes vs., 49
 for story structure, 16,
 44–49, 166
Art distension, 128–32
Artists
 communicating with, 36, 57, 58,
 61, 71
 pacing and, 147
 styles of, 57
 writer as, 19, 20, 71
Associative symbols, 118, 119

B

Bá, Gabriel, 110
Backstory, 110–16, 167
Bad habits, avoiding, 30–34
Bird's-eye view, 65
Bleed pages, 154

C

Camera directions, 21, 25,
 62–66, 68
Capitalization, 31, 81
Captions, 79, 80, 82
Characters
 backstory and, 110–11
 complicated, 13, 90
 definition of, 89
 describing, 67
 development of, 100
 emotions of, 100
 empathizing vs. sympathizing
 with, 92
 extras, 90
 flat, 90–91, 98
 with flaws, 92–93
 focus on, 14
 genre, 101
 importance of, 89, 101
 look of, 15, 90, 100, 101, 168
 main, 92–93
 motivations of, 6, 93–98
 movie actors vs., 29, 100
 naming, 93
 number of, 98
 plot and, 99
 round, 90
 subtext and, 111
 in synopsis, 166
 types of, 90–91
 in video games, 99
Close shot, 63
Close-up, 63, 64

Colloquialism, 82
Comics writing
 as art form, 1
 audience for, 1
 autobiographical elements of,
 6–7
 challenge of, 1, 173
 film writing vs., 2, 13, 20,
 141–42, 149
 good vs. bad, 176–77
 inspiration and, 178
 See also Characters; Script; Story
Conflict
 inner vs. outer, 9, 92, 155–59
 necessity of, 8–9
 pacing and, 146–47, 155–59
 resolution of, 178
 setting and, 104, 119
Contractions, 82
Correlative connections, 118
Criticism, getting, 33, 177
Crumb, Robert, 101

D

Dead space, 23
Deadwood, editing out, 124
Details, telling vs. incidental, 61
Dialogue
 actor's prompts in, 29
 definition of, 78
 editing, 27
 guidelines for, 78–79, 81–82
 for other time periods, 76, 77, 78
 profanity in, 81

sound effects vs., 138
in talking heads scenes, 86
whispered, 75
See also Word balloons
Digest size, 40
Donovan, Eryk, 108
Drawability, 28–29
Dutch angles, 159

E

Editors, role of, 177
Empathy vs. sympathy, 92
Exposition, 43–44, 80, 83–85,
 87, 133
Extras, 90
Extreme close-up, 64

F

Finger, Bill, 90
First-person narration, 79
Flashbacks, 59
Fonts
 changing, 82
 choice of, 31
 size of, 75
Forced perspective, 64
Formulaic comics narratives,
 154–55
Full script
 advantages of, 23–24, 37
 definition of, 19, 20
 example of, 24–25
 formatting guidelines for, 21–23
 imagery in, 20, 28
 spacing in, 22, 27–28, 29
 text in, 21
 See also Script
Full shot, 63

G

Gags, 16, 17
Gaiman, Neil, 61
Generality vs. specificity, 66–67
Genre characters, 101
Gildersleeve, David, 36, 144
Glasl, Dan, 23, 24, 133
Grammar, 30, 31
Gutters, 28

H

High-angle shot, 65
Hooks, 14–15, 16, 154, 165

I

Issue breaks, 166–67

K

Kane, Bob, 90
Kirkman, Robert, 101
Kristantina, Ariela, 34

L

Loglines, 162–65
Long shot, 63
Low-angle shot, 65

M

Manga size, 40
McCloud, Scott, 66
McHargue, Dove, 40
McKee, Robert, 2, 44, 92,
 141–42
Medium shot, 63
Metaphors, 118
Miller, Frank, 105
Mise-en-scène, 107
Mood, 85–86, 104, 115–16
Moon, Fábio, 110
Moore, Alan, 61, 118
Motifs, 118

N

Names, 93
Narration, 79, 80, 82
Narrative syllogism, 9, 10, 12

O

Objectivity, 6–7, 10
Omniscient narration, 79, 80
Onomatopoeia, 22, 30, 80
Over-the-shoulder shot, 64

P

Pacing
 art distension and, 128–32
 artists and, 147
 complications and, 122–23
 conflict and, 146–47, 155–59
 definition of, 121
 editing and, 124
 exposition and, 133
 fixing bad, 159
 formula, 154
 importance of, 121
 joy of discovery and, 124
 page count and, 128
 reactions and, 149
 redundancy and, 147–49
 scene length and, 133
 story openings and, 154–55
 story time vs. real time, 133–39

tempo and rhythm, 142–44, 146,
 150, 151–54
time compression vs. expansion,
 124–28, 133
Page
 breakdowns, 23–24, 44–49
 counts, 128, 159
 dimensions of, 40
 dramatic potential of, 41
 numbering, 62
 outlines, 41, 49
 panels per, 25, 34, 35, 39, 40, 41,
 42, 144–45, 176
 structuring, 50–55
 visualizing, 39, 40, 42, 66
Panels
 descriptions of, 61–62
 gutters and, 28
 inset, 129
 large, 142–43
 numbering, 62
 number of, per page, 25, 34, 35,
 39, 40, 41, 42, 144–45, 176
 one action per, 26, 62
 relationships between, 28,
 50–55, 122–23
 skewed, 154
 word balloons per, 78
Pan shot, 66, 141, 142
Passive voice, 31, 165
Perspective
 forced, 64
 one-, two-, or three-point, 63
Pitch packets, 169–70
Point-of-view shot, 64
Polyptych, 66, 141, 142
Preaching, avoiding, 10
Profanity, 81
Punctuation, 30, 31, 81

R

Reactions, 149
Redundancy, 147–49
Reference photos, 31
Rhythm, 142–44, 146, 151–54
Risks, taking, 7, 30

S

Scenes
 acts vs., 49
 avoiding dull, 84–85
 descriptions of, 58, 61–62,
 66–71
 development of, 43–44
 ending, at bottom of page, 49
 length of, 133
 talking heads, 86

Schultz, Mark, 175–78
Script
 audience for, 20
 balancing text and image in, 87
 as blueprint, 58–61
 drawability and, 28–29
 editing, 30–34
 energy, 73
 formatting, 20–28, 29–30, 31,
 34–37
 page outlines as aid to writing,
 49–50
 purpose of, 20
 reading aloud, 94
 shot calls in, 62–66
 writing, as process, 28
 See also Full script
Second-person narration, 79
Series, multiple-issue, 166–67
Setting
 art style and, 106, 109
 conflict and, 104, 119
 establishing, 67, 74
 historical, 104, 105–6
 physical aspects of, 104
 readers' expectations and, 107–
 10, 115–16
 researching, 104, 106
 social and cultural aspects of,
 104, 106
 as symbol, 116–19
 in synopsis, 165–66
Sevy, Phil, 169–70
Shortfalls, 11
Short-story format, 175
Shot calls, 62–66, 68
Showing vs. telling, 12–13, 43–44,
 55, 81
Sidekicks, 91
Similes, 118
Simon, Joe, 91
Skewed panels, 154
Sound effects (SFX), 22, 30, 31, 80,
 134, 138
Specificity vs. generality, 66–67
Spiegelman, Art, 155
Splash pages, 142, 144
Stereotypes, 90, 91
Story
 action in, 11–12
 beats in, 41

climax of, 11, 16, 154
complexities in, 9–10
conflict and, 8–9, 10
denouement of, 11
developing, 7–11
editing, 124, 159
gags vs., 16, 17
generating ideas for, 5, 6–7,
 16–17
hearing, 86
hook of, 14–15, 16,
 154, 165
importance of, 1
logic, 121
mood of, 85–86, 104, 115–16
objects in, 14, 15
opening, 154–55
proposals, 169–70
spine, 10
structure of, 11, 16, 29–30,
 44–49, 166
tension in, 11
visualizing, 11–14, 86
writing vs. editing, 29
 See also Pacing; Script; Synopsis
Submissions
 artwork accompanying, 163, 171
 guidelines for, 162
 story proposals for, 169–71
Subtext, 111
Symbolism, 116–19
Sympathy vs. empathy, 92
Synopsis
 characters in, 166
 common mistakes in, 167
 creating, 16–17, 161, 164–65
 definition of, 16, 162
 examples of, 164, 167–69
 guidelines for, 165
 for multiple-issue series, 166–67
 setting in, 165–66
 story structure in, 166

T

Takahashi, Rumiko, 15
Talking heads scenes, 86
Telling details, 61
Telling vs. showing, 12–13, 43–44,
 55, 81
Tempo, 142, 144, 146, 150, 151–54

Text
 balancing action and, 83–85, 87
 correlating, 81
 editing, 82
 excessive, 78, 81, 82
 in full script, 21
 importance of, 73
 mixing, with tempo and rhythm,
 151–54
 for other time periods, 76, 77, 78
 uses for, 74–81
 See also Dialogue; Narration;
 Sound effects; Thoughts
Tezuka, Osama, 61
Third-person narration, 79, 80
Thoughts, 79–80
Three-act structure, 16, 44–49, 166
Thumbnails, 34, 41, 78
Time
 compression vs. expansion of,
 124–28, 133
 passage of, 105–6, 121
 story vs. real, 133–39
Treatments, 162
Tropes, 15

V

Video game characters, 99
Voice, active vs. passive, 31, 165
Vonnegut, Kurt, 106

W

Ware, Chris, 118
Wheeler, Dave, 167
Whispering, 75
Word balloons
 editing, 82
 formatting, 22
 importance of, 73
 numbering, 22
 per panel, 78
 for thoughts, 79–80
 See also Dialogue
Worm's-eye view, 65